Young America

A FOLK-ART HISTORY

Jean Lipman

Elizabeth V. Warren

Robert Bishop

HUDSON HILLS PRESS IN ASSOCIATION WITH THE MUSEUM OF AMERICAN FOLK ART, NEW YORK

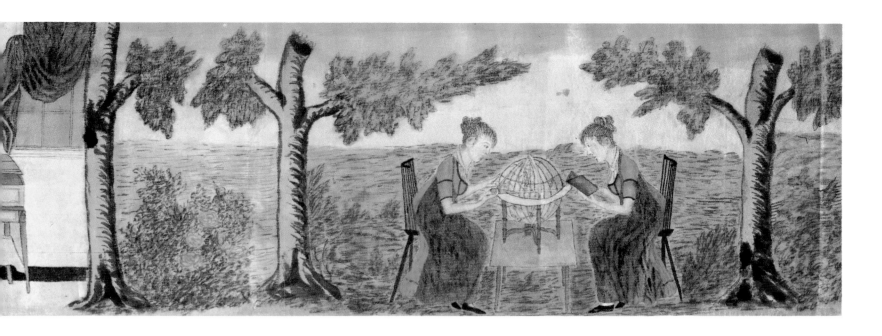

Young America

A FOLK-ART HISTORY

Published in the United States by Hudson Hills Press, Inc.
Suite 1308, 230 Fifth Avenue, New York, NY 10001-7704.

Distributed in the United States, its territories and possessions,
Mexico, and Central and South America by Rizzoli International Publications, Inc.

Distributed in Canada by Irwin Publishing Inc.

Distributed in the United Kingdom, Eire, Europe, Israel, and the Middle East by Phaidon Press Limited.

Distributed in Japan by Yohan (Western Publications Distribution Agency).

Editor and Publisher: Paul Anbinder
Copy editor: Alexandra Bonfante-Warren
Designer: Betty Binns Graphics/Betty Binns and Karen Kowles
Composition: A&S Graphics, Inc.
Manufactured in Japan by Toppan Printing Company

Library of Congress Cataloguing-in-Publication Data

Lipman, Jean, date–
Young America.

Bibliography: p.
Includes index.
1. Folk art—United States—History.
2. United States—Social life and customs.
I. Warren, Elizabeth, 1950– . II. Bishop, Robert Charles. III. Title.
NK805.L53 1986 709'.73 86-10248

ISBN 0-933920-76-8 (alk. paper)

TITLE PAGE ILLUSTRATIONS:
Scenes from a Seminary for Young Ladies (details), c. 1810–20. Artist unknown.
Watercolor and ink on silk, 7 × approximately 97 inches.
The St. Louis Art Museum, St. Louis, Missouri

COVER ILLUSTRATION:
Burroughs (detail), 1876. Jurgan Frederick Huge.
Bridgeport Public Library, Historical Collections,
Bridgeport, Connecticut.

Contents

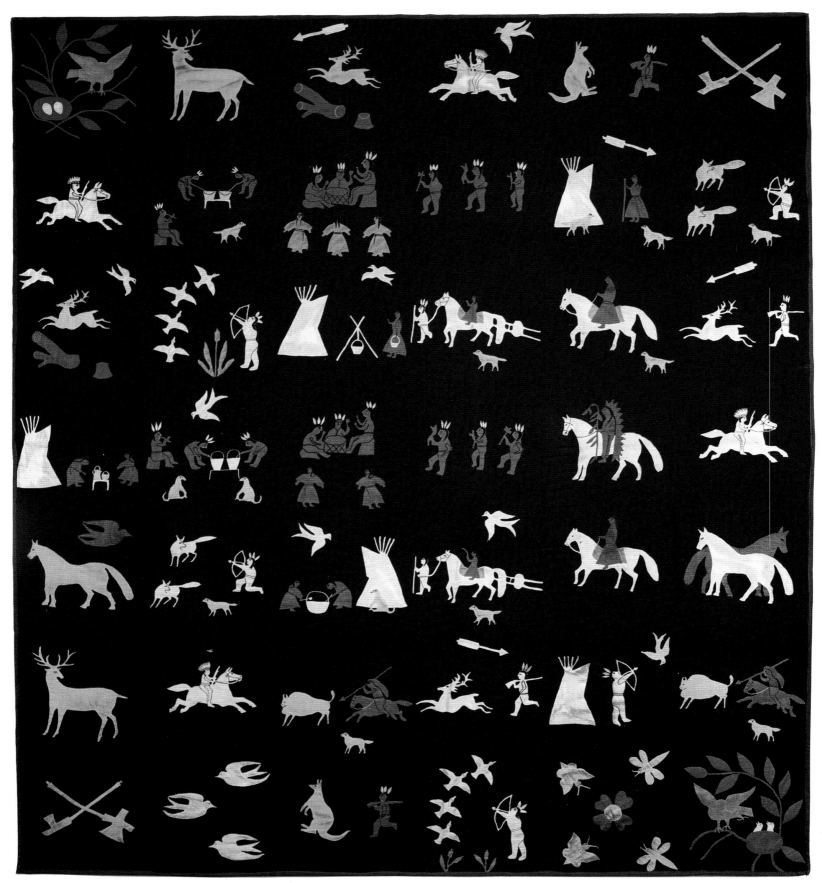

Pictograph Quilt, c. 1900. Unknown Sioux Indian.
Appliquéd cotton, 78 × 70 inches.
Collection of David A. Schorsch

Acknowledgments

THE PRODUCTION of this book and of the coordinated traveling exhibition has been a multiyear process involving the cooperation and expertise of many people throughout the country. In particular, we would like to thank the following for their special contributions:

At the Museum of American Folk Art: Mary Ann Demos, Associate Curator, who coordinated all the work in progress during the production of this book with a fine hand, and who is associate curator of the exhibition; Gerard C. Wertkin, Assistant Director, and Joyce Hill, Consulting Research Curator, who gave valuable editorial assistance; Carl Palusci, who provided research on the art objects and their historical context; Cynthia Sutherland, Charlotte Emans, and Michael McManus, who were responsible for preliminary research; and Carleton Palmer, staff photographer, who was responsible for special photography.

At Hudson Hills Press: Paul Anbinder, Editor and Publisher, for his guidance and support; Alexandra Bonfante-Warren, Copy Editor, whose precisionist ways helped to make the text of this book as close to perfect as possible; and Betty Binns and Karen Kowles, whose sensitivity to folk art shows in the design of this book.

Special thanks are due Anita Duquette, Manager, Rights and Reproductions, at the Whitney Museum of American Art, and Cyril I. Nelson, Senior Editor, at E. P. Dutton, for their help in obtaining photographs; and Colonel Alexander W. Gentleman for his valuable editorial suggestions and his generous contribution for special photography.

We would like to express our gratitude to the IBM Corporation for sponsoring the traveling exhibition, *Young America: A Folk-Art History*.

Appreciative thanks to all the museums and private collectors, mentioned in the captions, who helped us obtain photographs and provided information on the objects in their collections. We would especially like to acknowledge those people and institutions who helped us to research two areas of American art that are presented here as folk art for the first time: Native American art and folk photography. In the field of Native American art, we thank Ruth Slivka Taylor, Registrar's Assistant, at the Museum of the American Indian, New York City; Lee Cohen, Director, Gallery 10, Scottsdale, Arizona; Marilyn Shanewise, Administrative Assistant, at the Center for Western Studies, Joslyn Art Museum, Omaha, Nebraska; and Michael Fox, Director, Anne E. Marshall, Curator of Collections, and Mary Graham, Librarian, at The Heard Museum, Phoenix, Arizona. In the area of folk photography, we are grateful to Robert A. Mayer, Director of George Eastman House, Rochester, New York; John E. Carter, Curator of Photographs, at the Nebraska State Historical Society; Susan F. Walker, Secretary, Kansas Collection, at the University of Kansas Libraries, Lawrence, Kansas; and Peter Palmquist, Arcata, California.

THE FIRST EXHIBITION of American folk art was held in 1924 at the Whitney Studio Club in New York, an informal center for artists established by Gertrude Vanderbilt Whitney in 1918. Folk art had just been "discovered," and there were no publications or collections devoted to it. Today, the multitude of collectors can consult hundreds of books, articles, and exhibition catalogues about this material, now prized by both the critical art elite and a large, enthusiastic public.

By the early 1930s, the Museum of Modern Art in New York, the Newark Museum, and a number of other museums and art galleries had held folk-art exhibitions. By the 1940s a good many publications were devoted to this subject, and collectors were multiplying.

However, the question of what, exactly, folk art was—how it could be defined and what made it a significant part of American cultural history—remained under discussion for decades, and is still being considered and reconsidered today by art historians, collectors, dealers, and museum curators. The best definition I can arrive at is a composite of brief comments by Holger Cahill and Alice Winchester. Cahill described folk art as "the unconventional side of American art." Winchester, in her Introduction for *The Flowering of American Folk Art,* wrote: "In simplest terms, American folk art consists of paintings, sculpture, and decorations of various kinds, characterized by an artistic innocence that distinguishes them from works of so-called fine art or the formal decorative arts." In my Preface for the same book I summarized my concept of its importance in American cultural history, and I still hold with this: that in a fresh, vigorous, vernacular style it pictures the mainstream of American life in the formative years of our democracy.

In the beginning, folk art was viewed by collectors and sold by dealers as a lowly kind of antique, not fitting neatly or attractively into any of the acceptable categories. "Early Americana" was the handiest label they could find, and most pieces, sadly enough it seemed, were not nearly "early" enough: most of them were made toward the middle of the nineteenth century, whereas prices depended largely, as they did for American antiques, on how far back they could be dated in the 1700s. But because it had taken quite a while following the Declaration of Independence for a correspondingly bold and independent art to develop a distinctive native style, most original and talented folk artists were usually nineteenth-century—rather than eighteenth-century—people. Thus, "late" is generally better than "early" for American folk art.

Collecting folk art in the pioneering days of the 1930s and 1940s was easy and inexpensive—*very* rewarding. The objects my husband and I sought were just beginning to be transferred from attics to the antiques shops that dotted the main country roads in New England, New York, and Pennsylvania. They suddenly became plentiful in the shops; owners were delighted to sell them instead of consigning them to the trash bin when they moved or cleaned house. As there were scarcely any criteria (except age, and sometimes size) on which the dealers based their prices, we could collect most economically and according to our own evaluations, which were related not to antiques but to the same standards of excellence that we would have demanded from Calder or Picasso. We were rather arrogantly positive about our opinions of what made various examples of folk art great, good, or not so good, and to sharpen our critical eyes we soon made a practice, when visiting collections and dealers, of grading every piece as A, B, or C. We tried, of course, to avoid acquiring works that did not at least come close to the A level. However, we often changed our minds, and over the years weeded out and sold several hundred downgraded objects.

One of the amusing highlights of our canny collecting was the acquisition of *Winter Sunday in Norway, Maine,* which appears in the "Church and School" chapter of this book (fig. 2.6). It has been featured in many publications, and was reproduced several years ago as one of the U.S. Christmas stamps. The price we were asked for it was fifty cents. Sometime later, we turned down an A+ *Peaceable Kingdom* by Edward Hicks, now in the Abby Aldrich Rockefeller Folk Art Center in Williamsburg, Virginia, because of its crazy price—five hundred dollars. A lesser example of this great series of paintings was sold sometime ago for almost two thousand times that sum. Recently, I came across a quote from a letter delivered to Hicks's neighbor John Watson, in 1844, that had accompanied the Williamsburg *Peaceable Kingdom*: "I send thee by my son one of the best paintings I ever done (& it may be the last). The Price as agreed upon is twenty dollars with the additional sum of one dollar 75 cents which I gave Edward Trego for the fraim . . . with ten coats of varnish. . . ."

I listed, year by year, in a little black notebook, the provenance, date, medium, and price of each of the examples of folk art that we assembled from 1938 to 1950, when we sold the collection to Stephen Clark for the New York State Historical Association in Cooperstown. The four hundred works, representing every category of folk art from paintings to ship figureheads, were sold for seventy-five thousand dollars, a price arrived at by exactly doubling the price we had paid for each piece (for example, one dollar for the *Winter Sunday* that had cost fifty cents). The collection included two great *Peaceable Kingdoms,* a Hicks *Declaration of Independence,* and dozens of the masterpieces featured thereafter in books on American folk art.

A few of the prices we paid for works reproduced in this book are: *Marblehead Fireside (fig. 1.33),* $5; *Darkytown* (fig. 4.19), from the distinguished Harry Stone Gallery in New York, exchanged for a large eighteenth-century over-mantel panel that had cost us $28, plus $100 in cash (Harry Stone had gotten it from a junkman in exchange for $1 and a bottle of whiskey); *York Springs Graveyard* by R. Fibich (fig. 8.1), from the shop of Joe Kindig, Jr., in York, Pennsylvania, $50 plus $4 for a splendid painted frame; a group of major watercolors by Eunice Pinney (see figs. 1.43 and 8.5), $48 each; the painted-wood and wire *Indian Archer* weathervane (fig. 9.32), $5—the first example of folk sculpture we bought (although I protested violently that we were collecting *paintings* and just couldn't buy *everything,* my husband bought it anyhow, and then we began to get hooked on weathervanes, cigar-store Indians, figureheads, and every sort of folk sculpture); two examples of memorial jewelry: *Portrait of a Sailor* (fig. 6.4), $5, and the War of 1812 presentation pin (fig. 7.10), bought for an extravagant $23 when prices were rising!

In the 1950s dealers and collectors began to be somewhat more interested in folk art—nineteenth- as well as eighteenth-century paintings and sculpture—for the direct and unpretentious way it provided a social history of the time. Some of the leading contemporary artists, however, appreciated folk art earlier for its distinctive style, in which they felt a kinship with their own work. Their art in turn often reflected this affinity: by 1930, Grant Wood, for instance, was making some very folk-arty paintings. Painters such as Charles Sheeler, Alexander Brook, Yasuo Kuniyoshi, Peggy Bacon, Charles Demuth, and sculptors Robert Laurent, William Zorach, and Elie Nadelman became enthusiastic collectors. Later, around 1950, when interest in folk art was beginning to peak, abstract art, with its focus on color, line, and form, was considered much more significant than representational painting and sculpture, and it was the abstract quality of folk art that avant-garde artists especially appreciated and praised. Andy Warhol, Frank Stella, Tony Berlant, and Roy Lichtenstein, for example, also became interested in and then collected, wrote, or painted pieces relating to Indians and Indian arts.

I introduced my first book on folk art (*American Primitive Painting,* 1942) with an essay titled "A Critical Definition." The focus of the definition was that the paintings under consideration were "all 'primitive' in a sense directly opposed to 'academic,' in style abstract as opposed to illusionistic." I went on to say:

The style of the typical American Primitive is at every point based upon an essentially nonoptical vision. It is a style depending upon what the artist knew rather than upon what he saw, and so the facts of physical reality were largely sifted through the mind and personality of the painter. The degree of excellence in one of these primitive paintings depends upon the clarity, energy, and coherence of the artist's mental picture rather than upon the beauty or interest actually inherent in the subject matter, and upon the

artist's instinctive sense of color and design when transposing his mental pictures on to a painted surface rather than upon a technical facility for reconstructing in paint his observations of nature. Abstract design is the heart and soul of the American Primitive, and it is this fact which has won for it the acclaim of the moderns.

Today no one denies the importance of these "moderns"—the Precisionists, and, later, the Abstract Expressionists—who brought American art to international acclaim at midcentury. But now interest in representational art—landscapes, figurative paintings and sculpture, even still lifes—has come full circle. The folk artists' coherent abstraction *and*—instead of *rather than*—their interesting subject matter now seem a better way to sum up their achievement. I continue to hold to my conviction that the folk artists' freedom from the restrictions of academic art, indeed their technical liabilities, made way for a compensating emphasis on and splendid achievement in the realm of pure design. It is certainly this bold abstraction that first gained their distinguished place in our art history. Now that the critical battle for folk art as *art* has been won, it seems clear that we no longer need to denigrate the *content* of folk art. Content and style fuse perfectly in the best work. The subject matter—the people, places, and events of their time—was exactly what the folk artists wished to record, and the vivid, stylized way they did this secured their recognition in Amer-

ican history as significant artists, many now known by name, many still anonymous.

This book features the representational work of these folk artists along with quotations from period diaries, letters, memoirs, and other documents that describe the way they—the folk—lived and dressed, worked and played.

The period covered is the time between the American Revolution and World War I, when America was young both in years and in spirit. A few decades before the First World War, urban sophistication had been gradually altering the ideas and arts of the simpler rural folk; the war finally obliterated the collective naïveté that had distinguished the folk artists and their patrons. The early pioneer optimism continued, however, through the nineteenth and early twentieth centuries: nothing seemed impossible in the new democracy; the potential for progress in rural and urban life, travel, and scientific exploration were thought to be infinite. By the beginning of the twentieth century all the seeds had been sown for the upcoming goals of economic prosperity, worldwide travel at breathtaking speed, and medical and scientific miracles, while the naïve pictorial records of the hardier, simpler, more serene times, out of date and out of interest, were relegated to attics or trash cans. Only a few decades later, the days of America's youth became a subject of nostalgic and historic interest, and collectors began to search for the surprisingly abundant records of these times, as described by the folk artists.

Then, quite suddenly, the flowering of our native folk art became recognized as a rich and splendid achievement in the history of American art.

It may be of interest to know that my little black book, now in the archives of the Museum of American Folk Art, also listed my ideas for folk-art articles and books—crossed off as they were published. One that remained not crossed off in 1950 was "A Primer of Pioneer Life in America" with the description: "Picture book showing life & customs in early America through masterpiece examples of folk art—how they lived, traveled, worked, were educated—where they settled, how they dressed, how they made American history—etc." It still seemed a good idea thirty years later, and we started to plan *Young America.*

In selecting the examples of folk art for this book and the coordinated exhibition, our aim was to choose the best possible examples from the standpoint of both content and style, seen from the point of view of the folk artists and their audience as well as from our own. We believe that the works we show—done by Anglos and Indians, Pennsylvania Germans and New Englanders, all the folk from Maine to California—are strong and original and wonderful art that add up to a vivid, firsthand history of how life was lived when America was young.

Jean Lipman

Bellows, c. 1820. Artist unknown.
Painted wood and leather, 21 inches high.
Museum of the City of New York, New York

Introduction: Between Two Wars

IN THE YEARS BETWEEN the American Revolution and World War I, it was the folk artist, far more than the academy-trained fine artist, who recorded what everyday life was like in this young country. Local happenings, family activities, and day-to-day occupations, as well as historic events, were all captured by artists who were more than just witnesses: they were themselves part of the communities they recorded and therefore an important part of the changing scene of American life.

Young America: A Folk-Art History presents the work of these artists as an informal social history of the period. It deals with the activities that were most important to the folk artists and to the people who supported them—the middle class that emerged after the Revolution to form an increasingly significant segment of American society, the men and women not traditionally considered artists or patrons of the arts. They were the farmers, shopkeepers, sailors and soldiers, carpenters and craftsmen, factory workers, and others who engaged in all the many occupations that were an integral part of this country's rapid expansion from the end of the eighteenth century through the beginning of the twentieth.

In assembling the objects for this book, we looked at thousands of examples of folk art. It was essential that each piece not only contribute to the story that was being told here, but that it be among the finest examples of its type—something that rated an A in Jean Lipman's "little black book," mentioned in her Foreword. With these criteria in mind, many old favorites have been included, as well as newly discovered pieces of equal quality.

For many of the objects selected, there were dozens of others that told the same tale, and it was enlightening for us to see what subjects most often captured the imaginations of the artists. The impact of the railroad, for example, was immediately made clear by the great many representations of trains in all media. The domestic animals that played a crucial role in the life of Young America were found on everything from schoolgirl needlework to weathervanes. And, of course, patriotic subjects, especially representations of George Washington, were perennially popular.

After assembling a collection of outstanding examples, the major themes—the aspects of life that were important to the artists and the people they worked for—became apparent. The pieces fell into categories that we arranged into ten chapters to tell the story of life, as the folk artists saw it, in a rapidly changing America: House and Garden; Church and School; On the Farm; In Town; On the Road; At Sea; War; Weddings, Births, and Deaths; Work; and Play.

If there are gaps in this social history, it is because there are not significant examples of folk art to illustrate every aspect of daily life. This book is about Young America as the folk artists—not the historians—recorded it. Certain

subjects were less important to these artists and their patrons than others, and in some cases cultural or religious tradition forbade the representation of certain subjects. For example, the Amish religion dictates against the making of images of those people or their activities. In the Southwest, the prevailing Spanish-Catholic culture encouraged the production only of art objects that had religious significance: even though we searched exhaustively, we (and the Southwestern museum curators we consulted) could find no secular folk art that depicted what life was like in this area for our period.

Except for Native American examples, there is much more art from the East Coast than from the West or from the midwestern states, primarily because during the period in question the eastern seaboard had been settled for many years and had developed both an artistic heritage and a market for art, while the rest of the country was still a frontier. Homeowners in the Northeast were paying artists to paint landscapes over their fireplaces at a time when pioneers were satisfied if they could erect a one-room cabin to house their family. This time lag also explains why folk art from the Midwest and West often displays a rural, rustic quality far later than much of the art from the East.

It will be obvious to the reader that, while we are featuring people involved in doing things, not every work of folk art included in this book depicts an activity. Other kinds of art can tell a great deal about a society and about a period in history. Portraits, for example, often convey significant information, about both the subject's life and the time in which he or she lived. Landscapes and paintings of towns and buildings can also reveal much about a society. Certain pieces have been included simply because we feel they will help the reader to understand and visualize more fully what life was like in this period. These last objects are, for the most part, the work of folk artists other than painters, whose media do not lend themselves as easily to depicting activity. Carousel horses, cigar-store Indians, pottery, decoys, weathervanes, whirligigs, and other, mostly sculptural, forms of folk art, are shown in black-and-white text illustrations throughout the book.

A number of excerpts from diaries, letters, newspapers, and books of and on the period have been included in the text. These words, sometimes written by the folk artists themselves, add to our understanding of both the art and the time in which it was created. Particularly illuminating were the diaries of artist Ruth Henshaw Bascom and the letters of artist Deborah Goldsmith. We also found two collections of reminiscences of women who settled the American frontier of great interest: *Pioneer Women: Voices from the Kansas Prairies* by Joanna Stratton, and *Women of the West* by Cathy Luchetti and Carol Olwell. Complete listings for all the citations in the text will be found in the Authors' Bookshelf.

The time frame for choosing the works of art in this book and the coordinated exhibition is, admittedly, somewhat arbitrary. Certainly, there was folk art produced before 1776 and after 1914. In general, however, these two wars define the period during which a truly American folk-art tradition burgeoned and reached its fullest flowering—a time in which the greatest folk art, in numbers and in quality, was produced—before becoming diluted or replaced by the products of the Machine Age or overly influenced by the outside world.

Before the Revolution, much of what we consider American art was actually European in heritage and style. The spirit of '76 brought a new independence from the Old World, in art as in politics, and with it a great feeling of pride in being American. That independence and pride were reflected in the art. In contrast, World War I reintroduced the world to America. The development of new technology and methods of production, a process that started with the Industrial Revolution and was accelerated by the world war, contributed to the demise of the handmade products of the folk artist. Other new influences and inspirations contributed to the disappearance of the very American aspect characteristic of nineteenth-century folk art. The optimism and innocence that had been so often seen in the art of that period could not easily continue in the face of the horrors of World War I, and improved methods of communication and enhanced educational programs ended the personal isolation that played an important part in the creation of so much of the greatest folk art.

In a number of previous major works about folk art, 1876 was used as the outside boundary date for considering objects. In many respects the first hundred years of this country's independence were indeed the peak production years for folk art. But hindsight and new research have made it clear that the years between the Centennial and World War I were also important for the creation of folk art. Extending the time limit to 1914 allows us to consider works by a number of early-twentieth-century artists, such as Joseph Pickett and Olof Krans, who worked in the essentially nineteenth-century traditions in which they were brought up, and portrayed the world either as it was when they were young or as it still was even later in their relatively untouched corners of the universe.

In the later twentieth century, much of the folk art has been produced by people who were aware of various contemporary styles and chose to work in a naïve manner. On the other hand were those few who were genuinely isolated and insulated from the sophisticated twentieth-century world but were no longer depicting the mainstream of life in America, as did their counterparts of the late eighteenth and nineteenth centuries.

Although less great folk painting and sculpture was produced in the late nineteenth and early

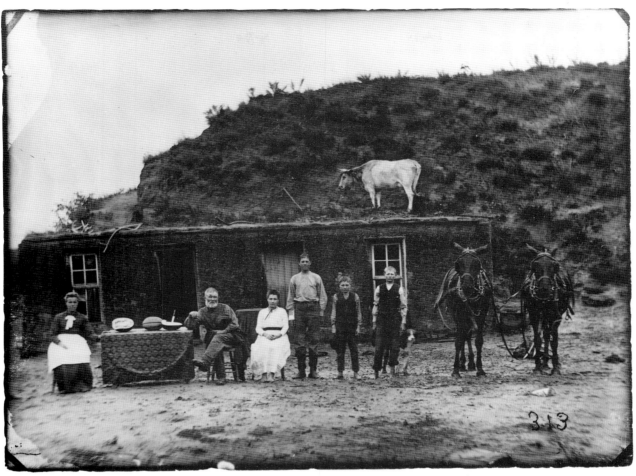

Settlers in Custer County, Nebraska, 1886. Solomon D. Butcher.
Photographic print from dry-plate glass plate, 6½ × 8½ inches.
The Nebraska State Historical Society, Lincoln, Nebraska
Solomon D. Butcher Collection

twentieth centuries, the period from 1876 to 1914 is of great interest for the relatively new medium of photography. For the first time in a major survey of the field, we are featuring photographs as a form of folk art in this book. Both the realism of the image produced by a camera and the fact that technology is involved have made it difficult for people to accept photography as a legitimate folk-art form. Where is the abstract quality associated with folk art? The distorted perspective? The amateur approach? Photographs just don't look "folky." Yet the criteria used here in selecting photographs were the same as those used for selecting folk paintings. For the most part, the photographers whose works are included here were professionals. Like many of the professional itinerant portrait and landscape painters who preceded them, these photographers were primarily concerned with taking likenesses of people, farms, shops—and with making a living, not necessarily creating art. Yet often, like the painters, their work was so fresh and original—the composition so striking, the impact so strong—that they did, indeed, create works of art. They frequently posed their subjects to obtain the best composition, but so did the folk painters. Most were paid for their work, but so were many of the other folk artists. And it is true that they received some rudimentary training in the use of the tools of their trade, but so did many of the most highly regarded folk painters of the eighteenth and nineteenth centuries. Often, however, the instructors of both folk painters and folk photographers had barely more knowledge of the subject than their pupils.

As to the frequently asked question "Isn't every amateur who takes a picture a valid folk photographer?" the answer is no. Is every amateur artist who wields a paintbrush or a whittler's knife a valid folk artist? Clearly not. Obviously, certain aesthetic criteria have to be met. Composition, design, an overall vision, command of the medium—all must be present in a successful work of folk art. Furthermore, the folk photographer, like any folk artist, is a member of the community, in the larger sense, that he is recording: unlike many fine artists, he shares the same social values, the same ethos as his subjects. There are no hard and fast rules, however. Just as the distinctions between folk and academic painting merge and overlap, so, too, the difference between folk and non-folk photography is not always clear. But we have tried to choose examples that best illustrate the central qualities of folk art as we have come to understand it.

Not only photography, but art by Native Americans is considered here for the first time in the context of American folk art. The study of these works, long the domain of anthropologists and folklorists, is now presented as an important field of interest for folk-art historians as well. Indeed, in their paintings, drawings, textiles, and other art forms, Native Americans followed the traditions of their cultures and communities, just as the Pennsylvania German fraktur artists or New England schoolgirl watercolorists were following theirs.

Besides the "pure" examples, some of the Native American art that is featured here has been produced using, not indigenous materials, but paints, pencils, and paper supplied by white men. The nineteenth-century Indian artists who created these works were, like many of their non-Indian counterparts, virtually untrained in the materials they were using, and unselfconscious about the kind of art they were producing. They were not influenced, as some would be in the 1920s and 1930s, by white patrons to produce a picturesque and popular version of American folk art. In these paintings and drawings, a combination of the traditional pictorial style with the new use of the white man's materials, the Native Americans were translating their native art traditions into a fresh, new kind of folk art.

ELIZABETH V. WARREN

Young America

A FOLK-ART HISTORY

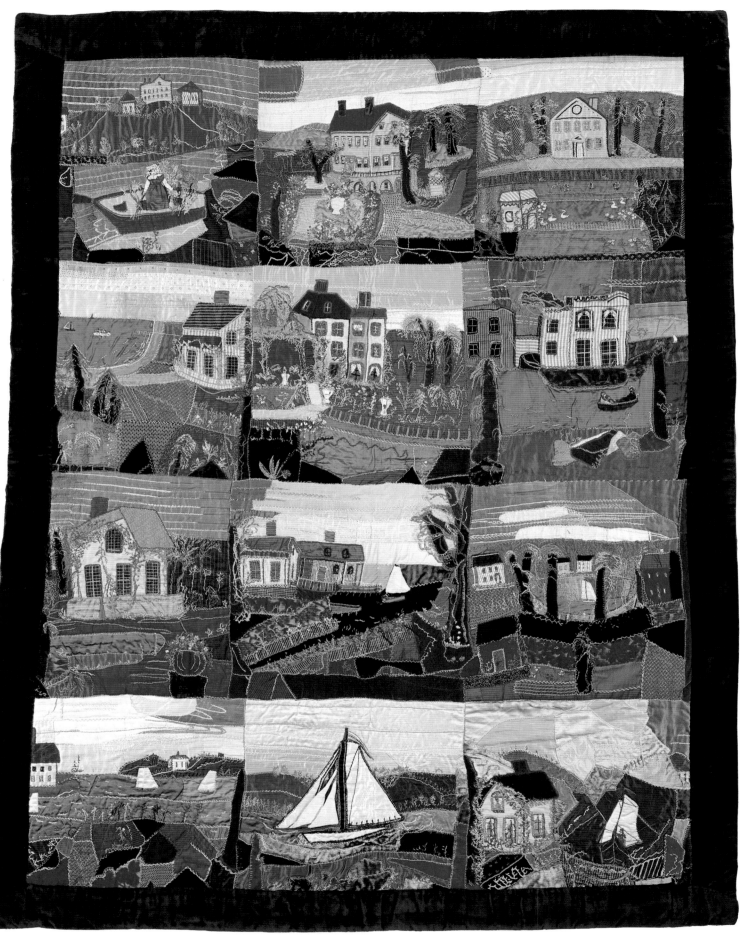

1.1 *Crazy Quilt*, c. 1875. Celestine Bacheller.
Pieced, appliqúed, and embroidered silk and velvet, 74¼ × 57 inches.
Museum of Fine Arts, Boston
Gift of Mr. and Mrs. Edward J. Healy
in memory of Mrs. Charles O'Malley

House and Garden

B Y T H E T I M E of the Revolution, almost anyone who owned a residence that provided more than basic shelter was justifiably house-proud. The first European homes on the American continent were modest at best, and more than a few early settlers survived those early winters by burrowing, animallike, into shelters that were not much better than holes in the ground. And while conditions steadily improved in the original settlements, as the population expanded there was always more wilderness to be conquered, more areas where a family considered itself lucky to have even a primitive cabin as protection against the elements.

It is not surprising, therefore, that homeowners wanted their residences, their furnishings, their gardens—all obtained at great physical and financial cost— recorded as symbols of their accomplishments. And, for most Americans who reached this level of success, it was the folk rather than the fine artist who was called upon to serve that need.

WHEN TIME AND MONEY eventually permitted, the colonists naturally looked to their European homelands for architectural inspiration. Thus, English frame houses prevailed in New England, brick was favored among the Dutch in New Amsterdam, and log construction was introduced by both the Swedish along the Delaware River and the Germans in Pennsylvania. Housing forms popular in France and Spain were also transplanted to those countries' colonies in the New World. So strong were the emotional ties with the cultures of the mother countries that rarely did the colonists adopt either Native American housing or the style of another cultural group even when, like the log cabin, it proved especially suitable to American climatic conditions.

In time, however, geography and available building materials prevailed as much as cultural heritage, and led to the evolution of "no style" housing in America, homes that combined features from a number of areas in a purely practical response to the environment. By the time of the Revolution, house styles in America ranged from tepees and other native forms to mansions, with great variety in between.

Indigenous shelter is represented here in the drawing by Buffalo Meat, a member of the Cheyenne tribe, titled *A New Married Man Receiving His Friends* (fig. 1.3). Arrested in 1875 for his role as a ringleader during an Indian uprising, Buffalo Meat completed this "memory picture"—his remembrance of what Cheyenne life in Wyoming and the Dakotas was like—while he was in prison at Fort Marion, St. Augustine, Florida.

The painted history of Indian life seems especially valid when done by the Indians themselves, as in nineteenth-century pictographs and scenes of daily life such as this, simply and crisply drawn and colored. Unfortunately, too much of the work done by twentieth-century Indians was indelibly styled by their well-meaning white patrons and art teachers in the Santa Fe, New Mexico, area. These mass-produced "Pueblo style" paintings of Indian life sold well, but they are so homogenized in style and content that they look as if one deliberately naïve artist could have made them all. In contrast, Buffalo Meat's drawing is a true folk expression. It tells us, in his own way, how he and his fellows lived in better days.

If Buffalo Meat's tepee represents the simplest form of housing in Young America, then *A View of Mount Vernon* (fig. 1.4) is a painting of one of the most elaborate. Almost as well represented in American folk art as Washington himself, depictions of Mount Vernon can be found in oil and watercolor paintings, in engravings, in schoolgirl needlework, on furniture, and, as here, on a *trompe l'oeil* painted fireboard, used to cover a fireplace during the summer months. Note that both the frame of the "painting" and the stone hearth below it are actually painted on the canvas; the slots are to accommodate andirons.

Few, if any, of the folk artists who painted, drew, or stitched Mount Vernon ever saw George Washington's fabled home, and none of them lived in Washington's grand style. But, like the General, his home became a symbol, well known through widely circulated prints, of what could be achieved in this young country.

In essence, Mount Vernon was a southern plantation, and its layout is much like the one recorded in the painting on wood titled *The Plantation* (fig. 1.5). This painting shows us much about both early-nineteenth-century architecture and about the folk artist's approach to landscape. The manor house, at the top of the hill, is essentially European in style. As one

1.2 *Houses and Barns Quilt*, c. 1910.
Artist unknown.
Pieced cotton, 88 × 84 inches.
Thos. K. Woodard:
American Antiques and Quilts, New York

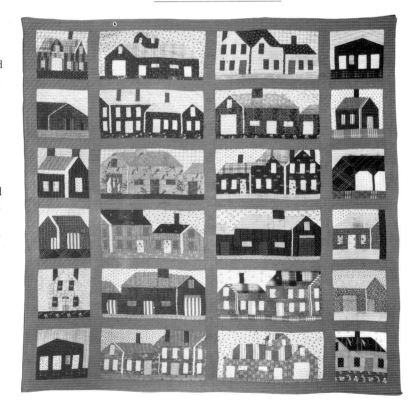

continues down the hill, however, the outbuildings, or "dependencies," owe their form more to their function and their situation than to any particular architectural heritage. They are examples of a folk architecture dictated by need.

We can see the entire hill, the main house, and all its adjuncts in this painting because unlike the academic artist who paints from nature—paints what he *sees*—the folk artist is more likely to paint what he *knows*. It does not matter that no single perspective would have enabled the creator of this picture to see everything in it at one time, it only matters that he knew that all the elements existed. Included in this landscape, therefore, are all the important components of life on this plantation: the water-driven mill, the waterfront warehouse, the ship that carries the produce to market and brings back news, goods, and people; even the grapes that grow on the land. Perspective and nature have been distorted by the artist in the interest of design—note how the hill narrows to provide a pocket of sky that silhouettes the grapevine—and in order to present his composite scene in orderly detail. Also in the interest of design, the artist made the waves drop neatly away from the boat, and confined the background trees to a fringe edging the hill.

Life in a New England seacoast town is represented by Dr. Rufus Hathaway's rendering of the house (fig. 1.6) of his father-in-law, Joshua Winsor. Hathaway, best known for his portraits—this is his only currently known landscape—is said by family tradition to have ridden into Duxbury, Massachusetts, in the early 1790s as an itinerant artist. After his marriage to Judith Winsor in December of 1795, her father, a prominent local businessman, persuaded Hathaway to enter the more highly regarded profession of medicine and give up his wandering existence. Hathaway continued painting along with doctoring, however, and his work includes a number of portraits of Duxbury residents, as well as this house portrait of Winsor's substantial red-painted home. The work tells us quite a lot about Winsor's accomplishments: besides the house—an enviable middle-class establishment in the eighteenth century—the painting also shows Winsor's wharves and counting house, his fleet of ships lying at anchor, and the owner of all this wealth himself, depicted in the foreground with keys in hand.

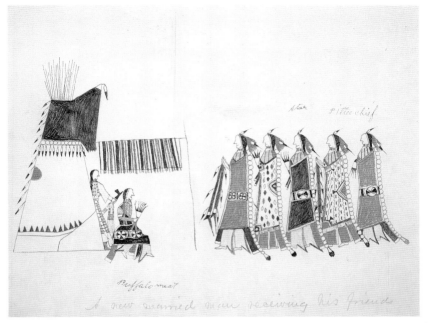

1.3 *A New Married Man Receiving His Friends*, c. 1876. Buffalo Meat, Cheyenne Indian.
Ink, pencil, and colored pencil on paper, 8¾ × 11¼ inches.
Amon Carter Museum, Fort Worth, Texas

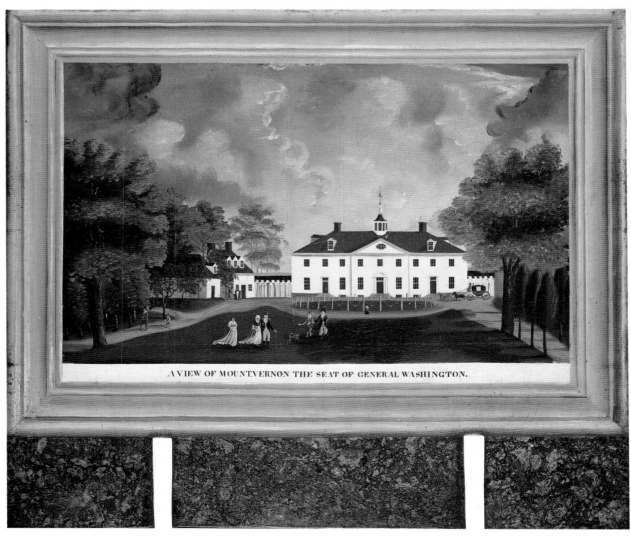

1.4 Fireboard, *A View of Mount Vernon*, c. 1790. Artist unknown.
Oil on canvas, 37⅝ × 43⅜ inches.
National Gallery of Art, Washington, D.C.
Gift of Edgar William and Bernice Chrysler Garbisch

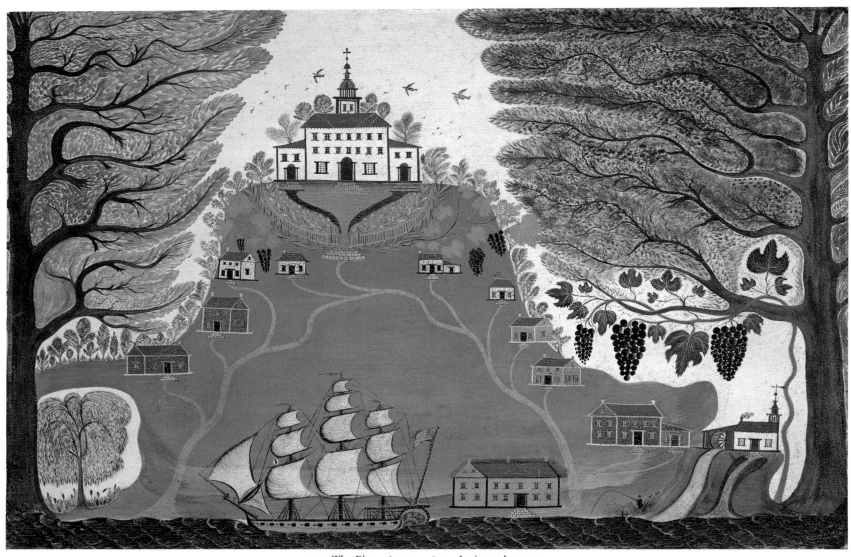

1.5 *The Plantation*, c. 1825. Artist unknown.
Oil on wood, 19⅛ × 29½ inches.
Metropolitan Museum of Art, New York
Gift of Edgar William and Bernice Chrysler Garbisch

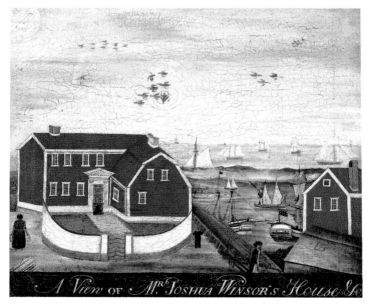

1.6 *A View of Joshua Winsor's House*, c. 1795. Rufus Hathaway.
Oil on canvas, 23¼ × 27½ inches.
Private Collection

The domestic landscape

A CULTIVATED FLOWER GARDEN, something impossible in wilderness conditions, was a luxury in Young America. The time-consuming, expensive, and purely decorative gardens that grew cutting flowers for the house or created beautiful vistas and walks were as much symbols of status and evidence of the increasing prosperity and leisure time of the middle class as substantial houses. European gardens, fondly remembered or copied from prints, were the models for Americans attempting to bring order and beauty to the wilderness. The folk artists managed to capture, in all media, not only the color and pattern of these gardens, but also the important role they played in daily life.

The garden was generally the domain of the woman of the house, a place where she could express herself artistically. Women frequently combined two of their major creative outlets, gardens and needlework: quilts were appliquéd with floral designs, or an entire garden might be recreated, as seen in the quilts pictured here. Celestine Bacheller's pieced, appliquéd, and embroidered Victorian crazy quilt (fig. 1.1) is believed to present actual scenes of the neighborhood in which the maker lived in Wyoma, Massachusetts, in the second half of the nineteenth century. These scenes include the well-tended flower gardens that surrounded Wyoma's houses.

An especially charming house and garden scene comprises one square of a Baltimore album quilt (fig. 1.8). These appliquéd quilts, now among the most valued examples of American textile arts, were made between 1848 and 1854 by a group of church women in Baltimore, Maryland. They are distinguished by their fabrics, design, content—often local Baltimore landmarks—and their superb craftsmanship.

Gardens are also represented here in another form of textile art, a yarn-sewn rug (fig. 1.14). Large, exotic-looking plants bloom in the center and around the border of this rug, a craft popular in the first half of the nineteenth century. They were usually made with two-ply yarn on a base of homespun linen, or sometimes a grain bag. The yarn was sewn through the basic fabric

*1.7 Mermaid Fountain, c. 1810.
Artist unknown.
Polychromed wood garden ornament
18 inches wide.
New York State Historical Association,
Cooperstown*

with a continuous running stitch, leaving loops on the top that formed and followed the shape of the design. When the loops were clipped, a soft pile surface resulted.

The importance of gardens is revealed by the frequency with which they appear in paintings, both of people and places. In eighteenth-century England, it became popular for portrait artists to include in their pictures landscape elements that had some relevance to their subjects' lives, and this tradition crossed the ocean with artists returning to America after the Revolution. It is likely, therefore, that in the late-eighteenth-century portrait of Mrs. Hezekiah Beardsley (fig. 1.11) the view outside the curtained window is Mrs. Beardsley's own front garden. The suggestion that a well-ordered garden was important in Mrs. Beardsley's life is reinforced by

the fact that the companion portrait of her husband has only a vaguely defined landscape visible outside the window.

To date, the unidentified artist who created these and a number of other similar unsigned portraits is known, in this couple's honor, as "The Beardsley Limner." A recent article by Colleen Heslip and Helen Kellogg, however, advances the theory, based on a comparison of stylistic traits, that the unknown late-eighteenth-century artist may have been Sarah Perkins, an artist best known for her pastel portraits.

Gardens in portraits are not always entirely realistic, and European-style landscapes frequently appear in American folk paintings. Both Henry Walton's portrait of *Three Sisters in a Landscape* (fig. 1.9) and the anonymous painting of Mrs. Keyser of Baltimore, Maryland (fig. 1.10), feature accurate renditions of the American costumes of that period and background gardens that recall the Old World. Walton, an artist who painted and lithographed town views and maps, as well as portraits, in the Finger Lakes region of New York, has here adapted the style of the English "conversation piece," a format he undoubtedly saw in European prints, for his depiction of three girls in an idyllic setting.

Because they are not bound by traditional rules of scale or perspective, folk artists frequently use such simple devices as size or position to indicate the relative importance of elements in their paintings. Notice, for example, the size of the flowers in relation to the figure in the *Woman with Umbrella* (fig. 1.12) and the *Lady in a Yellow Dress Watering Roses* (fig. 1.16), and their position in the foreground of *The Convent Garden* (fig. 1.15) and the *House with Six-bed Garden* (fig. 1.13). Attributed to David Huebner—who would have been a thirteen-year-old boy when he painted the latter in 1818—this picture portrays the typical plan of the Pennsylvania kitchen garden. But while most kitchen gardens provided the house with vegetables for the table, this artist has chosen to show only the decorative flowers usually confined to perimeter paths.

1.8 *Baltimore Album Quilt* (detail), 1850. Attributed to Mary Evans.
Pieced and appliquéd cotton, 104 × 104 inches.
Private Collection

1.9 *Three Sisters in a Landscape*, c. 1838. Henry Walton.
Oil on canvas, 19 × 16 inches.
Private Collection

1.10 *Mrs. Keyser*, 1834. Artist unknown.
Watercolor and ink on paper, 23 × 18 inches.
Collection of Mr. and Mrs. Burton E. Purmell

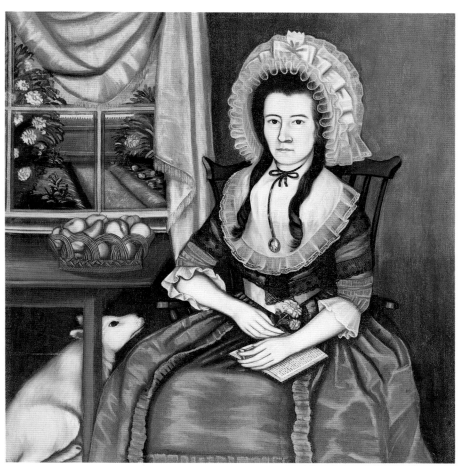

1.11 *Mrs. Hezekiah Beardsley*, c. 1785–90. Beardsley Limner.
Oil on canvas, 45 × 43 inches.
Yale University Art Gallery, New Haven, Connecticut
Gift of Gwendolen Jones Giddings

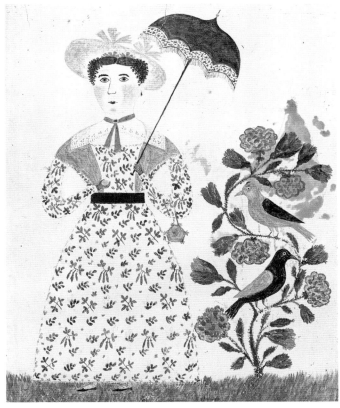

1.12 *Woman with Umbrella*, c. 1850. Artist unknown.
Watercolor and ink on paper, 9 × 8 inches.
America Hurrah Antiques, New York

1.13 *House with Six-bed Garden*, 1818. David Huebner.
Watercolor and ink on paper, 12⁷/₁₆ × 7¾ inches.
Schwenkfelder Library, Pennsburg, Pennsylvania

1.14 Rug, 1820–30. Artist unknown.
Wool on linen, 28¼ × 58½ inches.
America Hurrah Antiques, New York

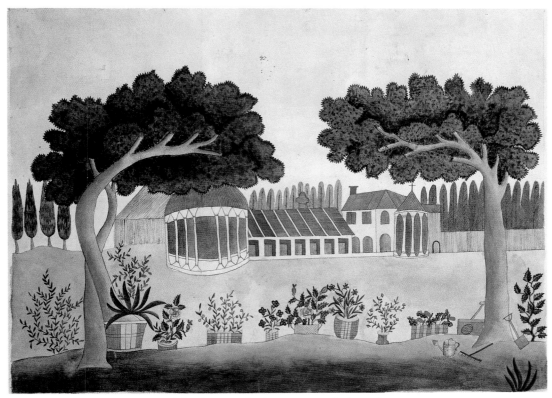

1.15 *The Convent Garden*, c. 1850. Artist unknown.
Watercolor and ink on paper, 14¼ × 18⅞ inches.
The Art Museum, Princeton University, Princeton, New Jersey
The Edward Duff Balken Collection of American Folk Art
Gift of E. D. Balken

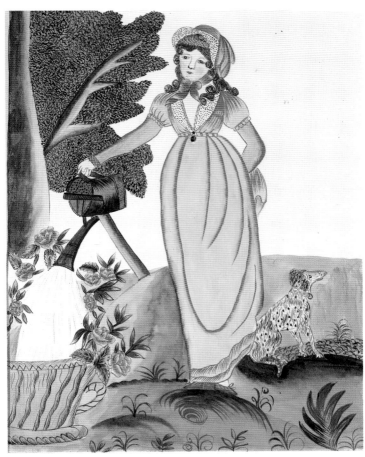

1.16 *Lady in a Yellow Dress Watering Roses*, c. 1830. Elizabeth Glasen
Watercolor and ink on paper, 9¾ × 7¾ inches.
Collection of Jeanine Coyne

WILLS, HOUSEHOLD INVENTORIES, account books, and other written records are of great value in reconstructing the way of life of the past. But the bare bones provided by these documents are fleshed out by, first, the paintings, and, later, the photographs that show us exactly how the objects listed in an inventory were used. Visual images allow us to see where such furnishings were placed, what backgrounds they were set against, and which pieces were most highly valued by their owners.

Much of the information we have comes from portraits that were painted in the subjects' homes and often include furnishings that actually stood in the houses. Study of these folk paintings has proved that eighteenth- and nineteenth-century homes, far from being plain wood and white-painted environments, were more often characterized by a wealth of vivid color and a gay mix of patterns. Floors, walls, furniture, and fabrics were frequently painted in a riotous display of designs, and the resulting interiors provided irresistible subjects for the folk artists.

Patterned wallpapers, first imported from Europe and later manufactured in America, became popular during the period of prosperity that immediately followed the Revolution. But such items were luxuries for most people, far too expensive for all save the most successful. The less well-to-do, however, could recreate the look of costly wallpaper with paint. Stencils, used in making hand-painted wallpapers, could also be used for painting directly on plaster walls, and it did not take long for ingenious craftsmen to develop their own, simpler designs that would give a room much the same look as repeat-patterned wallpaper. Frequently, the artists who painted these stylized designs—leaves and flowers, swags and ribbons, pineapples, birds, and geometric motifs—were itinerant, traveling from house to house, town to town, in search of work. Examples of stenciled walls are seen in the 1839 *Portrait of John Thomas Avery* (fig. 1.39) by an unknown artist, and the *Interior of Moses Morse House* (fig. 1.40), an early-nineteenth-century watercolor from New Hampshire by Joseph Warren Leavitt. The stencils in Morse's house are identifiable as the work of an itinerant artist whose patterns can still be found in other New England homes. Moses Morse, the owner of the house, was a cabinetmaker in Loudon, New Hampshire, who made the secretary seen in the illustration, as well as the inlaid frame on the picture.

Floors were sometimes even more exuberantly patterned than walls in Young America. During the late seventeenth and early eighteenth centuries, rugs, considered too valuable to use on the floor, were reserved for tabletops. When, by the middle of the eighteenth century, they found their way to the floor, it was still only in the homes of the wealthy. Colonial women in New England often sprinkled their floors with sand, sweeping designs in it with brooms as part of their housekeeping chores. When itinerant stencilers visited, they were paid to paint the floors as well as the walls, or else the floors were painted freehand, often in imitation of expensive woven carpets, parquet, or tiles. One of the most popular ways to cover floors from the Revolutionary period to the end of the nineteenth century was with painted canvas or linen floor cloths. The 1801 watercolor that shows the Albany, New York, residence of Nathan Hawley (page 188) contains what appears to be a painted floor cloth, as does the Connecticut watercolor portrait of *Two Women* (fig. 1.43) by Eunice Pinney. In this painting, a masterpiece of design, the artist has cleverly adapted the furnishings to suit her oval design. Instead of bordering the windows, the draperies dramatically frame the entire scene of the painting.

Striped carpeting, often homemade of wool or rags, was also a popular nineteenth-century floor covering, clearly seen in the painting of *The Talcott Family* (fig. 1.35), the work of another woman folk artist, Deborah Goldsmith. Where Mrs. Pinney was an amateur artist, a talented housewife who took up painting in her middle years, Deborah Goldsmith was a professional, an itinerant who traveled in the Hamilton, New York, region in the early 1830s, painting portraits to support her aged and impoverished parents. Marriage to the son of one of the families she painted ended her journeys, but she painted until she died, prematurely, at the age of twenty-seven.

Furniture was as popular a surface for paint decoration as walls and floors. Furnishings made of inexpensive wood, such as pine, were

1.18 *Two Children in Gingham*, c. 1860.
Artist unknown.
Albumen print, cabinet card, 5¼ × 3¼ inches.
International Museum of Photography at
George Eastman House, Rochester, New York

painted to imitate more expensive varieties, while furniture made of a number of different woods—a common practice—was painted to hide that fact. Much furniture was painted simply because it was practical and became fashionable to do so, and the result was attractive. A variety of techniques, including sponge painting, grain painting, stenciling, and freehand decoration, was used, sometimes with a number of skills applied to a single piece. In New England, Joseph H. Davis, a prolific itinerant who signed one of his works "Joseph H. Davis Left Hand Painter," created watercolors that display such a knowledge of painting and graining furniture that it is logical to assume that he had spent some time as a furniture decorator. Besides the painted table and chairs, his 1837 portrait of *The Tilton Family* (fig. 1.24) also includes a wildly patterned floor, another trademark of Davis's paintings.

Homes in Pennsylvania were just as lively and colorful. In Jacob Maentel's companion portraits of *A Pennsylvania Gentleman and His Wife* (fig. 1.29), every possible surface has been decorated—except for the black-clad gentleman and his equally sedate wife. This somber couple stands out dramatically against a wall that has been either papered, painted, or both; the yellow-painted, bamboo-turned Windsor chairs; the grain-painted table; and the looking-glass with a colorful scene painted at the top. Maen-

1.17 Table cover, c. 1870. Artist unknown.
Wool embroidery and cotton appliqué on wool,
31½ inches diameter.
Schwenkfelder Museum, Pennsburg, Pennsylvania

tel, an immigrant born in Kassel, Germany, in 1763, lived a full hundred years, dying in 1863 in New Harmony, Indiana. He was known during his lifetime as a farmer who was fond of painting, and is now highly regarded as an artist for his remarkable portraits of both Pennsylvania and Indiana residents, many of them set in elaborately decorated rooms such as this.

Sometimes folk artists were inspired by interior scenes from printed sources and enhanced those scenes to make them more colorful or to give them the livelier patterns that they favored in their own homes. MaryAn Smith, for example, was obviously so pleased with the pattern she chose for the curtains in her 1854 watercolor *The Tow Sisters* (fig. 1.38) that she carried a similar motif onto the sisters' dresses. Although it has subsequently been proved that the poor-spelling Miss Smith copied the composition of this painting from an N. Currier lithograph, *The Two Sisters,* dated 1845, nothing else is known about the artist. When the watercolor and lithograph are compared side by side, however, Smith's sense of design and delight in color and pattern stand out, for she has taken the sedate fabrics of the published picture and replaced them with boldly drawn ones of her own.

As mentioned before, the objects that folk painters chose to include in their pictures, as well as the size and position of these objects, frequently indicate the importance of these things in the lives of the subjects. For example, in the painting of Mrs. Reuben Humphreys attributed to Richard Brunton (fig. 1.22), the flowered china tea set and Chippendale looking-glass occupy as much space on the canvas as Mrs. Humphreys and her baby, Eliza, indicating how proud the lady must have been to own them. Brunton was an artist who turned his talents to counterfeiting and, in all probability, this picture and the companion portrait of Mr. Humphreys were painted about 1800, when Humphreys was superintendent of Newgate Prison in Connecticut and Brunton was a prisoner there.

Portraits are full of other kinds of information about the daily lives of their subjects. The sitter's profession is frequently indicated by the pose, the setting, and the accessories. It may take a second glance to realize that the painting of Dr. Philemon Tracy (fig. 1.31) is a portrait of a doctor at work. In his right hand he holds the wrist of a female patient, in his left, a vial of medicine. This painting also tells us something about the customs that attended the practice of medicine in the late eighteenth century: a bed-ridden lady was not to be seen by the doctor—only her wrist might be exposed so that he could take her pulse!

When books are included in portraits, it is almost always a sign that the subject was literate—not as common an accomplishment in the past as it is today. The setting for the 1801 double portrait of James Prince and his son William

Henry by John Brewster, Jr. (fig. 1.23), reveals that Mr. Prince was a learned, prosperous man. The Chippendale bookcase full of beautifully bound volumes, the portable desk and writing supplies, the damask curtains, and the carpet all suggest that Prince was an influential force in the business, political, and church affairs of Newburyport, Massachusetts. Brewster, a deaf-mute itinerant artist, lodged with the family while he painted this and three other portraits of the Prince children. The somewhat unpredictable nature of an itinerant's life is revealed in the advertisements Brewster placed in the *Newburyport Herald* at various times (fig. 1.19). On December 25, 1801, while he was staying with the Princes, Brewster wrote:

John Brewster Portrait and Miniature Painter Respectfully informs the Ladies and Gentlemen of Newburyport, that if they wish to employ him in the line of his profession, he is at Mr. James Prince's where a Specimen of his Paintings may be seen. He flatters himself, if any will please to call, they will be pleased with the striking likeness of his, and with the reasonableness of his prices. N.B. If there is no application made to him within ten days he will leave town.

John Brewster, Jr., was a remarkable man as well as a remarkable artist. Born in Connecticut in 1766, he received instruction in painting there from the Reverend Joseph Steward, a successful, self-taught portrait painter. When Brewster's younger brother, Royal, married and settled in Buxton, Maine, John followed him and made Maine his permanent home, in between painting trips to Connecticut and Massachusetts. In April

1817, the Connecticut Asylum for the Education and Instruction of Deaf and Dumb Persons was opened in Hartford, Connecticut, with seven pupils, including fifty-one-year-old John Brewster, Jr. Brewster was probably the oldest pupil at the school, and one of the very few who supported themselves.

It has been suggested that Brewster's afflictions, while isolating him somewhat from the world around him, also served to add a special quality to his portraits. His handicaps, it is argued, made him extra sensitive to his subjects and made possible the unique insights into the personalities of his sitters that come across so strongly in his paintings. Whatever the reason, his portraits stand as masterpieces of American folk art.

The adult and child in the double portrait by Sheldon Peck, *Anna Gould Crane and Granddaughter Jennette* (fig. 1.36), might not have been able to read some of Mr. Prince's weighty tomes, but they probably could read the family Bible pictured on the covered table next to them. Peck commonly used draped tables and Bibles as props and often painted simulated wood-grained frames directly onto the canvas, but his hallmark, found in some form in almost all of his paintings, is the rabbit-foot motif, seen here as the print of Jennette's dress. This picture, made in Eola, Illinois, is recorded in the family Bible that lies on the table as having been "painted in trade for one cow."

During Peck's long career he painted portraits in Vermont, western New York State, and finally Lombard, Illinois, near Chicago, where he settled in 1838. His travels west brought him in

John Brewster,
Portrait and Miniature PAINTER,
INFORMS the Ladies and Gentlemen of Newburyport, that he has commenced the business of his profession in this town, and has taken lodgings for a few weeks at Capt. Benjamin Gould's, Federal street, where he will gratefully receive and punctually attend any orders with which they may please to honor him; and wait on them at their own lodgings if agreeable.
☞ Prices—Portraits 15, and Miniatures 10 dollars. Newburyport, Nov. 17.

contact with new clients for his unsophisticated portraits, but eventually he, like all the portrait artists of the day, had to compete with that new invention, the daguerreotype, introduced to America from France in 1839 by the painter Samuel F. B. Morse, better known today as the inventor of the telegraph.

Daguerreotypes were cheaper and faster to produce than painted portraits, and their images were more realistic. Many artists found they simply could not compete, and had to find other means of employment. Others stayed in business for a while by offering what the photographs could not—color, large size, and the ability to include family members who were not present, including those who were deceased. And many artists found a way to combine painting and photography in their portraits, although it was, in our view, to the detriment of the art.

Comparing Erastus Salisbury Field's 1839 painting of *Joseph Moore and His Family* (fig. 1.25) with one he did almost twenty years later, *The Family of Deacon Wilson Brainard* (fig. 1.26), immediately shows the damaging effect of photography on the traditional qualities of nineteenth-century folk portraiture. Field, an itinerant artist who had made a handsome living painting his many Massachusetts and New York relatives and friends, experienced a decline in commissions around 1840. In 1841 he returned to New York City, where he had spent a brief period at the beginning of his career as an apprentice in Morse's studio. Although we have no proof, it is possible that Field returned to his old teacher to learn the new technology.

Field's intent in learning photography was, as Morse had said of his own interest in the subject, "to accumulate for my studio models for my canvases." Field posed and photographed his patrons, and later enlarged the results on canvas and in color, often combining a number of photographs in a single painting. The painting of the Brainards looks as though it was composed of three such photographs, plus photographs of two children who were deceased at the time the painting was done. This method caused Field's paintings to lose their former spontaneity and lively design. Eventually, he could no longer make a living as an artist and spent his old age painting biblical, mythological, and historical paintings at his familial home, Plumtrees, Massachusetts.

The development of photography may have ended the careers of many itinerant folk portraitists, but it meant the birth of a new breed of artist, the folk photographer, a topic discussed in the Introduction and in succeeding sections, including chapter nine, "Work."

An important part of life at home in Young America involved children and pets, subjects of some of the most charming folk paintings. One artist well known today for his nineteenth-century portraits that include both children and pets is Ammi Phillips, who painted *Girl in Red Dress with Cat and Dog* (fig. 1.27) and *Mrs. Stephan Nottingham Ostrander (Maria Overbagh) and Son Titus* (fig. 1.28). While it may appear that the little girl in red and the Ostranders owned the same dog, a study of Phillips's work reveals that the identical animal appears in a number of his paintings. Likewise, he painted several girls in similar poses with similar red dresses and coral beads. This recurrence of motifs in paintings by folk artists once gave rise to the myth that itinerant artists such as Phillips, who worked in the New York, Connecticut, and Massachusetts area, spent their winters painting "stock" portraits of headless bodies. They would then, it was said, travel from town to town during the summer months, offering patrons their choice of body to which a head would be added. Research into the careers of these artists has proved that this was not how they worked.

What folk portraitists such as Phillips *did* do was to keep in mind a file of themes and motifs, upon which they could call as needed. After all, the more portraits they completed, the more they could earn, so it was incumbent upon them to finish paintings as quickly as possible. These stock methods of solving problems such as costumes, backgrounds, poses, and anatomy were used frequently as timesaving devices. This was also a reasonably sure way of pleasing clients, who could be shown recently completed commissions and be assured of what they would be getting. Because most folk paintings are unsigned, such stylistic devices provide useful clues for folk-art historians in attributing works to specific artists.

Portraits of children are also important sources of information about the way of life in Young America. Infant death was a sad but common occurrence, and small children, in accordance with common folklore, often wore coral necklaces to ward off evil and illness. We see evidence of this superstition in Phillips's painting of the *Girl in Red* and in the portraits of two other little girls dressed in red: a miniature portrait on ivory, possibly a posthumous memorial, of Lisa Maria Gibbs (fig. 1.44) of Massachusetts, attributed to Joseph Whiting Stock; and Mary Eliza Lindsay, pictured with her father, Andrew Lindsay (fig. 1.42). Painted in 1828 in Guilford County, North Carolina, the latter painting and a group of related watercolors have been attributed to an artist known only as the Guilford Limner.

Children's portraits often suggest their happy

times. Both Stock's *Lisa Maria Gibbs* (fig. 1.44) and *Charles Mortimer French* (fig. 1.37) by Asahel Lynde Powers of Vermont are depicted with their favorite toys. *Jonathan Knight* (fig. 1.30), a late-eighteenth-century young man who attended Yale University and was a founder of the Yale Medical School, is shown with the appropriate reading material for a studious boy. The open book under his hand reads: "I am but a little child, I know not how to go out or come in, give me therefore O Lord, a wise and understanding heart that I may discern between good and bad, approve, and follow the things that are excellent."

So far, our look into lives "at home" has dealt only with private, single-family houses. But by the middle of the nineteenth century many people had left their rural homes to seek employment in the cities, and many more immigrants had arrived in the cities and towns of America. Boardinghouses provided convenient urban lodging, and a series of watercolors created in Philadelphia during the 1850s shows us what life was like in such an establishment. The artist, Joseph Shoemaker Russell, was a native of New Bedford, Massachusetts, who moved to Philadelphia in 1818 to become a dealer in New Bedford whale oil. In his drawings of Mrs. Smith's boardinghouse (figs. 1.41a–d), Russell recorded daily life in lively scenes and provided us with enormous detail about the furnishings of the mid-1850s: most notable is the brand new piped-in gas table lamp in the parlor (fig. 1.41c).

As we have seen, and will continue to see in this book, many of the people we call folk artists were artists only by avocation: they had to depend upon other trades for a living. Frequently these occupations can be deduced from the materials the artists used to express themselves. Scrimshaw—incised and painted whale teeth or bones—for example, was created by sailors in need of recreation during the long hours at sea. The maker of the engraved whale's tooth titled *The Family in the Parlor* (fig. 1.32) was probably fondly recalling life on shore while he was on a multiyear voyage at sea. This art form is discussed further in chapter six, "At Sea."

By the same token, M. E. Ferrill, the mid-nineteenth-century creator of a unique "at home" painting on leather (fig. 1.33), was probably a cobbler or other craftsman who had access to large pieces of leather. But it must be remembered that many folk artists used any material at hand, and it is not unusual to find folk paintings on wallboard, glass, mattress ticking, cardboard, on the backs of other paintings, and on a wide range of other unconventional materials.

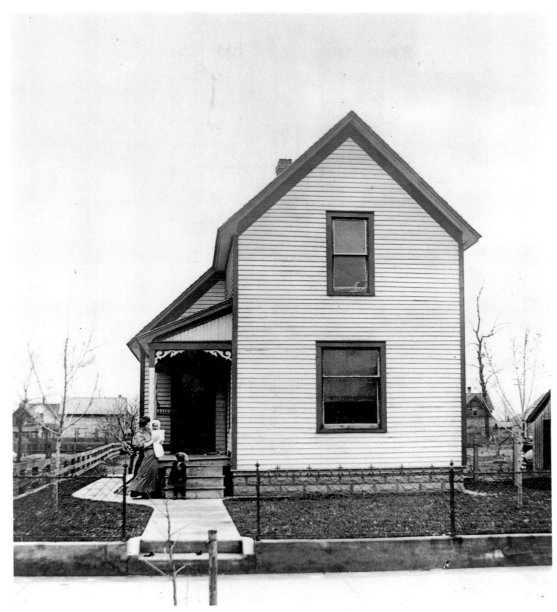

1.20 Postcard, c. 1909. Artist unknown.
5⅜ × 3½ inches.
Gotham Book Mart & Gallery, Inc., New York

1.21 *Man Feeding a Bear an Ear of Corn*, c. 1840. Artist unknown.
Watercolor and ink on paper, 5⅝ × 7½ inches.
Private Collection

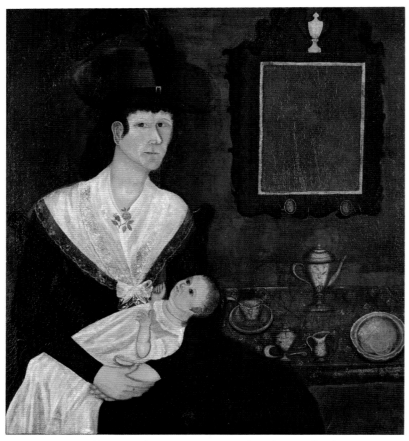

1.22 *Mrs. Reuben Humphreys*, c. 1800. Attributed to Richard Brunton.
Oil on canvas, 44½ × 40½ inches.
Connecticut Historical Society, Hartford

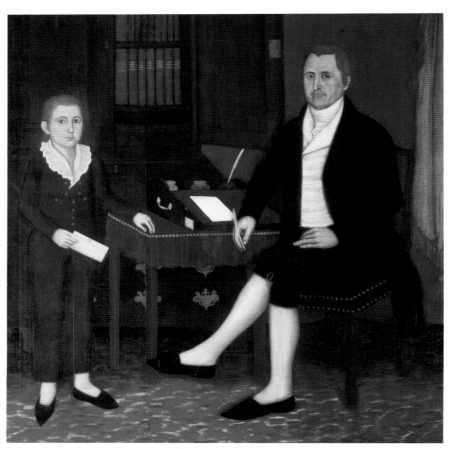

1.23 *James Prince and William Henry Prince*, 1801. John Brewster, Jr.
Oil on canvas, 60⅜ × 60½ inches.
Historical Society of Old Newbury, Newburyport, Massachusetts

1.24 *The Tilton Family*, 1837. Joseph H. Davis.
Watercolor, pencil, and ink on paper, 10 × 15¹⁄₁₆ inches.
Abby Aldrich Rockefeller Folk Art Center, Williamsburg, Virginia

1.25 *Joseph Moore and His Family*, 1839. Erastus Salisbury Field.
Oil on canvas, 82¾ × 93¼ inches.
Museum of Fine Arts, Boston
M. and M. Karolik Collection

1.26 *The Family of Deacon Wilson Brainard*, c. 1858. Erastus Salisbury Field.
Oil on paper mounted on linen, 35¾ × 43¼ inches.
Old Sturbridge Village, Sturbridge, Massachusetts

1.27 *Girl in Red Dress with Cat and Dog*, 1834–36. Ammi Phillips.
Oil on canvas, 30 × 25 inches.
Museum of American Folk Art, New York
Promised anonymous gift

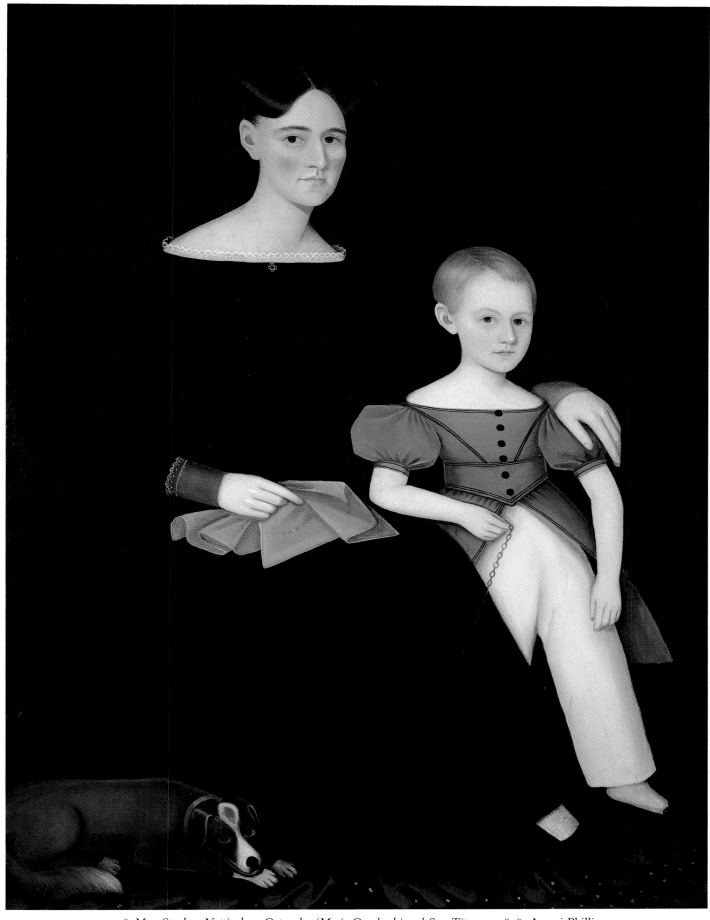

1.28 *Mrs. Stephan Nottingham Ostrander (Maria Overbagh) and Son Titus*, c. 1838. Ammi Phillips.
Oil on canvas, 58 × 44 inches.
Collection of Mrs. Alice M. Kaplan

1.29 *A Pennsylvania Gentleman and His Wife*, c. 1820. Jacob Maentel.
Watercolor and ink on paper, 11⅝ × 7½ inches each.
Private Collection

1.30 *Jonathan Knight*, c. 1797. Artist unknown.
Oil on wood, 32 × 22 inches.
Private Collection

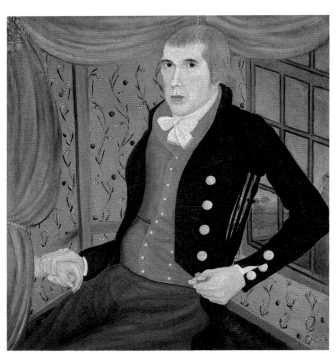

1.31 *Dr. Philemon Tracy*, c. 1790. Artist unknown.
Oil on canvas, 31⅛ × 28⅞ inches.
National Gallery of Art, Washington, D.C.
Gift of Edgar William and Bernice Chrysler Garbisch

1.32 *The Family in the Parlor*, c. 1840.
Artist unknown.
Engraved whale's tooth, 6 inches high.
National Museum of American History,
Smithsonian Institution, Washington, D.C.

1.33 *Marblehead Fireside*, c. 1875. M. E. Ferrill.
Oil on leather, 16 × 21½ inches.
Collection of Joan and Malcolm Lowenthal

1.34 *Family of Four*, 1832. J. Evans.
Watercolor and ink on paper, 14 × 17¾ inches.
National Gallery of Art, Washington, D.C.
Gift of Edgar William and Bernice Chrysler Garbisch

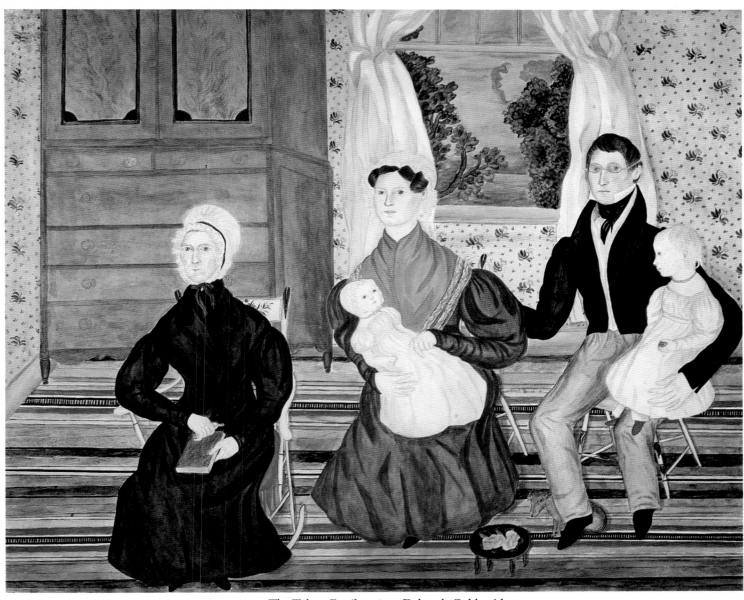

1.35 *The Talcott Family*, 1832. Deborah Goldsmith.
Watercolor, pencil, and gilt on paper, 14¼ × 17¾ inches.
Abby Aldrich Rockefeller Folk Art Center, Williamsburg, Virginia

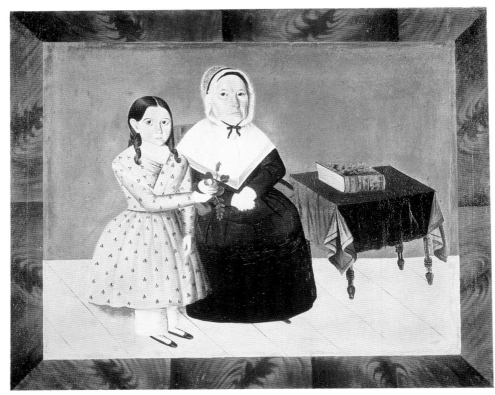

1.36 *Anna Gould Crane and Granddaughter Jennette*, c. 1845. Sheldon Peck.
Oil on canvas, 35½ × 45½ inches.
Private Collection

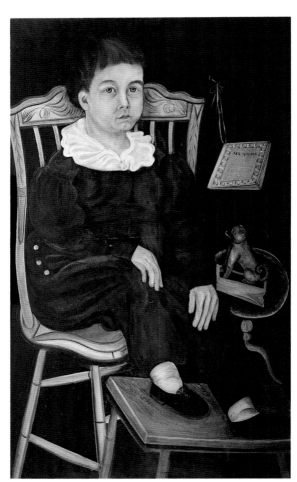

1.37 *Charles Mortimer French*, c. 1825. Asahel Lynde Powers.
Oil on canvas, 36 × 21¾ inches.
New York State Historical Association, Cooperstown

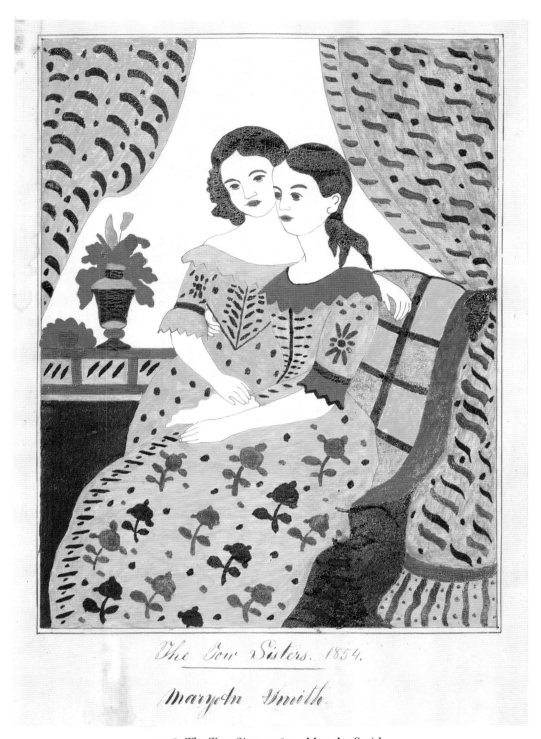

The Tow Sisters. 1854.

MaryAn Smith.

1.38 *The Tow Sisters*, 1854. MaryAn Smith.
Watercolor and ink on paper, 14¾ × 12 inches.
Private Collection

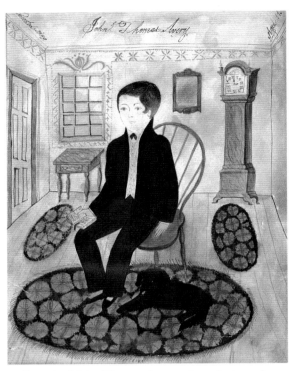

1.39 *Portrait of John Thomas Avery*, 1839. Artist unknown.
Watercolor and ink on paper, 15½ × 11½ inches.
Collection of Mr. and Mrs. Samuel Schwartz

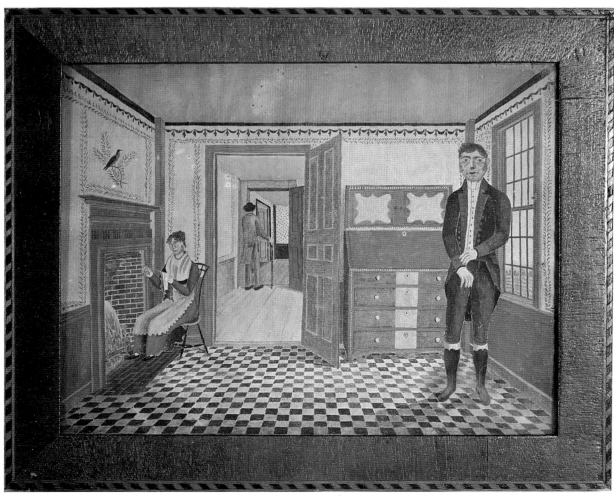

1.40 *Interior of Moses Morse House*, c. 1825. Joseph Warren Leavitt.
Watercolor on paper, inlaid wood frame, 7 × 9 inches.
Little Collection

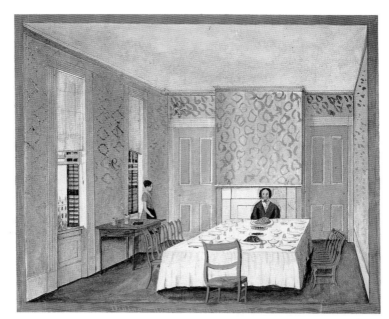

1.41a *Dining Room at Mrs. Smith's*, 1853. Joseph S. Russell.
Watercolor and ink on paper, 7⅛ × 8½ inches.
Little Collection

1.41b *Mr. J. S. Russell's Room at Mrs. Smith's Broad Street*, 1853. Joseph S. Russell.
Watercolor and ink on paper, 5½ × 9½ inches.
Little Collection

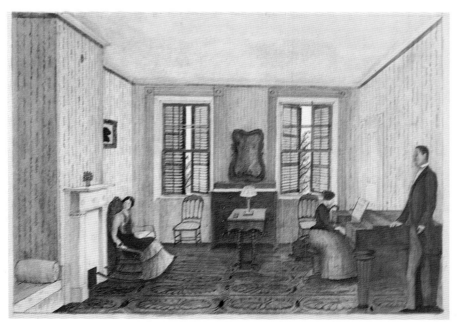

1.41c *Sitting Room of the Russell Daughters*, 1854. Joseph S. Russell.
Watercolor and ink on paper, 6½ × 9¼ inches.
Little Collection

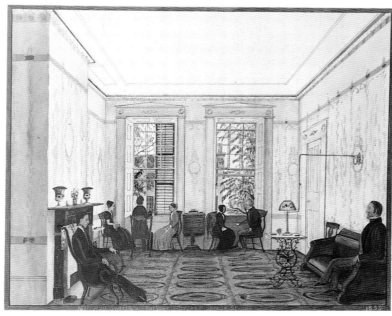

1.41d *Parlor in Mrs. Smith's Boardinghouse*, 1853. Joseph S. Russell.
Watercolor and ink on paper, 8½ × 10¼ inches.
Little Collection

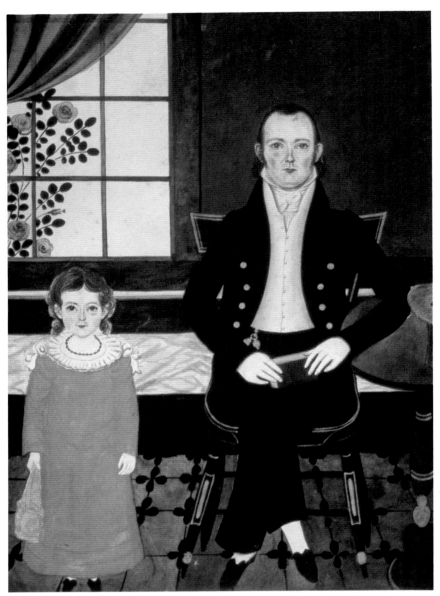

1.42 *Andrew Lindsay and Daughter Mary Eliza*, 1828. Guilford Limner.
Watercolor on paper, 9½ × 11½ inches.
Private Collection

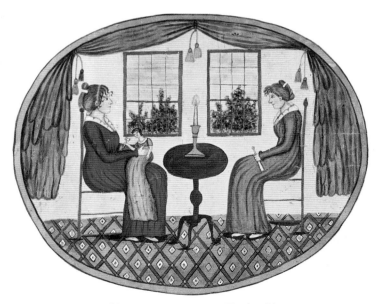

1.43 *Two Women*, c. 1815. Eunice Pinney.
Watercolor and ink on paper, 11 × 14⅜ inches.
New York State Historical Association, Cooperstown

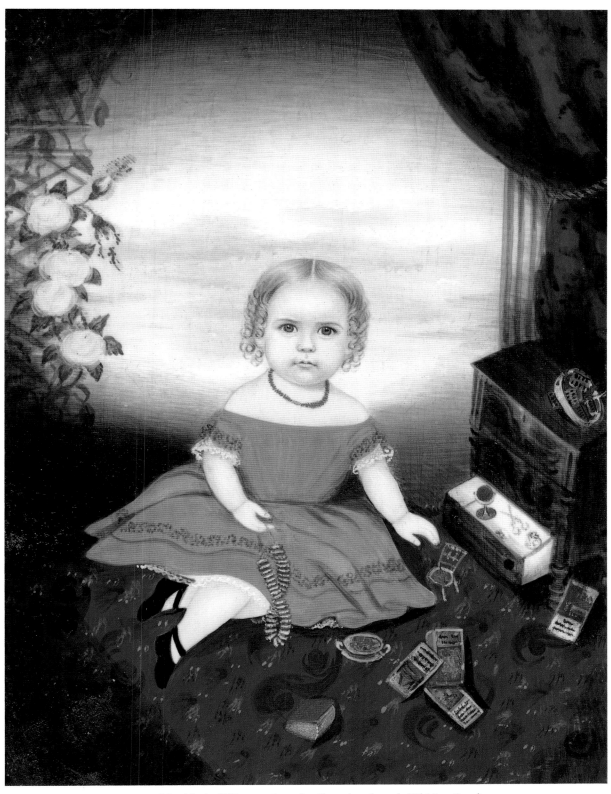

1.44 *Lisa Maria Gibbs*, c. 1835. Attributed to Joseph Whiting Stock.
Oil on ivory, 5⅞ × 3⅞ inches.
Private Collection

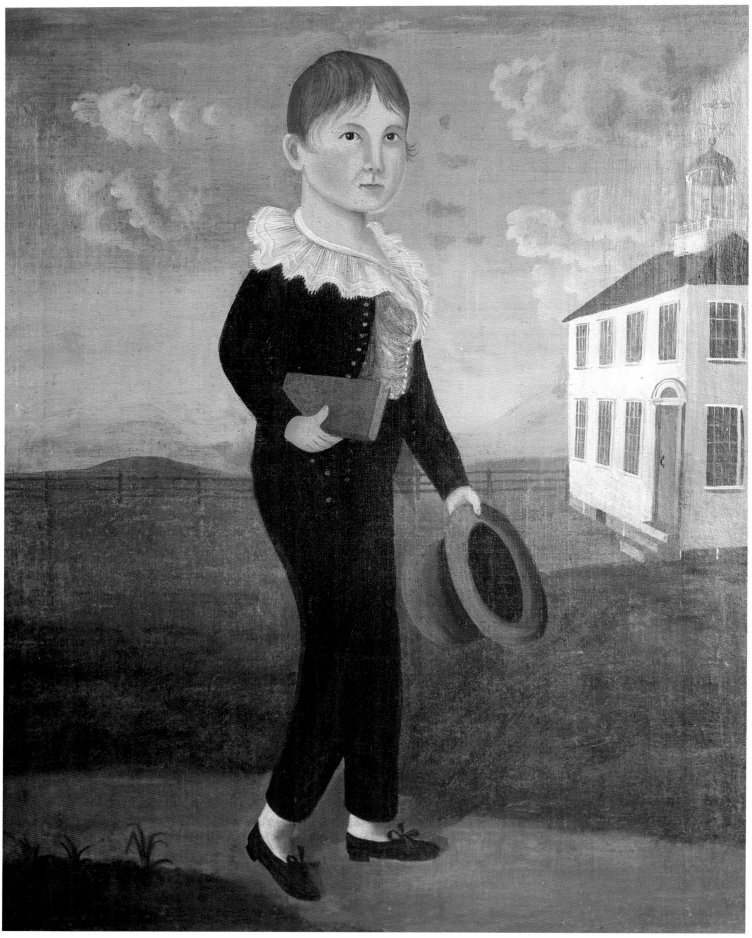

2.1 *George Richardson*, c. 1820. Artist unknown.
Oil on canvas, 21 × 17 inches.
Little Collection

Church and School

THE SEARCH for intellectual freedom was one of the most important reasons for the settlement of America. This idealized concept included the right to worship as one chose and the right to obtain an education, opportunities not generally available in sixteenth- and seventeenth-century Europe. Attending religious services and school, no matter how informal these might be, were, therefore, two of the most important activities in the lives of the American people. Not surprisingly, these activities were recorded by the folk artists.

Church and school also became important meeting places, sources of more than one kind of knowledge. Especially in wilderness or even rural areas, the opportunity to meet with neighbors that was afforded by religious services, no matter how infrequent, was greatly cherished, while for children, school was often the only exposure to a world beyond their own small universe. The folk artist recorded this social function of church and school as well.

I N THIS SECTION, we will look at folk art that suggests the great complexity and diversity of the churchgoing experience in America. Sabbath observances ranged from the sedate gatherings of New England to the frontier meetings of Mormons and Indians. As seen here, fiery sermons, missionary zeal, customs and songs brought from the Old World, and visions of Utopia on the American continent could all be part of the experience of attending religious services.

New England, home of the first colonies founded for religious reasons, has a heritage of somber Sunday services. The stark simplicity that often accompanied the Sabbath in New England is apparent in the painting titled *Winter Sunday in Norway, Maine* (fig. 2.6). In its restrained color and design, this painting imparts to us a feeling of the serenity that reigned on quiet Sunday mornings in snowy Maine.

One New England preacher, famous in the late eighteenth and early nineteenth centuries for his sermons, has been memorialized in a painting on a papier-mâché tray (fig. 2.7). Lemuel Haynes, an exceptional though now little-known figure in American history, was a revolutionary war soldier, a Congregational minister in New England, and the first black recipient of an honorary master of arts degree. While his fame derived in part from his race (his congregations were all white), he also became widely known for his advocacy of a number of political causes. He favored strong national government under President Washington, he opposed the War of 1812, and he denounced the proposed secession of New England in the early nineteenth century. Whether the artist who created this picture was one of Haynes's congregants, or simply someone who had heard of the unusual black preacher, is not known.

One of the most fascinating chapters in American religious history can only be glimpsed in the lithograph titled *Shakers, Their Mode of Worship* (fig. 2.9), engraved by D. W. Kellogg & Co. in the middle of the nineteenth century. In 1774, eight "Shaking Quakers," as they were derisively called because of the form of worship seen here, followed their leader, Mother Ann Lee, from England to America, some of them eventually settling at Watervliet, near Albany, New York. From this small beginning, the Shakers became the most successful of the communal societies that sprang up across America in the years following the Revolution. A celibate society, they gained new members through conversion, and their numbers grew steadily during the waves of religious revivalism that

2.2 *Glass-Windowed Church*, c. 1875. Artist unknown. Plaster and glass, 21¾ inches high. Museum of American Folk Art, New York

periodically swept the country during the nineteenth century. At its peak, the United Society of Believers in Christ's Second Appearing (the Shakers' official name) included between five and six thousand members in communities from the New England states as far south as Florida, and as far west as Indiana.

The dance shown in this lithograph is not necessarily a "celebration," but a religious ceremony. For the Shakers, contact with God was through the whole body—dance and song were prayer and communion, means of achieving that contact. Throughout the nineteenth century, these Sunday gatherings were open to the public and became tourist attractions, even though a form of worship that exercised the body as well as the soul, and created a sense of exaltation among the worshipers, was difficult for the "world's people"—the outsiders—to understand. But, for the Shakers, the combination of rhythmic body motions, communal singing, and deep religious fervor created a perfect spiritual union.

Religious practice, as well as almost every other aspect of life among the nineteenth-century Pennsylvania Germans, has been well documented in the pictures and words of Lewis Miller. More than any other artist presented in this book, Miller epitomizes the role of the folk artist as chronicler of daily life, and, for that reason, is an artist to whom we will return a number of times in later sections. A native of York, Pennsylvania, Miller was a carpenter and, as historian Donald Shelley has called him, a "pictorial raconteur." Miller, born in 1796, recorded the life of his community in York from 1810 until 1865 and kept sketchbooks of his travels to New York City and Virginia, and even of a grand tour of Europe.

Miller's *The Chronicle of York,* a book of some two thousand drawings, includes some scenes

2.3 Water cooler, c. 1870. Artist unknown. Stoneware, 23 inches high. Collection of Arthur and Esther Goldberg

the artist drew from hearsay, such as the work labeled "Die Deutsch Lutherische Kirche in York, pa." (fig. 2.5), which probably represents that church during the period between 1799 and 1811. Taken together, the pictures and words of Miller's *Chronicle* also provide an autobiography of the artist for, as he tells us on the title page with only slight exaggeration:

All of this Pictures Containing in this Book, Search and Examin them. the are true Sketches, I myself being there upon the places and Spot and put down what happened. And was close by of the Greatest number. Saw the whole Scene Enacted before my Eyes. . . . I See all is Vanity in this Knowing world.

In the watercolor detailing the interior of the German Lutheran church, Miller has made Sunday service come alive for us. Clearly visible under the balcony is the imposing, full-length portrait of Martin Luther. On the balcony panels we see Luke, Paul, Peter, Samuel, Joshua, Solomon, David, and Saul, and scenes of Adam and Eve and Abraham's sacrifice of Isaac. The choir and the worshipers have been identified, and we can even watch as the large coal stove is stoked and an errant dog is chased from the sanctuary.

A totally different kind of church and style of preaching have been recorded in a series of paintings by C. C. A. Christensen that record the dramatic history of the Mormons. Christensen was an immigrant who converted to the faith of the Latter-day Saints while still a young man in Denmark. He served as a Mormon missionary in Scandinavia, then traveled to the United States in 1857, making the journey overland to Utah on foot.

Like many other folk artists, Christensen earned much of his living with decorative and house painting; he made banners, theatrical scenery, coffins, headboards, flour boxes, and window blinds, as well as working his farm. He never lost his missionary zeal, however, and eventually he found a way to combine his artistic talent with his desire to record the history of the Mormon Church. His "Mormon Panorama," as it came to be known, is a series of large paintings depicting the early days of the

2.4 Rocker, c. 1830. Artist unknown. Painted wood, 36½ inches high. Private Collection

Church of Jesus Christ of Latter-day Saints. The paintings were sewn to a backing, then unrolled vertically, while Christensen presented the accompanying narrative by lamplight.

The scene reproduced here, *Joseph Preaching to the Indians* (fig. 2.8), shows Joseph Smith, founder of the Mormons, addressing a tribe of Indians, whom the Mormons called Lamanites. An assembly similar to this one is known to have taken place in Illinois on August 12, 1841, at the Mormon meeting grounds in a grove near the former town of Commerce, rechristened Nauvoo ("a beautiful place" in Hebrew) by Smith

to celebrate the Mormons' new city there. They felt that they had a message of great importance for the Indians, whom they believed to be descendants of the Israelites. Smith told the Indians that the "Book of Mormon," translated by him, was a history of their people, and many Indians were reportedly deeply impressed by his message.

Christensen usually traveled with his panorama in the winter, when farm work was slow, and exhibited it in Mormon communities throughout Utah, Arizona, Idaho, and Wyoming. Other panoramas of the time were travelogues,

morality tales, historical narratives, horror thrillers, newsreels—in short, the nineteenth-century ancestors of the modern motion picture. And like the early movies, panoramas were a modestly priced art form, available to the general populace. Especially after the introduction of photography, when portrait painting suffered a severe decline, some folk artists turned to panoramas as a means of making a living. They packed their scrolls into carts and traveled from town to town, putting on a show wherever they could find an audience.

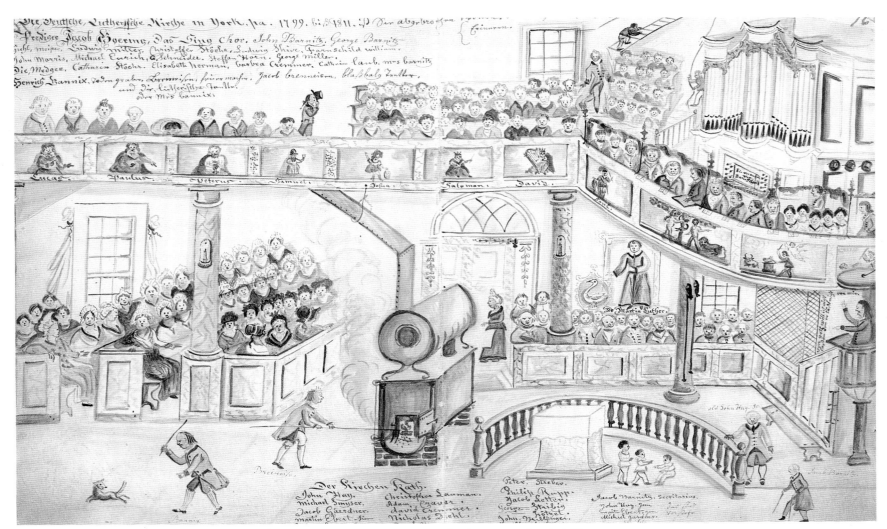

2.5 *Inside the Old Lutheran Church*, c. 1849. Lewis Miller.
Watercolor and ink on paper, 9½ × 15½ inches.
Collection of Carol K. Woodbury and Family

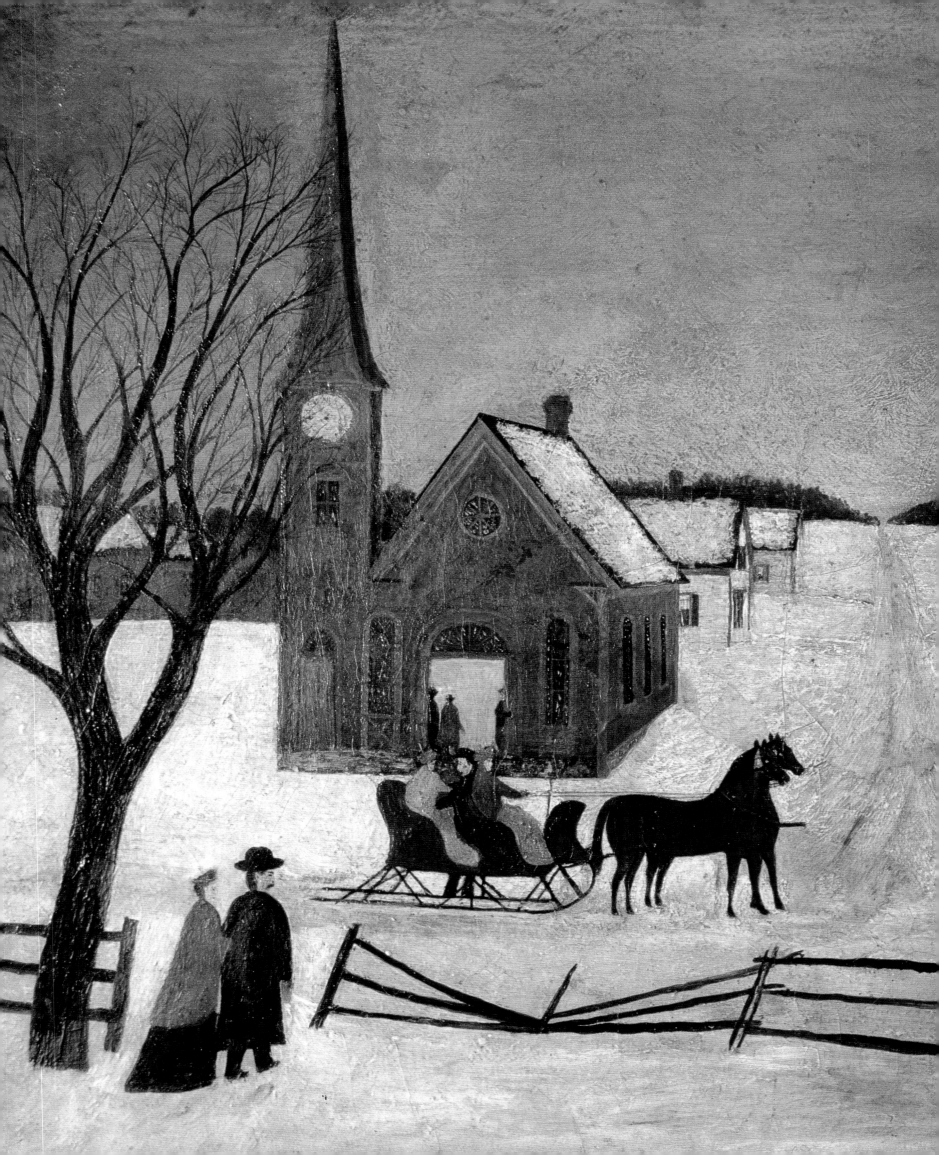

2.6 (opposite) *Winter Sunday in Norway, Maine* (detail), c. 1860. Artist unknown.
Oil on canvas, 21⅛ × 27⅛ inches.
New York State Historical Association, Cooperstown

2.7 *Lemuel Haynes in the Pulpit*, c. 1850. Artist unknown.
Oil on molded papier-mâché, 21 × 27⅝ inches.
Museum of Art, Rhode Island School of Design
Gift of Miss Lucy T. Aldrich

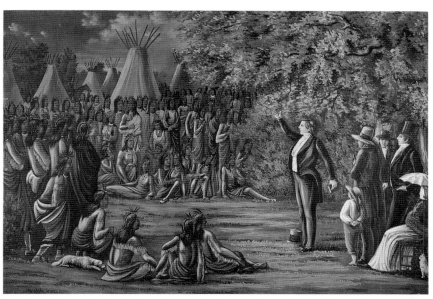

2.8 *Joseph Preaching to the Indians*, 1865–90. C. C. A. Christensen.
Tempera on linen, 78 × 114 inches.
Brigham Young University Art Museum, Provo, Utah

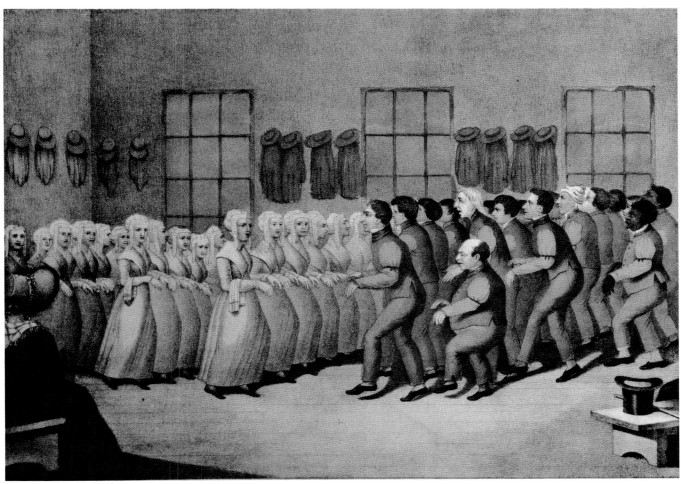

2.9 *Shakers, Their Mode of Worship*, c. 1840. D. W. Kellogg & Co.
Lithograph, 9⅛ × 13 inches.
The Shaker Museum, Old Chatham, New York

WHILE LAWS REQUIRING towns in America to provide schooling for children were passed as early as the seventeenth century in Massachusetts, the kind and quality of education in Young America actually ran the gamut from nonexistent to university level. During the period of this survey, however, it was at the one-room schoolhouse that a great many Americans obtained their basic education.

The strict nature of such a school in New England is apparent in the scene inscribed by Jonathan Jennin (fig. 2.12). In this probably child's-eye-view of school, a little girl cries in the front row, while a boy in the back row wears a dunce cap and holds his just-cuffed ear. A second disgraced boy, perhaps the one who wrote the graffiti on the wall, stands on the "dunce's block" at the left. The schoolmaster is portrayed as disproportionately large, as he must have appeared to his frightened students.

At these schools, a single teacher was responsible for instructing children of all ages in a variety of subjects. Attendance was not compulsory, and the size of the student population frequently depended upon the season and whether or not the children were needed to work at home. The schools were usually physically uncomfortable. Many had only lard-greased paper for windows, allowing dim light but strong drafts to enter. Furniture—what there was of it—was crude, and usually consisted of rough benches without backs.

Conditions at these schools in the eastern states in the late eighteenth and early nineteenth centuries were not much different from those on the frontier at the end of the nineteenth century, as seen in folk photographs of that era. The pioneer schoolhouse (fig. 2.15) is not even distinguished by a roof over its shaky benches, although it does have a blackboard, and a nearby tree acts as a handy hatrack.

These photographs of school days on the frontier (figs. 2.16 and 2.17) indicate the great lengths to which the pioneers sometimes went in order to secure education for their children. Journals and diaries kept on the frontier tell us of the scarcity of books, teachers, and furnishings for schools, as well as of schools themselves. One woman in Kansas in the 1870s was moved by necessity to start her own class. Her story is preserved by Joanna Stratton:

Her children were growing up . . . and there were no schools. So she searched out her hoarded school books and her old school bell, made the versatile flour barrel into a teacher's desk; the goods boxes, dining table, kitchen table, shoe bench, general utility table became students' desks; and the small Guy and Stella, and frequently some neighbor's child, mastered the intricacies of the old blue-backed speller and the McGuffey series of readers with their wonderful hero tales—and a greater heroism was all around them.

The parochial school also played an important role in the early educational system of this

2.10 Scrimshaw hornbook, c. 1840.
Artist unknown.
Engraved panbone, 12 inches high.
Collection of Daniel and Joanna S. Rose

country. A number of colonies were founded by religious groups, and in the following years thousands emigrated to America in search of religious freedom. The parochial school was an important element in keeping both the religion and the culture of the mother country alive in the new world. An example of this can be seen in Lewis Miller's drawing, *Ludwig Miller, Teacher at the Old Lutheran School House, in the Year 1805* (fig. 2.13), a lively view of the artist's own father teaching German religious music to a group of schoolchildren.

When looking at Miller's paintings, it is always a pleasure to study the artist's peripheral drawings and comments. In this case, look at "the hour glass, which tells the hour," which was probably carefully studied by early-nineteenth-century clock-watching students, and, in the top right-hand corner, a picture of Dr. John Morris curing young Lewis Miller of ringworm in 1800.

Parochial education of another kind is depicted in a rare group of watercolors by Native American artist Dennis Cusick that details the educational experience of Indian children at the Seneca Mission School House in New York

State. In the picture included here, *Keep the Sabbath* (fig. 2.14), children dressed in the costume of their tribe are being led in prayer by a white teacher. As in many schools of the day, religious education was combined with secular, as evidenced here by the reading charts on the wall and the penmanship and arithmetic lessons on the blackboard. An open Bible stands on the teacher's desk, and Bible texts on observing the Sabbath have been lettered above the scene.

Although not much is known about the creator of these watercolors, the inscription on the back of one of them might almost have been placed there to prove to us that Cusick was, indeed, a folk artist:

The pieces accompanying are the execution of an Indian youth of the Tuscarora Tribe, Age 21, son of the Interpreter and Chief Cusick. In acquiring the art, he has had no instruction except what he has received from copies. He is honest, temperate and industrious, and a member of the Church in that Tribe. Seneca Mission School House, Aug. 26, 1821, James Young.

Boys and girls attended classes together in the pictures we have looked at up to now, but the kind of education deemed proper for young women varied greatly over the period of our survey. Of great interest in the field of folk art are the finishing schools, or seminaries, that catered to the daughters of families with some means and that flourished from Colonial days until late in the nineteenth century. Genteel accomplishments such as music, dancing, drawing, and fancy needlework, all intended to prepare young ladies for marriage, were emphasized in these establishments. Today, many of the products of this education—the samplers, the mourning and other embroideries, the watercolor paintings—are considered significant forms of American folk art.

Advertisements in newspapers of the day tell us much about the course of study at these finishing schools. One teacher, recently arrived from London, announced in a Boston newspaper in 1799 that

She will instruct in Reading, Writing, & Arithmetic, Grammer, Geography, & History, with Rudiments of the French Language. All kinds of Needlework, Tambour, Embroidery, & Drawing, upon very moderate Terms. She presumes, that by an unremitting diligence, she shall merit the favor of all those who honour her with the care of their children. The terms are from Three to Six Dollars per quarter. All kinds of Needlework and Millinery shall be done, in the newest taste, with elegance and dispatch.

Rarely, however, were such complicated subjects as mathematics considered appropriate for young girls to study. Sarah Anna Emery described a teacher at her school who made it clear that "he would not permit his female pupils to cipher in 'Fractions.' It was a waste of time, wholly unnecessary, would never be of the least use to them. If we could count our beaux and our skeins of yarn it was sufficient."

Young girls learned plain sewing—basic mending and embroidery stitches—at home, as these were necessary skills for repairing and marking linens with the family name. Fancier stitches were taught in school, and samplers were originally made as records of frequently used motifs. They were also showpieces, however, on which the girl exhibited her mastery of difficult embroidery stitches, and which served as evidence of refinement and a proper education. Any family of the late eighteenth or early nineteenth century who had a daughter would be considered poor indeed if they did not have a sampler wrought by the girl to hang in the parlor. As Emery recalled, "One was considered very poorly educated who could not exhibit a sampler; some of these were large and elaborate specimens of handiwork; framed and glazed they often formed the chief ornament of the sitting room or best chamber."

Earlier samplers were used as references by the young needleworker, and often featured overall, random designs. Sometimes these record the daily round of activities. The 1795 example shown in chapter three, for instance (fig. 3.9), stitched by an anonymous young girl, probably in Chester County, Pennsylvania, includes such charming rural vignettes as women drawing water at the well, a galloping horse, and a farmer plowing.

These designs were not the original inventions of the students, but were usually drawn directly on a silk or linen backing by the instructor. Accordingly, the scenes tend to be stylized, rather than true to life or based on any particular event. Today, in fact, samplers and other needlework pictures can often be attributed to specific schools and teachers, based on their designs. Mary Antrim's signed 1807 needlework (chapter three, fig. 3.8), for example, is typical of an important group of samplers worked at an unidentified young ladies' seminary in Burlington County, New Jersey, between 1804 and 1807.

Besides sewing, other activities deemed suitable for girls at school are brought to life for us in a miniature panorama depicting *Scenes from a Seminary for Young Ladies* (title page). Here, in vignettes only seven inches high, we see the young ladies at a rural academy practicing their music, studying geography with a globe, reading their lessons under the supervision of a bonneted schoolmistress, and enjoying their leisure time by jumping rope. A connection between the academy and a farm is implied by scenes with farm subjects and details of women, not students, shown dairying.

The twelve scenes that comprise the complete panorama provide us with an unusual amount of detail about the daily life of the students at such seminaries. The depiction of the girls' uni-

forms, for example, is rare: their red Empire-style dresses with blue aprons are quite stylish, especially considering the rural setting of the school. Furnishings and musical instruments are also portrayed in great detail.

Unfortunately, this panorama cannot as yet be traced to any specific academy. Within the first decades of the nineteenth century the concept of seminaries had spread westward, so that girls' schools were not uncommon in the territories which became the midwestern and southern states. The setting could be New England, the South, or the Appalachian region. It is likely that the artist was a student or perhaps a teacher at the academy shown.

The unusual size of this watercolor on silk—ninety-seven inches long and only seven inches high—and its division into separate narrative scenes suggest that it may have been rolled from one cylinder to another in some sort of viewing box. Small panoramas were produced by amateurs as well as by commercial concerns throughout the nineteenth century. Viewing boxes for these small works ranged from simple wooden frames with roller devices at either end to complicated cardboard or wood "proscenium stages" with elaborate, painted exteriors.

By the end of the nineteenth century, schoolhouses in long-settled areas were sturdy edifices, not very different from those we know today. Although Joseph Pickett's *Manchester Valley* (fig. 2.18) was painted to commemorate the coming of the railroad to New Hope, Pennsylvania, in 1891, it was often called *The School House* be-

2.11 *Schoolhouse Quilt*, 1900–10.
Artist unknown.
Pieced cotton, 82 × 72 inches.
Private Collection

cause its most prominent feature is the imposing New Hope High School that stood on a hill just outside town, in the area known locally as Manchester Valley.

One of only a handful of known surviving paintings by Pickett, *Manchester Valley* is a masterpiece of American folk art. In this picture, as in *The Plantation* (chapter one, fig. 1.5), we see how the folk artist arranged perspective to suit his needs, with objects of greater importance given greater scale, regardless of distance. Here, the high school dwarfs the mills in the foreground, even though the latter were actually the taller buildings. There is also a dramatic feeling of tension in this painting, created by the train, the creek, and the contours of the land all flowing to the left, while the prevailing winds, indicated by the trees and the position of the flag, blow to the right.

Pickett worked on each painting for years, adding color until he achieved the raised textures that give parts of his pictures the appearance of relief. In *Manchester Valley*, the tiny figures on the train, the fireman and the conductor, are modeled in half-round and the bark of the trees is built up to high relief. Pickett also added interest here by mixing in such materials as sand and shell, giving the trestle foundation the actual feel of cement.

Like many folk artists, especially in the twentieth century, which saw longer life spans and more leisure time, Pickett did not begin to paint until late in life. He followed the carnival as a young man and then opened a grocery and general store in New Hope. It was not until after his marriage in the late 1890s that Pickett started to paint in the back room of his store, and he continued until he died in 1918.

Insight into Pickett's technique, as well as the thought processes of many folk artists, is provided by Pickett's friend Mrs. Martha R. Janney. In this excerpt from an article, she describes Pickett at work on *Manchester Valley*.

"What do you think of the flag?" Joe would ask. "Doesn't it need another coat of paint?"

As the paint was already about a quarter of an inch thick, the answer would be "no." And the flag would get another coat of paint anyway.

"Now look at that train," Joe would say. "See—you can read 'Reading Rail Road' right on it."

And you could!

"Joe," I would say, "if you would paint what you see and not what you know, you would get somewhere."

"What do you mean?" asked Joe.

"There is no fence around the schoolhouse."

"Yes, there is," says Joe.

"Let's look."

There was no fence. It had been gone for years.

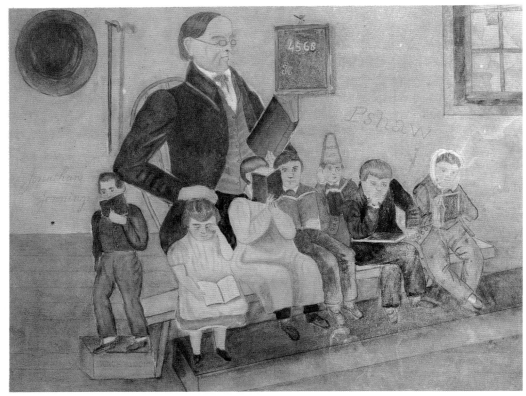

2.12 *The School Room*, c. 1830. Jonathan Jennin.
Watercolor, graphite, and crayon on paper, 12¼ × 16 inches.
Collection of John and Joan L. Thayer

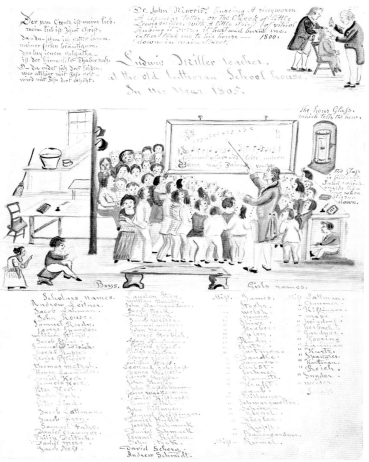

2.13 *Ludwig Miller, Teacher at the Old Lutheran School House,
in the Year 1805*, c. 1850. Lewis Miller.
Watercolor and ink on paper, 9⅞ × 7⅝ inches.
Historical Society of York County, York, Pennsylvania

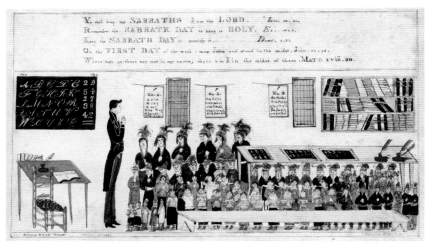

2.14 *Keep the Sabbath*, 1821. Dennis Cusick.
Watercolor and ink on paper, 8 × 11 inches.
Private Collection

2.15 A pioneer schoolhouse, 1892. Attributed to E. H. Turner.
Photographic print, 5 × 8 inches.
San Diego Historical Society, TICOR Collection
San Diego, California

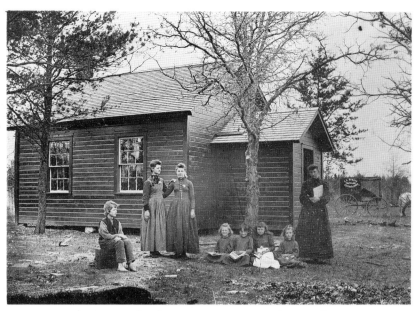

2.16 Halcyon School, Wisconsin, c. 1893. Artist unknown.
Glass-plate negative, 6½ × 8½ inches.
State Historical Society of Wisconsin, Madison
Charles Van Schaick Collection

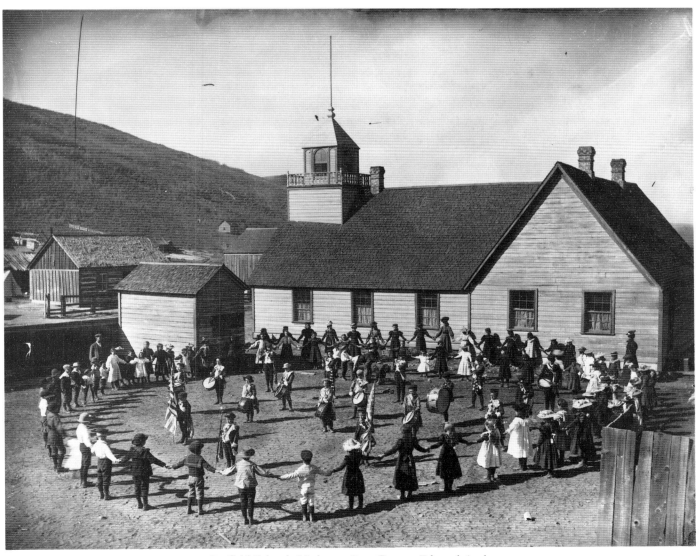

2.17 Scofield School, Utah, c. 1899. George Edward Anderson.
Photographic print from glass-plate negative, 8 × 10 inches.
Harold B. Lee Library, Brigham Young University, Provo, Utah

2.18 *Manchester Valley*, 1914–18. Joseph Pickett.
Oil with sand on canvas, 45½ × 60⅝ inches.
The Museum of Modern Art, New York
Gift of Abby Aldrich Rockefeller

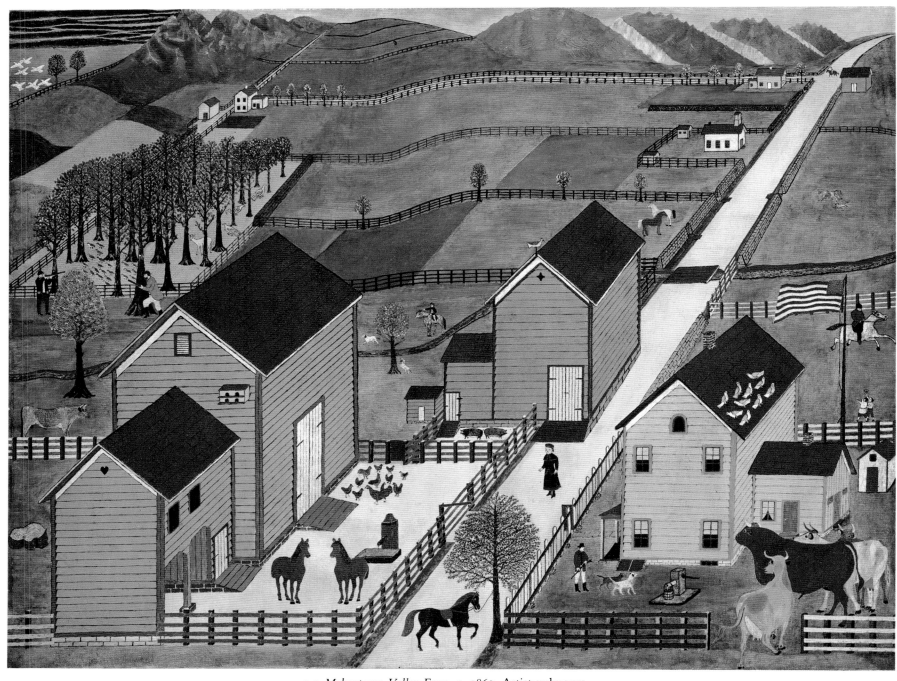

3.1 *Mahantango Valley Farm*, c. 1860. Artist unknown.
Oil on linen window shade, 28 × 35⅜ inches.
National Gallery of Art, Washington, D.C.
Gift of Edgar William and Bernice Chrysler Garbisch

On the Farm

URING THE PERIOD we call Young America, ours was a nation of farmers. Many of the immigrants who settled this country, such as the Pennsylvania Germans, were farmers in Europe who came to America not to change their agricultural lifestyle but to insure its continuation. The major difference was that, unlike their European counterparts, farmers here were not peasants, but usually land-owning citizens. When good land grew scarce and expensive in the original colonies, there was always more land and opportunity to the west.

In 1790 more than ninety percent of all working Americans were employed on the land. Although by 1910 this figure had declined to approximately thirty percent, the great increase in the population over the years meant that there were still a large number of people involved in agriculture. For these years the never-ending daily cycle of work on the farm formed the core of American life.

The rural nature of life for so many Americans was recorded by the folk artists. The well-ordered farms, comfortable farmhouses, and contented livestock included in paintings, drawings, needlework, photographs, and sculpture provides for us, today, a nostalgic picture of country life in earlier days. Because, in general, landscape painting is a later phenomenon in American folk art than portrait painting, most of the farmscapes included here date from the nineteenth century. Before this, there simply had not been a tradition of—nor a market for—landscapes. By the mid-nineteenth century, however, the wide distribution of prints that included landscape scenes helped to inspire folk artists and popularize the genre.

Proud residences

FARMS IN YOUNG AMERICA ranged from small subsistence holdings to large plantations. For the most part, the folk artists portrayed average situations, the prosperous farms that required hard work by everyone in the family to maintain.

Paul Seifert was an artist who specialized in portraits of such farms. A German immigrant who reached Richland City in Wisconsin on a lumber raft in 1867, Seifert earned his living, first, by selling the flowers, fruits, and vegetables that he grew on his eighty-acre farm, and, later in life, as a taxidermist. His greatest enjoyment, however, was painting, and he often took off on foot with his stack of colored papers and boxes of paints. He would travel from farm to farm, sketching, on order from the proud farm owners, the neat homesteads, the livestock, the daily activities, all set against the wide skies and vast plains of Wisconsin. The cost was never more than $2.50 per picture, framed.

Residence of Mr. E. R. Jones (fig. 3.5), painted in 1881, is typical of Seifert's work. In this picture, we see his orderly sense of design, his love of anecdotal detail, and his crisp, clear palette. It is interesting to note that Seifert typically used colored paper or cardboard for his scenes, and this basic color—tan or gray or blue—determined the dominant tone of the painting in an original and arresting manner. The Jones farm, depicted after an early snowfall, is given a wintry feeling by the gray paper; the bright red barn, green fir trees, and orange oaks stand out in vivid contrast. As was probably true of life on this farm, it is the barn rather than the house in the painting that is the center of interest; the matching red color in the inscription reemphasizes its importance.

Seifert's philosophy about his painting was simple. He could have been speaking for countless other folk artists as well when, as his granddaughter recalled, he said, "People like my work and I like to paint for them."

The orderly design in Seifert's farm portraits is enhanced by the linear pattern of the fences. In *Pennsylvania Farmstead with Many Fences* (fig. 3.10), painted about 1840, the fences create the design. In this work, we can see how folk artists, innocent of the rules of perspective or classic

composition, could make use of a simple element, such as the fences, to organize their paintings. The order in *Pennsylvania Farmstead* is carried to an extreme: the fences divide the property into rectangular areas; every tree is neatly lined up; and even the bricks, roof tiles, and windowpanes stand out as design elements. There are no animals or human beings: the painting is a pared-down, maplike rendering of the property that nevertheless delights and charms us with its elaborate patterning. A second watercolor, similar in content and possibly painted by the same hand, is signed "Drawed by Chas. Wolf" and dated 1847. This suggests that there was a Pennsylvania artist who, like Seifert in Wisconsin, pleased both himself and the local farmers with portraits of their "proud residences."

Another artist who must have pleased his prosperous farmer-client was Charles C. Hofmann, who painted *View of Henry Z. Van Reed's Farm* (fig. 3.13) in 1872. Hofmann, a German immigrant better known for his paintings of the Pennsylvania almshouses that sheltered him when he periodically admitted himself

for "intemperance," was hired by Van Reed to paint his farm and paper mill for the price of five dollars plus one quart of whiskey. The owner himself is depicted in the left foreground, talking with the drover delivering a load of rags to the paper mill. Van Reed later commissioned Hofmann to paint four additional views, one for each of his children, again priced at five dollars and a quart of whiskey each.

Hofmann's precisionist style and his elaborate manner of labeling his paintings are reminiscent of nineteenth-century lithographs. On one of his paintings of the Berks County almshouse the word "lithograph" appears after Hofmann's name. This fact, combined with the artist's great skill in rendering detail, suggests that Hofmann may once have worked in the lithography trade, perhaps in Germany, or that he may have planned some of his paintings for graphic reproduction.

Owners of small farms on the frontier were as desirous of having their property documented in paintings as were successful Eastern farmers such as Mr. Van Reed. The small watercolor of *Julius Meyenberg's Farm* (fig. 3.11) by Louis Hoppe charmingly describes Texas farm life during that state's frontier period. Meyenberg, born in Hanover in 1819, came to this country in 1844. In 1850 he bought a farm in Fayette County, Texas, and married Kunigunde Oske. Six of the couple's eight children, all born on the farm, appear in this painting.

While a good deal is known about the owner of the farm, little has been recorded about the artist who painted its portrait. Hoppe was an itinerant laborer who worked on the Meyenberg farm, as well as on another farm that he painted, also in watercolor. These are the only two landscapes of his that have been found and, along with two small still lifes, comprise Hoppe's total known body of work.

Small as it is, the painting of the Meyenberg farm provides us with some significant information about farm life on the Texas frontier. We learn, for example, that the farmhouse was made of logs, and probably started as a single-room cabin that was added onto when the farm and family began to grow. The family's livestock and pets have been included, and we can

THE FIELD ENGINE;
A MACHINE FOR HARROWING, SOWING AND ROLLING AT THE SAME TIME

3.3 *The Field Engine*, 1846. Rufus Porter.
Engraving, 4¾ × 7½ inches.
From *Scientific American*, August 6, 1846

even see that Mr. Meyenberg was fond of smoking a long "churchwarden's" pipe.

Representations of life on the farm and portraits of farms were sometimes part of the interior decoration of houses. Rural landscapes were popular scenes for both fireboards (figs. 3.6 and 3.7) and murals (fig. 3.12). The farm mural shown here, painted in a New Hampshire house around 1830, is the work of Rufus Porter, a remarkable artist, inventor, and journalist.

From 1815 to around 1840, Porter worked as an itinerant artist, painting both portraits and mural landscapes throughout New England and as far south as Virginia. In 1825, he published a book called *Curious Arts,* an art-instruction manual primarily designed to give the amateur public quick and easy recipes for various types of artwork. Included in this early book is a section on "Landscape Painting on Walls of Rooms," and in the years following the manual's publication Porter devoted himself chiefly to mural painting, decorating more than one hundred identified homes. His scenes were executed in large scale on dry plaster walls in a combination of freehand painting and stenciling, the foliage occasionally stamped in with a cork stopper instead of painted with a brush. All these methods had long been used for decorating plaster, woodwork, and furniture, but Rufus Porter was the first to popularize them for landscape painting. His simple murals provided an attractive and, at that time, less expensive substitute for the elaborate, imported scenic wallpapers then fashionable.

Porter was also the founder of *Scientific American,* and in a series of articles published in 1845 in the first issues, he discussed the mural painter's approach to his art. Porter enthusiastically recommended American farm scenery as subject matter and a deliberately abstract style as painting technique—a revolutionary concept in mid-nineteenth-century America. In one of the articles, he provided an explanation of why farm views were so popular as wall decoration in the nineteenth century.

There can be no scenery found in the world which presents a more gay and lively appearance in a paint-

3.4 Miniature deed box, c. 1830. Artist unknown.
Painted tin, 4 inches wide.
Collection of James G. Brooks, Jr.

ing, than an American farm, on a swell of land, and with various colored fields well arranged. . . . In finishing up landscape scenery, it is neither necessary nor expedient, in all cases, to imitate nature. There are a great variety of beautiful designs, which are easily and quickly produced with the brush, and which excel nature itself in picturesque brilliancy, and richly embellish the work though not in perfect imitation of anything.

During the years that Porter worked as an itinerant artist he was also actively involved in inventing a variety of time- and labor-saving devices. He was especially interested in machines that would speed travel, and he visualized the possibilities and drew up plans for an automobile, an elevated railroad, and a passenger plane. A number of his ideas, like *The Field Engine; A Machine for Harrowing, Sowing and Rolling at the Same Time* (fig. 3.3), presented in *Scientific American* in 1846, were designed to make life a bit easier on the farms he thought so beautiful.

While some early-nineteenth-century homeowners might have hired Rufus Porter or another itinerant artist to paint a mural scene, it was far more likely that any family with a girl of school age would have a sampler wrought by her hanging in the parlor. In a still largely rural America, samplers like those in figures 3.8 and 3.9 captured in delicate stitches the essence of life on the farm—the animals, the chores, the neatly kept fields and buildings.

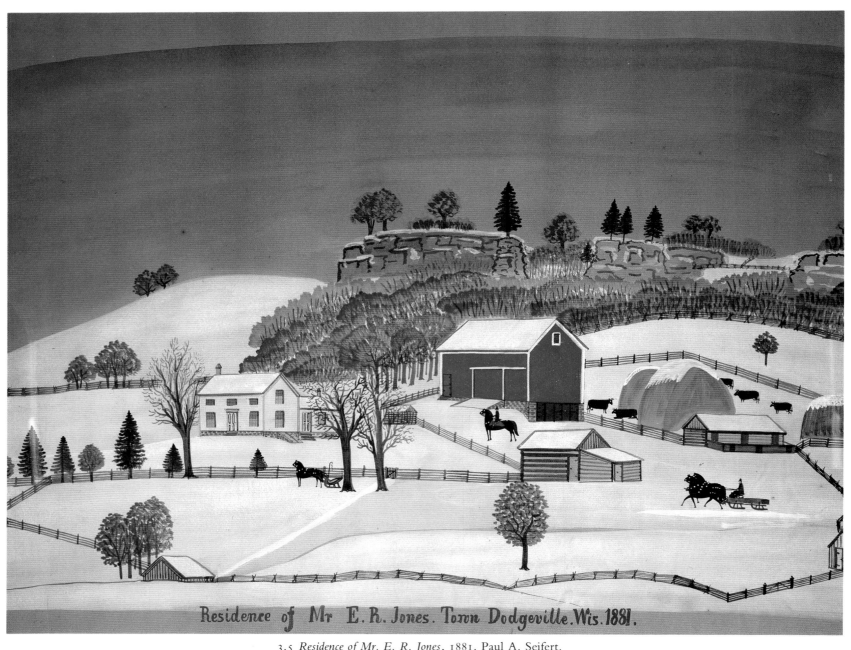

Residence of Mr E. R. Jones. Town Dodgeville. Wis. 1881.

3.5 *Residence of Mr. E. R. Jones*, 1881. Paul A. Seifert.
Watercolor and tempera on paper, 21½ × 27½ inches.
New York State Historical Association, Cooperstown

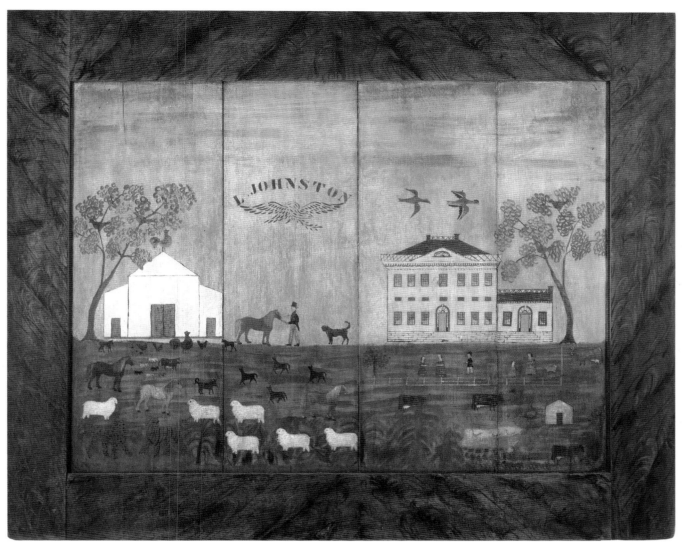

3.6 Fireboard, c. 1835. Attributed to L. Johnston.
Oil on panel, 44 × 54 inches.
Private Collection

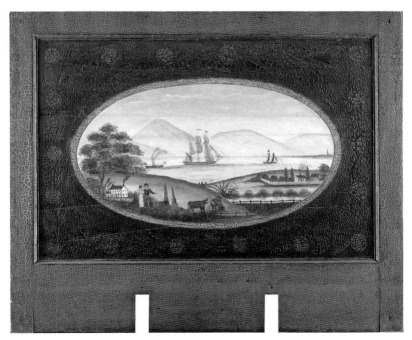

3.7 Fireboard, c. 1830. Artist unknown.
Oil on wood, 37 × 44 inches.
Private Collection

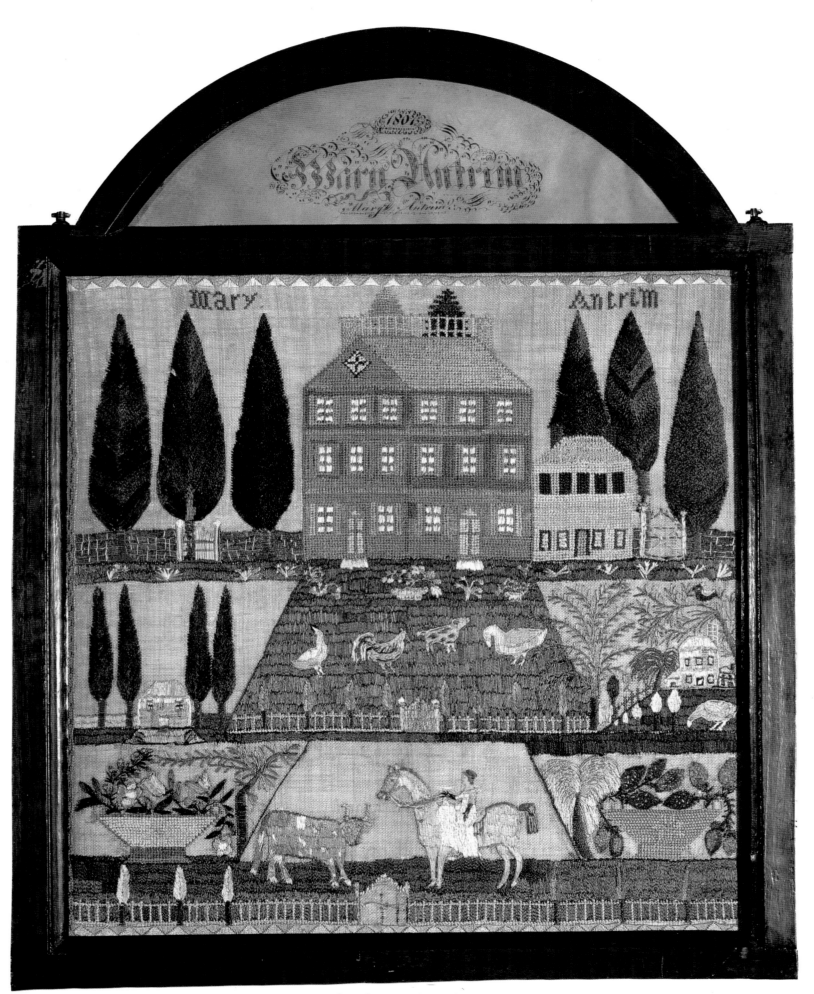

3.8 Sampler, 1807. Mary Antrim.
Silk on linen with painted paper, 24½ × 19⅜ inches.
Collection of Betty Ring

3.9 Sampler, 1795. Artist unknown.
Silk on wool, ribbon border, 11¼ × 12¼ inches.
Private Collection

3.10 *Pennsylvania Farmstead with Many Fences*, c. 1840. Artist unknown.
Watercolor and ink on paper, 18 × 23⅞ inches.
Museum of Fine Arts, Boston, Massachusetts
M. and M. Karolik Collection

3.11 *Julius Meyenberg's Farm*, c. 1864. Louis Hoppe.
Opaque and transparent watercolor and ink on paper, 8¼ × 11¾ inches.
The San Antonio Museum Association, San Antonio, Texas

3.12 Holsaert House, Hancock, New Hampshire, murals, c. 1825–30. Rufus Porter.
Water-base paint on plaster.
Collection of Charles M. and Dudley Cobb

3.13 *View of Henry Z. Van Reed's Farm*, 1872. Charles C. Hofmann.
Oil on canvas, 39 × 54½ inches.
Abby Aldrich Rockefeller Folk Art Center, Williamsburg, Virginia

ONE NEED ONLY LOOK at the large size and immaculate condition of a barn in Pennsylvania or gaze up at a rooster or cow weathervane in New England to understand how important animals were to life on the farm in Young America. A farm's livestock supplied food, fertilizer, labor, transportation, and companionship while alive, and was a source of food, clothing, fodder, grease, dyes, and other valuable products after death. Animals represented wealth to rural Americans, and were, therefore, prominently featured in depictions of farm life.

Some of the most famous paintings of animals in the history of American art are those by Edward Hicks, a Pennsylvania Quaker preacher, coachmaker, and artist best known for his many paintings of *The Peaceable Kingdom*. While these allegorical paintings are outside the scope of this book, two paintings with secular themes, *The Residence of David Twining, 1787* (fig. 3.16) and *An Indian summer view of the Farm & Stock of James C. Cornell of Northampton Bucks County Pennsylvania. That took the Premium in the Agricultural Society, october the 12, 1848* (fig. 3.17), are reproduced for the scenes they present of life on Bucks County, Pennsylvania, farms in the late eighteenth and early nineteenth centuries, as well as for their outstanding quality as folk art.

Painted late in Hicks's life, *The Residence of David Twining, 1787* is a nostalgic look back at the artist's happy boyhood home. Hicks was left motherless as an infant and was placed by his father with a Quaker couple, David and Elizabeth Twining, who raised the boy as if he were their own. In this picture, we see seven-year-old Edward at Elizabeth Twining's knee while David Twining, a successful farmer, is shown, hand on gate, in the broad-brimmed hat and drab coat of a plain Friend. Two of the Twinings' daughters are also included in the scene. Beulah, the youngest, stands in the

farmhouse doorway; her older sister Mary is pictured astride her horse as she waits for her husband to mount his. Images of motherhood abound in this painting: the cow has a calf, the mare a foal, and the ewe a lamb. While the composition is original, the pose of the sister's and brother-in-law's horses is derived from Thomas Sully's 1819 painting of *Washington at the Passage of the Delaware*, and was also used by Hicks in his versions of that event.

Hicks often drew from print sources for his compositions, and he also relied on his experience as a sign painter, frequently including the decorative borders and lettering used on signs in his pictures. These elements are most often seen in his religious paintings, but the strong colors and stylized animals of medieval heraldry that continued in tavern signs until the late eighteenth century are visible in such works as *The Cornell Farm*.

In this painting, the prize-winning stock of farmer Cornell is placed prominently in the foreground, clearly indicating its owner's pride of possession. Cornell himself has been included, and has been identified as the man in the gray, belted coat.

Whereas many folk artists are little-known or anonymous figures, Edward Hicks was a famous man in his day. When he died, on August 23, 1849, several thousand people attended his funeral, the largest ever held in Bucks County up to that time. They came, however, to mourn the preacher of the Society of Friends, the man they knew through his ministry and his published sermons. It was a century later that his paintings became recognized as masterpieces of American art, avidly sought by museums and collectors.

Mahantango Valley Farm (fig. 3.1) is an unusual mid-nineteenth-century painting, in that it decorates a linen window shade. It presents farm life in another part of Pennsylvania, where livestock is, however, as important as on the Cornell or Twining farm. The cows and bull in the foreground appear almost as large as the house and certainly dwarf the man and his dogs standing nearby. In this painting, as in others in this book, the fences play an important part in the overall design; here the intersection of the diagonal road with the horizontal fences creates an exciting linear pattern.

Animals represented prosperity on the rugged frontier as well as on manicured Pennsylvania farms. The Sylvester Rawding family, settlers in Custer County, Nebraska, displayed virtually all their valuable possessions when they had their portrait taken by photographer Solomon

3.15 *Mare and Foal*, c. 1850. Artist unknown. Painted wood weathervane, 31 inches wide. New York State Historical Association, Cooperstown

D. Butcher in 1886 (page 11). This included the pair of mules, lined up with the family, and the cow, brought up to the sod roof of the house so that she could be in the photograph too.

Among the American Indians, horses and other domesticated farm animals were especially valuable. The Navajo, for example, considered the horse a symbol of wealth. In the 1880s, when the Navajo began to employ pictographic designs as major motifs in their blankets, they sometimes used the horse symbol, rendered, as shown here, by lines built up with their traditionally stepped edges (fig. 3.19).

As mentioned before, animal forms were often used for weathervanes. A farm that specialized in cattle might want a cow vane, or a horse breeder might specify a grouping like the *Mare and Foal* (fig. 3.15) when he ordered his weathervane, but these were more than merely decorative items to top off a barn. Vanes had a practical purpose, especially in the life of the farmer. A farmer who was caught out in the field when the rain started often lost a full day's work; furthermore, once the plowed ground became wet, it pulled the shoes off a horse, causing the farmer to lose more time and incur an unnecessary expense. If, however, he knew that an east wind usually means rain—as it does in much of northeastern America—and he had some means of telling that the wind was blowing from the east, he could plan his day more efficiently. Similarly, sailors, travelers, and anyone else whose work depended on the weather needed to know the wind direction, and weathervanes served the purpose.

3.14 Mourning watchfob with portrait of a cow, c. 1875. Artist unknown. Watercolor on horn, hair, silver, 10½ inches long. Museum of American Folk Art, New York

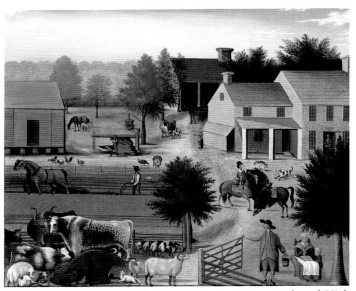

3.16 *The Residence of David Twining, 1787,* 1846–47. Edward Hicks.
Oil on canvas, 26½ × 31⁹⁄₁₆ inches.
Abby Aldrich Rockefeller Folk Art Center, Williamsburg, Virginia

3.17 *The Cornell Farm,* 1848. Edward Hicks.
Oil on canvas, 36¾ × 49 inches.
National Gallery of Art, Washington, D.C.
Gift of Edgar William and Bernice Chrysler Garbisch

3.18 *Farmyard Quilt*, c. 1875. Artist unknown.
Pieced and appliquéd cotton, 86 × 86 inches.
Private Collection

3.19 Navajo blanket, 1880–90. Artist unknown.
Yarn, 81 × 52 inches.
The Taylor Museum of the Colorado Springs Fine Arts Center
Gift of Alice Bemis Taylor

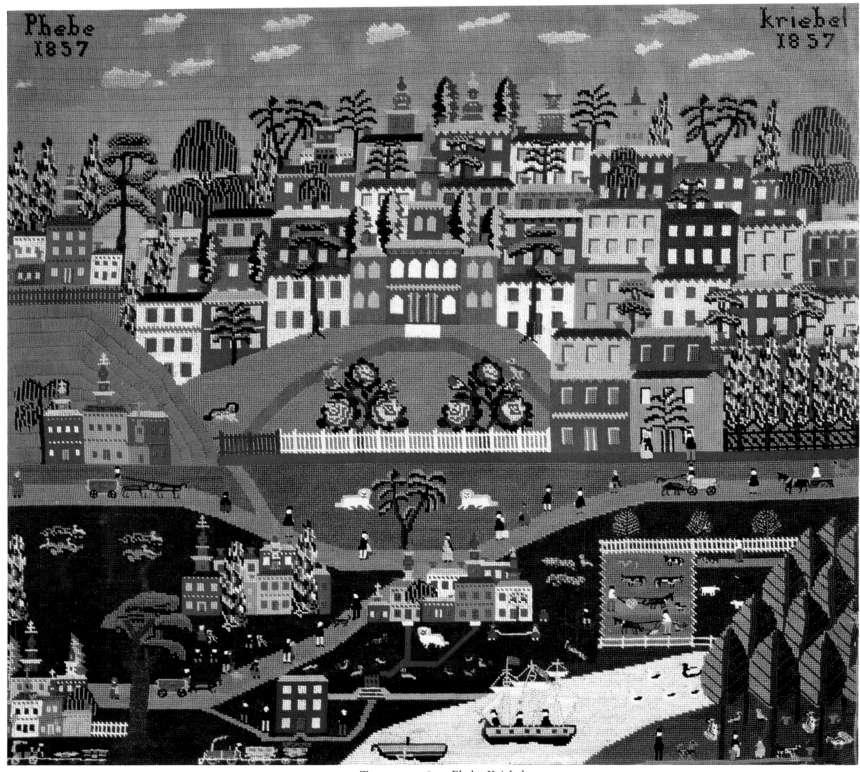

4.1 *Townscape*, 1857. Phebe Kriebel.
Wool embroidery on canvas, 27 × 25 inches.
Schwenkfelder Museum, Pennsburg, Pennsylvania

In Town

*I*N THE FIRST YEARS of the new American Republic, the number of people living in urban areas was small, encompassing only five percent of the total population. Boston, New York, Philadelphia, Baltimore, and Charleston were burgeoning cities in an otherwise mostly forested and rural country, and the relatively poor avenues of communication between these cities helped them retain their unique characters, which stemmed from the different backgrounds of their founders and the different economic bases of the communities.

Increased immigration and the onset of industrialization were two major reasons for the change in our society, from one with a predominantly rural flavor to one with an urban outlook. Folk artists, often immigrants themselves, recorded life in the expanding cities, providing valuable records of neighborhoods and architecture that were soon to be replaced by urban development, as well as ways of life that were quickly forgotten as the population became more sophisticated and "Americanized." We therefore find folk artists documenting young cities such as New York, Boston, Cleveland, and San Antonio when these still retained a provincial aspect.

Folk artists also flourished in the many villages, towns, and medium-size cities that boomed throughout the country with the onset of the industrial age and the opening of the West. Here, too, they depicted the changing aspect of much of American life, while preserving for the future vivid images of the pioneer settlements, farming villages, and seaport towns that would never look the same again.

At times, this "in town" art is slightly more detailed, slightly more complex than its country counterparts, just as life in the cities was inherently more complex than in rural areas. Yet it is still the art of the "folk," the people who painted life as they saw it around them, and who, even in their urban surroundings, remained uninfluenced by the academic art of the day.

LIFE IN AN EXPANDING East Coast town in the late nineteenth century is summarized in Jurgan Frederick Huge's painting of the Burroughs Building (fig. 4.4), an important commercial establishment at the corner of Main and John streets in Bridgeport, Connecticut. The growing pains felt by that city are clear in the rather awkward placement of the newly erected four-story building at a corner of the intersection between a tree-lined residential street and the primary business thoroughfare.

Huge was born in Hamburg, Germany, in 1809, and emigrated to America as a very young man. By 1830 he was married to Miss Mary Shelton, daughter of a substantial citizen of Bridgeport, and he was first listed in the Bridgeport directory for 1862 as "J. F. Huge, grocer." Because he signed and dated most of his paintings, however, we know that he was already active as a professional artist well before 1838, when one of his paintings of a steamboat was reproduced in a lithograph—sign of an established reputation. Later city directories describe Huge as "Grocer and artist" (1869–70), "landscape and marine artist, groceries, &c" (1871–72), and finally as "teacher in drawing and painting, landscape and marine artist," the grocery business, at last, given up.

Although he is most celebrated as a marine artist, Huge also painted a number of townscapes that show the homes and daily life of Bridgeport. In *Burroughs*, which was most likely a commissioned work, the city's life and look are fully sampled in the carefully composed street scene. No detail is lost in Huge's sharp watercolor-and-ink rendering of the elaborate facade of the building, the pavement, the shop windows and even the shoppers inside, the horse-drawn streetcar and carriages, the horsemen, and people of all ages.

Huge's landscapes, however, are not realistic in an academic, visual sense; they are composite scenes made up of more elements than would meet the eye at any given moment, with details shown more sharply than they could be seen from any viewpoint. Huge planned his compositions to present as many of the elements that interested him—and his clients—as possible. These concepts are especially clear in the painting here attributed to Huge, but previously known only by its descriptive title *Composite Harbor Scene with Volcano* (fig. 4.5). In this imaginary setting, Huge has combined a variety of subjects that he had painted previously, and that obviously still captured his interest. The landscape is similar to a painting he did of the Bay of Naples (which included smoking Mount Vesuvius), while the building identified as a "Woolen Factory," near the center of town, is undoubtedly the same building that was the subject of a painting he made about 1839 and that he mentioned in his 1869–70 directory listing when he described himself as "Grocer and artist, North Avenue near Woolen Mills." The steamboat and sailing ships are also similar to any number that Huge painted, as are the horses, carriages, people, and buildings. Unlike Huge's other paintings known to us, however, this composite scene—Bridgeport harbor overlooked by an active volcano—is one that existed only in the artist's mind.

The mood of the urban overtaking the rural, the new outpacing the old, that is created in Huge's paintings such as *Burroughs* can also be seen in landscapes of some of our major cities when they were young and growing. Everything is fresh and new in the Cleveland of 1839, as shown by Sebastian Heine's painting, *Cleveland Public Square* (fig. 4.6). The trees have been recently planted, the buildings sport bright paint, and even the horses seem to step especially briskly, as if they, too, were youthful.

Much the same feeling is apparent in *The Claremont Hotel, New York* (fig. 4.7). A popular

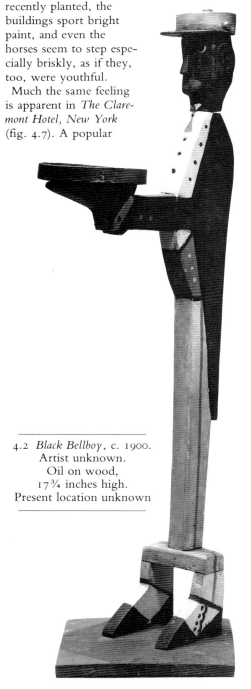

4.2 *Black Bellboy*, c. 1900. Artist unknown. Oil on wood, 17¾ inches high. Present location unknown

New York City resort hotel in the mid-nineteenth century, the Claremont was situated in the then almost rural neighborhood of Riverside Drive and 124th Street in Manhattan—where Grant's Tomb stands today.

Both *Cleveland Public Square* and *The Claremont* give the appearance of having derived some of their elements—the basic composition or the manner of rendering horse-drawn carriages, for example—from prints. By the late eighteenth century there were drawing books that gave instructions in composition, perspective, and coloring, and also provided illustrations to copy and details on how to enlarge or diminish a print when transforming it into a painting. Books of engravings, such as *American Scenery*, a collection of 119 engraved views from drawings by W. H. Bartlett that was published in London in 1840, were popular sources for amateur landscape artists. Also providing inspiration, if not subjects to copy exactly, were the many lithographs and new illustrated weeklies that appeared in the middle of the nineteenth century.

One man who is known to have adapted prints, including some by Bartlett, is Joseph H. Hidley, the painter of *Poestenkill, New York: Winter* (fig. 4.8). In the mid-nineteenth century, Hidley worked in this town near Troy, New York, as a house painter, carpenter, taxidermist, and handyman, and, in a shed behind his house, painted still lifes and landscapes, including four scenes of Poestenkill. These townscapes were all painted from imaginary elevated viewpoints that allowed Hidley accurately to record the village layout and show the residents involved in their daily tasks. In the winter scene, we see onehorse sleighs moving briskly down side streets; one horse-drawn wagon on runners is pulled up in front of the hotel, and a second is seen going down the road. Another horse, this one unharnessed, is tethered in front of what looks like a blacksmith shop in the foreground, while, nearby, two wagons that have not yet changed from wheels to runners are stuck in the snow. In a companion summer view, the same wagons are seen again, this time carrying loads of hay and wood. The men are in shirt sleeves instead of topcoats, and cows graze behind the houses.

Small changes in Hidley's series of town paintings help establish the chronology of these works and indicate the artist's desire to record the effect of daily activities on the topography of Poestenkill. Trees are chopped down or grow, woodpiles diminish, and a house and shop, at first separate structures, are later joined. The basic plan of the town, however, remains the same in all the pictures, and many of the buildings still exist today in identifiable form.

Most of Hidley's landscapes are painted on wood, and his winter scene of Poestenkill is on an unusual, octagonal-shaped board that com-

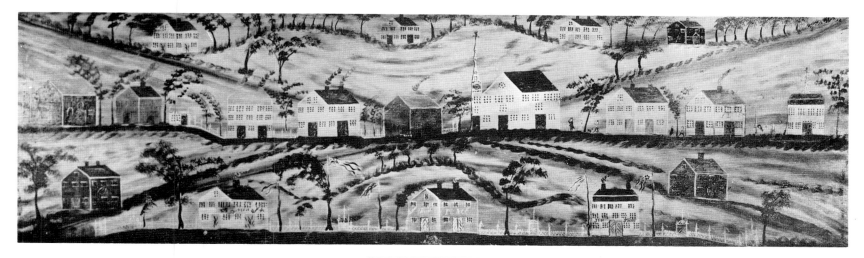

4.3 *Amen Street*, c. 1800. Attributed to Jared Jessup.
Oil on wood overmantel, 48 inches wide.
Destroyed

presses the realistic view into a tight, oval design. Other, rectangular views of the town are more expansive, and permit more of the village and the surrounding landscape to be seen. In all of the paintings, however, Hidley's strong sense of order and design prevails.

Jonathan Fisher, a New England minister, painter, engraver, linguist, poet, architect, craftsman, surveyor, naturalist, and teacher, was another multidisciplined folk artist who taught himself by copying printed pictures and studying the few art-instruction books that were available when he was a student at Harvard at the end of the eighteenth century. Fisher spent his entire professional career as minister of the Congregational Church in Blue Hill, Maine, a small coastal farming and fishing village surrounded by wilderness. One of his paintings, a large canvas which he inscribed "A morning View of Bluehill/Village. Sept. 1824/Jon. Fisher pinx." (fig. 4.10), presents a wonderful panoramic view of his parish.

A series of horizontals, dramatized by the stone fence in the foreground, and one strong vertical line organize this painting. The eye is drawn across, starting with the ship entering the harbor at left, and then up to the church at the end of the village's sole road. Houses and barns are clustered along the road, and wide fields are marked off by more fences and dotted with tree stumps. Two sunbonneted women in the foreground survey the panorama, which includes a man raising a stick to strike a snake. Fisher's paintings, like his engravings, show great interest in pattern and line, as well as simple realism.

Like many other folk artists, Fisher practiced his craft for his own pleasure, rarely selling a painting, and often using his engravings to illustrate his poems and Bible teachings for children. We know more about Fisher than we do about most artists—or, for that matter, almost anyone of the time—because, among his many talents, one was for note-keeping. For more than fifty years he maintained a journal in which he recorded daily events, and a diary devoted to his spiritual concerns. He wrote sketches of his life and kept his accounts to the penny; he even invented a form of shorthand,

called a "philosophical alphabet," which he used to make copies of letters, sermons, and memoranda.

While Joseph Hidley and Jonathan Fisher looked to books and prints for inspirations for some of their pictures, John Rasmussen is a painter known today for the near-copies he executed of a contemporary late-nineteenth-century folk artist's work. Rasmussen, a German immigrant house painter who settled in Reading, Pennsylvania, entered the Berks County Almshouse for vagrancy and intemperance during the last three years in the life of Charles Hofmann, an artist discussed in chapter three, who was also an inmate at the almshouse. Rasmussen produced a few landscapes, portraits, baptismal certificates, and still lifes, as well as at least six known views (including fig. 4.16) of the almshouse community, almost a separate village in itself, based primarily on Hofmann's 1878 painting.

Rasmussen painted his almshouse pictures, as Hofmann sometimes did, in oil on zinc, a support that makes the colors appear especially vibrant. The hard, smooth surface also made possible minute detail, another characteristic of the so-called "almshouse painters."

The almshouse paintings, like a number of works we have looked at, could actually serve as maps of the communities depicted. The same is true of two paintings from the western frontier. *Sun River, Montana* (fig. 4.13), painted by an unknown late-nineteenth-century artist, is representative of any number of similar settlements of the period. The livery, saloon, post office, brewery, stage stop, and blacksmith shop probably did not look very different in the next town at which the wagon train, shown passing down the main street, would stop.

East Side Main Plaza, San Antonio, Texas (fig. 4.15) by William G. M. Samuel has the same "maplike" quality as the other paintings, while

also presenting another important aspect of the townscapes. Frequently, these paintings are all that historians have to rely on when recreating the layout and envisioning the buildings of towns, like San Antonio, that have undergone immense change over the years. In this picture, for example, we learn that in 1849 San Antonio had a building with a clock tower on the east side of the Main Plaza. While documents of the time tell us that this structure, the Casa Reales, was the seat of the local government and home of the local constabulary, Samuel's painting shows us exactly what it looked like and what surrounded it.

Samuel was another folk artist who apparently painted only for his own pleasure, and his subjects, whether portraits or landscapes, always had local historical significance. He was an extremely colorful man who moved from Missouri to Texas in the 1830s, shortly after the fall of the Alamo. He was an Indian fighter, a participant in the war with Mexico, and a captain of artillery in the Confederate army. He also served as a city marshal, a notary public, and a deputy sheriff. Samuel's obituary refers to him as "one of the best known characters of this city . . . a dead shot and by common consent the bravest man of his day in this section."

Layouts of very special kinds of towns, Shaker communities, are shown here in two examples. *Plan of Watervliet, N.Y.* (fig. 4.22), a large map of the first Shaker settlement, was drawn in 1839, probably by David Austin Buckingham, a member of the community at that time. Watervliet was unique among Shaker villages in its layout, which grouped the buildings around a central common, clearly seen in the drawing. The large structure at the head of the common is the dwelling house. To the right and below this is the gambrel-roofed first meeting house, erected in 1791 for the Watervliet community by Brother Moses Johnson of Enfield, New Hampshire. The ministry house, between the dwelling and meeting houses, was built in 1825 and still stands, as does the 1830 brick trustee's office at the lower right, and the brick shop, the center building on the left, built in 1822. These buildings are now part of the facili-

ties of the Albany County Ann Lee Home.

The Alfred, Maine, Shaker community is shown in the painting (fig. 4.21) by Joshua Bussell, and here, too, the artist has made it simple to find one's way around this more typical Shaker town. All the buildings, from the stable to the ox barn, have been numbered, with an easy-reference key at the top left of the picture. The strong color and bold architecture in *View of Alfred, Maine, Shaker Village* help make this an outstanding folk painting, while no less useful as a map than the skeletal town plan of Watervliet.

Since the Millennial Laws governing Shaker life in the early years of the communities prohibited the display of images, we have few firsthand visual depictions of what life was like in the communities of those days, although written accounts abound. Any printed illustrations were made by outsiders, mostly after the introduction of photography (see chapter two, fig. 2.9). Exactly when or why the Shakers began to accept the pictorial image is not known for certain, but the Shakers responded as enthusiastically as the rest of the world to the new technology of photography, introduced to America in 1839. In the late nineteenth century, in shops open to the public, the Shakers sold, singly and in sets, the paired photographs known as stereographs, which, when properly viewed, give an illusion of depth. More than 350 different stereographs, or stereoscopic views, of the Shakers exist, and it is to these and other photographs that we look for visual examples of what life was like inside the communities.

Gymnastic Exercises (fig. 4.23) is a stereoscopic view that presents a little-known fact of Shaker life: although the Shakers were celibate, there were children in the settlements. They either arrived with parents who had chosen to join the society, or were orphans adopted by the community. When they reached the age of twenty-one, the children were allowed to choose whether they wished to join the religion. Shaker villages therefore maintained schools, and the activity depicted in this stereoscopic view was a part of the school-day routine.

Life in another kind of community is recalled in *Darkytown* (fig. 4.19), an anonymous late-nineteenth-century painting on glass, another example of how a composite scene may be created by a folk artist. One senses that each figure and group existed as a memory-image in the artist's mind and that he set them down in paint in the same arrested poses in which he saw them, exaggerated as caricatures, in his mind's eye. The figures bear no more visual relationship to their background space than if they had been cutout silhouettes pasted on it. Yet the arrangement works wonderfully; the lively figures occupy their sparse background in a way that both isolates them as vignettes and joins them in a series of neatly organized pyramidal groups. This is an exciting example of the feeling for design that distinguishes the best folk art.

Other forms of folk art besides painting and photography provide information about how communities were laid out and what they looked like. Phebe Kriebel's needlework *Townscape* (fig. 4.1) shows Towamencin Township, Pennsylvania, in 1857 when the young Pennsylvania German woman lived there with her husband. In this scene, however, the buildings, hills, and river have all been flattened to suit the medium and slightly rearranged to accommodate Mrs. Kriebel's neatly balanced design.

A section of a New England town—church, houses, and domestic animals—is depicted with simple clarity in a late-nineteenth-century hooked rug (fig. 4.17). On the surface, hooked rugs, popular from the mid-nineteenth century to the present day, look much like the shirred rug seen in chapter one. Most were made with jute burlap backings, an ideal fabric for hooking. Loops of long fabric strips were drawn with a hook from back to front through an opening. The strips were looped on the surface, but carried along flat on the underside, to be pulled through again to form the next loop. Hooking, therefore, resulted in continuous rows of flat stitches on the reverse, with no open spaces such as would be found in a yarn-sewn rug. But, as with yarn-sewn rugs, the surface could remain looped, or be clipped to produce a soft pile.

Another textile townscape is a delightful abstraction of a town plan. The woman who created the pieced quilt (fig. 4.20) started with the common "schoolhouse" pattern, then arranged the houses to build an entire town, said to be York, Pennsylvania. A moon and stars look down on almost sixty buildings, including two churches with graveyards, and structures labeled "Barn" and "Union Depot." An especially charming touch is the railroad, complete with telephone poles, that runs through the center of town.

No one captured the activities of life in York, or any other town for that matter, as well as Lewis Miller. In the scene included here (fig. 4.11) from Miller's sketchbook—his chronicles of his life and the activities of the town—Miller tells us, in words and pictures, about the day, October 24, 1822, he went from York to Lancaster, Pennsylvania, to see a man called Loechlor hung. We also learn about a nineteenth-century scandal: Loechlor, it seems, was hung for shooting a neighbor's wife. "Hack made to free with Loechlor's wife, and to revenge himself he shoot Hack's wife out of mistake. he was in the kitchen and shot through the door with his Pistol. Hack and his wife where both in bed. the hearing him out side rattle, and made a noise. Loechlor killing his wife the same night."

As we can see from the drawing, a hanging was an exciting event in the life of the townsfolk, who are arriving from all directions in all kinds of vehicles. Miller confirms this with his final statement about the day: "Oh! what a crowd of people to see a poor sinner of a creature hung at the gallows!"

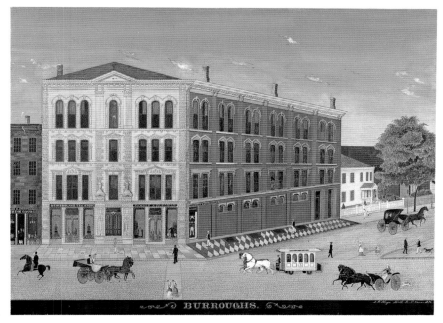

4.4 *Burroughs*, 1876. Jurgan Frederick Huge.
Watercolor, ink, and gilt on paper, 29¼ × 39½ inches.
Bridgeport Public Library, Historical Collections
Bridgeport, Connecticut

4.5 *Composite Harbor Scene with Volcano*, c. 1875. Attributed to Jurgan Frederick Huge.
Oil on canvas, 25½ × 40⅛ inches.
The Fine Arts Museums of San Francisco
Gift of Edgar William and Bernice Chrysler Garbisch

4.6 *Cleveland Public Square*, 1839. Sebastian Heine.
Oil on canvas, 17½ × 25 inches.
Western Reserve Historical Society, Cleveland, Ohio

4.7 *The Claremont Hotel, New York*, c. 1850. Artist unknown.
Oil on canvas, 26¼ × 35 inches.
Metropolitan Museum of Art, The Edward W. C. Arnold Collection
of New York Prints, Maps, and Pictures
Bequest of Edward W. C. Arnold

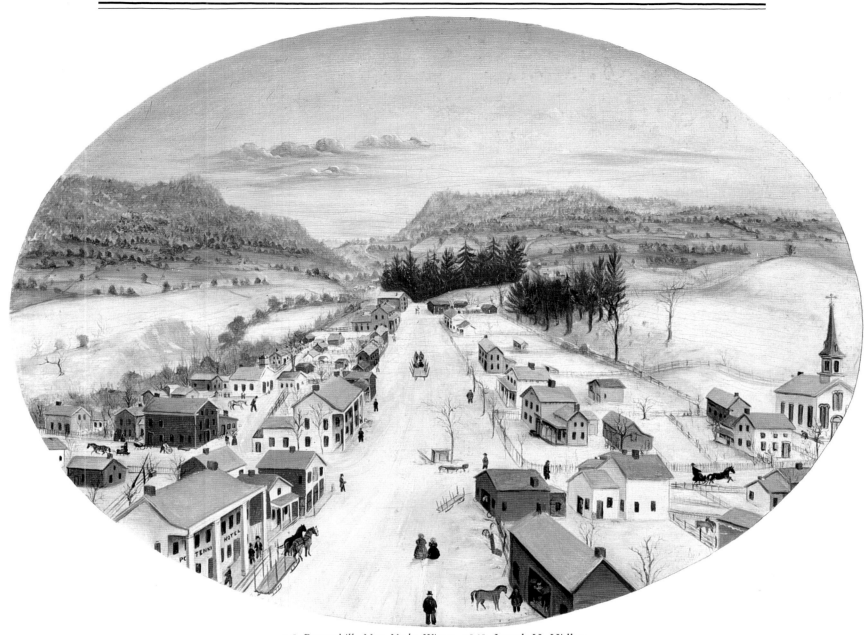

4.8 *Poestenkill, New York: Winter*, 1868. Joseph H. Hidley.
Oil on wood, 18¾ × 25⅜ inches.
Abby Aldrich Rockefeller Folk Art Center, Williamsburg, Virginia

4.9 *Seaport Town*, c. 1850. Artist unknown.
Oil on canvas, 28 × 36 inches.
Collection of Isobel and Harvey Kahn

4.10 *A Morning View of Bluehill Village*, 1824. Jonathan Fisher.
Oil on canvas, 25½ × 52 inches.
William A. Farnsworth Library and Art Museum, Rockland, Maine

4.11 *Hanging in Lancaster, 1822*, 1822. Lewis Miller.
Watercolor and ink on paper, 9⅞ × 7⁷⁄₁₆ inches.
The Historical Society of York County, York, Pennsylvania

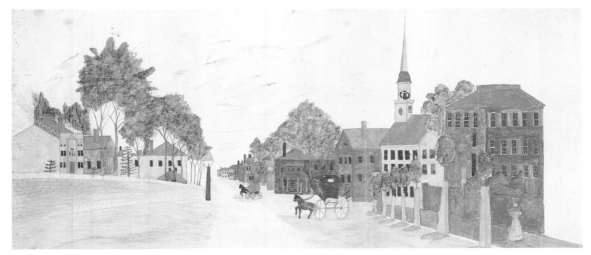

4.12 *Panorama of Massachusetts and Imaginary Scenes* (detail), c. 1850. Artist unknown.
Pencil, pen, and watercolor on paper, 10 inches × 42 feet 7½ inches.
Museum of Fine Arts, Boston, M. and M. Karolik Collection

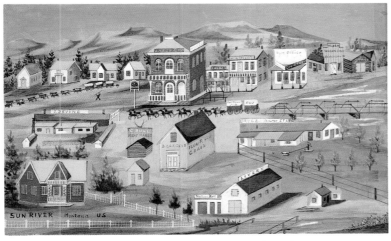

4.13 *Sun River, Montana*, c. 1885. Artist unknown.
Watercolor and ink on cardboard, 6 × 9½ inches.
Collection of Herbert W. Hemphill, Jr.

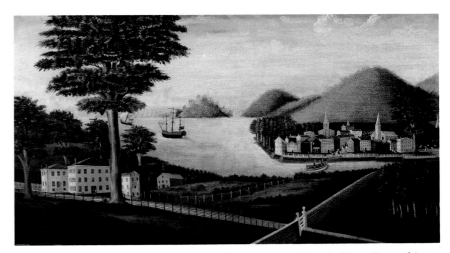

4.14 Overmantel from the Gardiner Gilman House, Exeter, New Hampshire,
c. 1800. Artist unknown.
Oil on wood, 28 × 47¾ inches.
Amon Carter Museum, Fort Worth, Texas

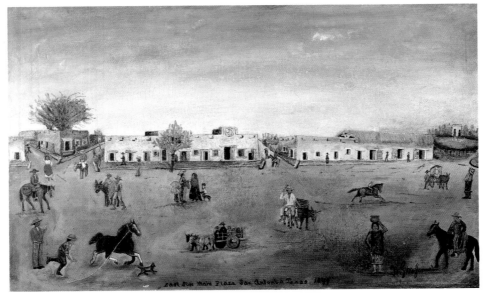

4.15 *East Side Main Plaza, San Antonio, Texas*, 1849. William G. M. Samuel.
Oil on canvas, mounted on wood, 22 × 36 inches.
San Antonio Museum Association, Texas, on loan from Bexar County

4.16 *View of the Berks County Almshouse*, 1881. John Rasmussen.
Oil on zinc, 39 × 46 inches.
New York State Historical Association, Cooperstown

4.17 Hooked rug, 1875–1900. Artist unknown.
Hooked rag on burlap, 27 × 50 inches.
Private Collection

4.18 Bench, c. 1840. Artist unknown.
Painted wood, 76 inches long.
Private Collection

4.19 *Darkytown*, c. 1880. Artist unknown.
Oil on glass, 23 × 28½ inches.
New York State Historical Association, Cooperstown

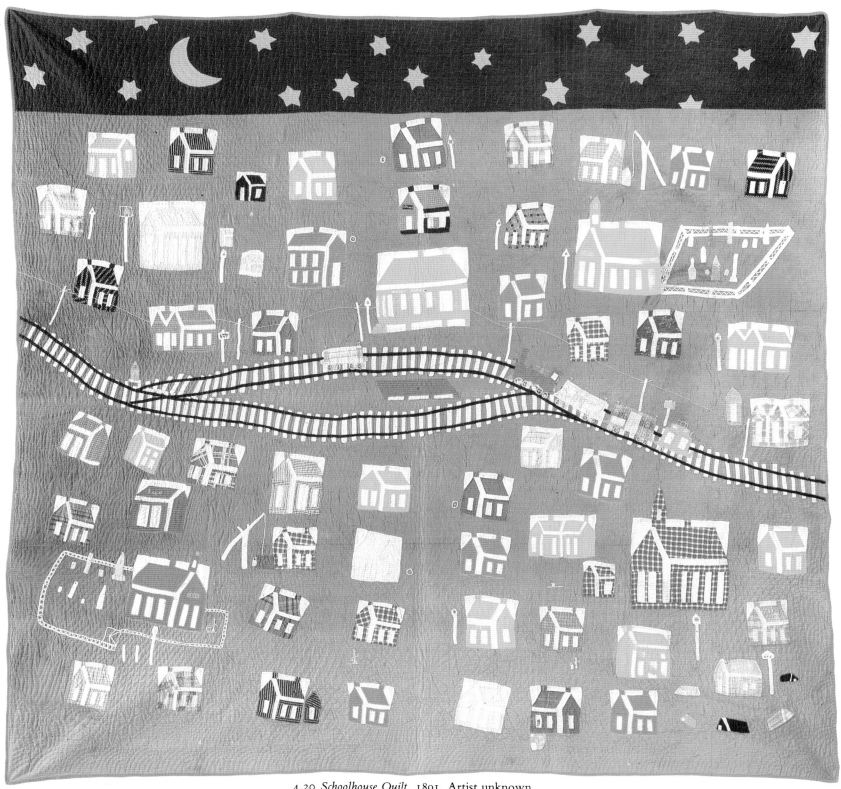

4.20 *Schoolhouse Quilt*, 1891. Artist unknown.
Pieced cotton, 78 × 80 inches.
Collection of Linda Pracilio

4.21 *View of Alfred, Maine, Shaker Village*, c. 1880. Joshua Bussell.
Watercolor, ink, and pencil on paper, 17¾ × 28 inches.
Private Collection

4.22 *Plan of Watervliet, N.Y.* (detail), 1839. Attributed to David Austin Buckingham.
Ink on paper, 48 × 27 inches.
Albany Institute of History and Art, Albany, New York

4.23 *Gymnastic Exercises*, c. 1870. W. G. C. Kimball.
Stereographic print, 3½ × 7 inches.
Shaker Village, Inc., Canterbury, New Hampshire

Few events of life in town in Young America were as horrifying—or as exciting—as a fire. Organized fire protection had early roots in this country: long before the revolutionary war, towns of any size had both fire wagons and volunteer firefighters. Many communities had laws requiring all households to have leather buckets in good condition and ready for use in case of fire. They were to be kept in the entrance hallways, and when an alarm was sounded, grabbed by the owner or a passing volunteer and used to combat the blaze. As seen in the 1787 engraving by Abraham Godwin (fig. 4.29), part of a certificate appointing one Peter Thompson a fireman of the City of New York, a bucket brigade started at the water supply and ended at the scene of the fire. The buckets had their owners' names and addresses on them for easy return, and were sometimes illustrated as well, often by a folk artist who began his career as a house, sign, or decorative painter.

Throughout the nineteenth century and into the twentieth, folk artists were called upon to embellish other items that were of importance to proud volunteer fire companies. Holiday celebrations and contests between brigades of firefighters gave the firefighters opportunities to display such ceremonial paraphernalia as painted parade hats (fig. 4.24) and elaborately decorated fire equipment. The latter could be quite expensive, and plated mountings of nickel, silver, or gold often adorned lavishly painted and carved wagons. Sometimes the painted panels were a bit risqué, to the delight of the firemen and onlookers.

An early, hand-pulled *Fire Engine Superior* (fig. 4.31) decorates a common Pennsylvania kitchen utensil—a cakeboard. Used for making traditional marzipan cakes, these boards were carved from hardwoods that could withstand the heat of an oven. To make a cake with an intriguing design like this, the dough is rolled very thin and then pressed onto the board; when it comes out of the oven, the thin, hard cake is embellished with the picture in low relief.

The importance and high status of the fireman is emphasized by the mid-nineteenth-century portrait of a man who chose to have himself represented in his ceremonial uniform (fig. 4.26). Through the window in the background, his company is shown hard at work. This painting is attributed to Sturtevant J. Hamblin, an artist whose work has often been grouped with that of his more famous brother-in-law, William Matthew Prior, and a number of other stylistically similar painters in the so-called "Prior-Hamblin" school. Hamblin came from a family of artisans and decorative painters in the Portland, Maine, area, although he was the only member of the family to advertise himself as a portrait painter, as he did in 1841 when he was living in Boston with Prior. Like Prior, Hamblin adjusted the amount of time he spent on a portrait according to the amount of money his

4.24 Fireman's parade hat, c. 1840.
Artist unknown.
Oil on leather, 13½ inches high.
Collection of Howard and Catherine Feldman

client could afford to pay. He could not reach the near-academic accomplishments of Prior, however, and so, instead of changing the amount of modeling on the face of the subject to suit his time schedule, Hamblin tended to adjust the size and add or delete details in a composition. This portrait of an unknown fireman, full of decorative details, must have been one of his more expensive accomplishments. (One of Prior's quick portraits retains a printed label, pasted on the back, that reads: "Done in about an hour's sitting. Price $2.92 including Frame, Glass, &c.")

The folk artists who painted firemen and fires captured all the drama of their subject: the fascination of the onlookers, the destruction of the flames, and sometimes the historical significance of the event. In the painting titled *Still Alarm* (fig. 4.30) the three strong horses and the firemen and engine they pull are portrayed by an anonymous artist as much larger than the people on the street, almost as tall, in fact, as the buildings they race by on their way to fight a raging fire. But this larger-than-life depiction, however distorted in scale, is probably an accurate representation of the way the exciting scene was perceived by the inhabitants of the town.

The Destruction of a Bath, Maine, Church (fig. 4.28) by John Hilling recreates the burning of Bath's Roman Catholic Old South Church in the 1850s by the Know-Nothings, a secret society. They were an extremely nativistic group who combated all "foreign" influences, particularly those of the Roman Catholic immigrants. A companion picture is an almost identical view of the church under attack by the gang directly before the fire. Five sets of these paintings are known, and, although there are slight variations in design, it seems probable that all were done

by the same hand. It would seem that this artist, like the portrait painters discussed in chapter one, established a successful design concept, then simply reused it. Hilling most likely found a ready market for these sets of paintings among the parishioners of the newly destroyed church. *The Weekly Mirror,* a Bath newspaper, reported on Friday, May 18, 1855, that "Mr. John Hilling of this city, has painted two representations of the old South, one as it was previous to the fire, and the other as it was at the time of the fire. They are perfect representations of the house and its destruction."

The historic destruction of another house of worship is recalled in *Burning of the Temple* (fig. 4.27), a scene from C. C. A. Christensen's "Mormon Panorama." In 1844 Joseph Smith was indicted for treason, imprisoned, and murdered by a disorderly mob at Nauvoo, Illinois, the town founded to be the Mormons' haven. In 1846, the majority of the Mormons, now led by Brigham Young, left Nauvoo and its temple. On the night of October 9, 1848, a Mormon-hating arsonist set fire to the building. At three o'clock in the morning of October 10, flames suddenly burst from the tall spire and those Mormons who had remained in Nauvoo saw their temple burn to the ground.

Christensen based this and the other scenes in his large-scale panoramic history on verbal accounts from primary witnesses to the events. New information was sometimes obtained after the finished works were shown, and Christensen would repaint portions of his work to include it. His paintings, therefore, not only capture the dignity, the excitement, or the horror of an event, but are also historically accurate.

4.25 *Fireman*, 1860–90.
Artist unknown.
Painted chalkware,
14⅜ inches high.
Museum of American Folk Art,
New York

4.26 *Fireman*, 1825–50. Attributed to Sturtevant J. Hamblin.
Oil on canvas, 36 × 29 inches.
New York State Historical Association, Cooperstown

4.27 *Burning of the Temple*, 1865–90. C. C. A. Christensen.
Tempera on linen, 78 × 114 inches.
Brigham Young University Art Museum, Provo, Utah

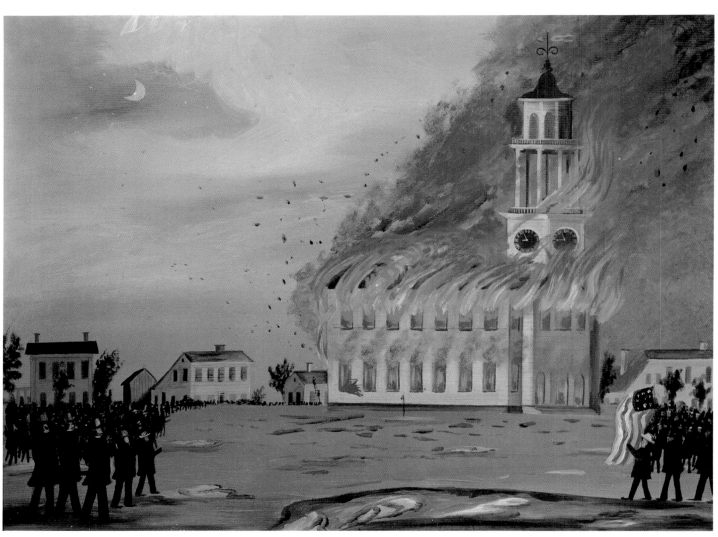

4.28 *The Destruction of a Bath, Maine, Church*, c. 1854. John Hilling.
Oil on canvas, 17½ × 23½ inches.
Collection of Mr. and Mrs. Robert P. Marcus

4.29 *Fighting a Fire in New York City*, 1787. Abraham Godwin.
Engraving, 9¾ × 11½ inches.
The Museum of the City of New York, New York

4.30 *Still Alarm*, c. 1890. Artist unknown.
Oil on canvas, 30 × 40 inches.
Collection of Mr. and Mrs. Robert P. Marcus

4.31 *Fire Engine Superior*, c. 1800. Artist unknown.
Carved wood cakeboard, 14⅜ inches wide
The New-York Historical Society, New York

5.1 *The Yellow Coach*, c. 1815–35. Artist unknown.
Oil on canvas, 33¾ × 36⅛ inches.
Abby Aldrich Rockefeller Folk Art Center, Williamsburg, Virginia

On the Road

*D*URING THE PERIOD we call Young America, the common means of transportation evolved from the stagecoach to the Tin Lizzie. Where once there were a few roads, and a horse-drawn vehicle was considered to be making good time if it traveled at three or four miles an hour, by 1909 Henry Ford had won a transcontinental race from New York to Seattle by crossing the country in an automobile in just twenty-two days and fifty-five minutes.

Conestoga wagons, canal boats, steamboats, balloons and other "flying machines," and, especially, trains also played a part not only in moving the population, but also in drastically changing the *Situation of America*—as one artist titled his 1848 painting (fig. 5.13), discussed later in this chapter. From a rural nation of isolated communities along the eastern seaboard, Young America became a country that stretched from the Atlantic to the Pacific, with cities, towns, and villages connected by thousands of miles of railroad tracks and a fast-growing system of roadways and waterways.

The folk artists were a part of this mobile society and the expansion westward. Many were itinerants, used to traveling from town to town in search of work and knowledgeable about life on the road—the inns and taverns, the vehicles, and their fellow travelers. Others were pioneers, participants in the migration westward. And a large number were immigrants, who had already made a long journey finally to reach these shores, and then, very often, prepared to start out again.

THE STAGECOACH was the most popular form of overland transport in the early days of the new republic. The typical journey was bumpy, crowded, and long: under adverse weather conditions it took one coach in 1796 five days to travel from Philadelphia to Baltimore. "My nerves have not yet recovered from the shock of the *wagon*," wrote one traveler after a trip from Baltimore to New York in 1794. Richard Brunton's early-nineteenth-century engraving, *Commercial Mail Stage, Thirty-nine Hours from Boston to New York* (fig. 5.4), created as an advertisement for a commercial mail stage, shows us what these vehicles looked like. Pulled by a team of four horses, the coach was usually composed of backless benches that seated nine or twelve passengers, with three occupants to a bench. The back and two sides had leather curtains that reached down to the elbow of the seated person. Passengers entered the coach from the front, and so had to climb over the benches to get to a seat. The safety of these high, long, and narrow vehicles depended on the driver, who, according to tradition, was often reckless and/or inebriated.

This artist is the same Richard Brunton who is thought to have painted the portrait of Mrs. Humphreys and her daughter (chapter one, fig. 1.22) when he was in Newgate Prison in Connecticut in 1800. Evidently, Brunton finally learned to put his engraving skills—once used for counterfeiting—to good and honest use.

The Yellow Coach (fig. 5.1), a conveyance similar to the one drawn by Brunton, stands out against the pale sky in a sprightly painting by an unidentified artist. As the artist obviously had difficulty with the perspective of the house, the relative skill shown in his execution of the coach and horses suggests that he may have copied this element from a print.

As these works testify, coaches were often decorated, sometimes elaborately. An advertisement in *Wood's Newark Gazette* at the end of the eighteenth century informed the residents of that town of one coach decorator's talents:

The Subscriber acquaints the public that he carries on the Coach Painting, Jappaning, High Varnishing etc, near Mr. Gifford's Tavern. Anyone who will favor him with their custom, in any of the above branches, may rely on having their work executed with the greatest dispatch.

It may be needless to acquaint the public that the art of Jappaning and High Polishing, is a secret known in America not more than sixteen months, and that it is practiced only in Philadelphia, New York, and Newark; it is one of the finest improvements made in Coach Painting for a century and a half. Matthias B. Higgins/Newark May 18, 1791.

Many of these coach decorators were also the folk artists who, like Edward Hicks, created masterful paintings when business was slow. And many of the artist/decorators also painted signs, including those that advertised the inns and taverns that served the stagecoach travelers.

The inn and tavern signs painted by folk artists were part of the scene "on the road" for more than two centuries. As early as 1645, the town of Salem, Massachusetts, required that taverns display signs for the convenience of travelers. Rhode Island had an equally early court order that commanded all tavern keepers to "cause to be sett out a convenient Sign at ye most conspicuous place of ye said house, thereby to give notice to strangers it is a house of public entertainment. . . ." These signs often sported eye-catching designs, intended to entice customers inside. Margaret Van Horn Dwight, a woman traveling to Ohio in 1810, remarked in her journal on the assortment of inn signs:

It is amusing to see the variety of paintings on the inn-keepers signs. I saw one in N.J. with Thos. Jeff'ns. head & shoulders & his name above it. Today I saw Gen. G. Washington, his name underneath. Gen. Putnam riding down the steps at Horseneck. One sign was merely 3 little kegs hanging down one after the other. They have the sun rising, setting, & at Meridian, here a full moon, a new moon, the moon & 7 stars around her, the Lion & Unicorn 'fighting &c,' & everything else that a dutchman has ever seen or heard of.

As seen in both Lewis Miller's drawing of *The York Hotels* (fig. 5.6) and Alexander Boudrou's painting of *A. Dickson Entering Bristol in 1819* (fig. 5.3), signs usually carried pictures or lettering on both sides and were hung from a tall post at right angles to the road, so as to be visible to travelers approaching from either direction. The sign for the Bristol Township Inn in Boudrou's painting, composed only of words, is an especially simple and unusual example. Literacy was not as common then as it is now, so most signs bore pictures that visually explained the name of the establishment or the services to be found within.

This painting is also interesting because of the dual perspective used by Boudrou. The scene is painted from two simultaneous vantage points:

horse and rider at eye level, rooftops below eye level. But although the view is unrealistic, the establishment depicted actually existed. In 1820, a Bristol Township Inn is known to have been situated on Second Street Pike in McCartersville, at that time a community in Philadelphia County. Since 1854, when the city expanded to the county limits, McCartersville has been a part of the northeastern section of Philadelphia.

A more typical inn sign, *Strangers, Resort* (fig. 5.5), presents a view of the jovial goings-on inside the hostelry. This dazzling 1815 advertisement for J. Carter's Inn in Clinton, Connecticut, portrays a soldier and a gentleman-traveler exchanging toasts across a tavern table set on a gaily patterned floor. The reverse side shows a man and his wife being driven in a carriage to the door of the inn.

Itinerant portrait painters occasionally painted signs and decorated the walls of roadside establishments, sometimes trading their artistic talents for room and board, or for other services. Vermont artist James Guild recorded one such transaction in his journal, kept from 1818 to 1824:

I put up at a tavern and told a Young Lady if she would wash my shirt, I would draw her likeness. The poor Girl sat niped up so prim and look so smileing it makes me smile when I think of while I was daubing on paint on a piece of paper, it would not be caled painting, for it looked more like a strangled cat than it did like her. However I told her it looked like her and she believed it, but I cut her profile and she had a profile if not a likeness.

Portrait painters traveled mainly because their own communities were too small to provide enough commissions to keep them in business. Often, the artists journeyed to towns where they had relatives or friends, or introductions from satisfied clients to prospective clients, and they often lodged with one of these families while they were in the neighborhood (see John Brewster, Jr.'s, advertisement in chapter one, fig. 1.19). Frequently, however, they hired a room or put up at the local tavern in a town where they had previously been successful or where they had heard the prospects might be good, and advertised their presence in the local newspaper or with handbills that they posted. The uncertainty of this life is illustrated in a letter that itinerant artist Deborah Goldsmith wrote her future husband, George Throop, while she was in Toddsville, New York, in the summer of 1832:

I do not know how long I shall stay in this place. I have business enough for the present, and for some reason or other, Mr. and Mrs. Lloyd seem to be over-anxious for me to remain here through the summer. A lady was here a few days since from Hartford. She thought I would do better there than here, and I may possibly go there, or to Cooperstown village, but I do not know yet, for I think I shall stay here as long as I can get portrait painting.

Itinerant artists not only painted signs and

5.2 *Man with Grapes*, c. 1850.
Artist unknown.
Painted wood, 16 inches high.
Guennol Collection

traded "likenesses" for their lodging, but they also sometimes decorated the rooms of the inns and taverns with stenciled and scenic designs. The quality of these rest stops varied greatly, and their stays were not always comfortable. Frequently, hard beds with husk-filled mattresses and scanty blankets had to be shared with strangers, and the food was poor. The exception was the kind of establishment shown in Lewis Miller's drawings of *The York Hotels* (fig. 5.6). "No better and good cooks can be found nowhere to prepare victuals for the table, as these taverns," Miller noted, and he followed this high praise with the names of the ladies of York who cooked in and kept the taverns. He also recorded the foods they prepared, and showed himself enjoying the delicacies as a young boy: "Mrs. Lottman frying sweetpotatos and give to Lewis Miller, some of them the first I ever tasted the where [they were] good eating. It was in her tavern, South George Street, 1799."

Besides "good eating," taverns, of course, dispensed "good drinking," a service indicated by the *Man with Grapes* (fig. 5.2). This stylish gent, only sixteen inches high, is thought to have stood on top of a bar in Maine in the middle of the nineteenth century, where he advertised that the "fruit of the vine" was available.

As well as places to sleep, eat, and drink, inns and taverns served as sources of information, places where news of the outside world could be obtained and gossip exchanged. The communities of America were served by a veritable army of itinerants who brought everything from shoes to furniture to the doors of rural housewives and carried the news of the day with them from town to town. Smart tavern-keepers realized early on that travelers took a vicarious pleasure in dining or rooming at an establishment that had previously been visited by some well-known personage or had been the scene of some outstanding event. Henry Wansey, a traveler, noted:

May 14, 1794. We now come to Weston [Massachusetts], which is five miles from Waltham, and had brought in . . . our breakfasts. . . . Captain Flagg charged us two shillings a head for our dejeunè, which we thought dear. We paid the dearer, I suppose, because General Washington had been entertained, and slept at his house.

5.3 *A. Dickson Entering Bristol in 1819,* 1851. Alexander Boudrou.
Oil on canvas, 21⅛ × 26³⁄₁₆ inches.
Abby Aldrich Rockefeller Folk Art Center, Williamsburg, Virginia

5.4 *Commercial Mail Stage, Thirty-nine Hours from Boston to New York*, 1815. Richard Brunton. Engraving, 6 × 11⅞ inches. American Antiquarian Society, Worcester, Massachusetts

5.5 *Strangers, Resort*, 1815. Artist unknown. Painted wood, 42 inches long. Connecticut Historical Society, Hartford

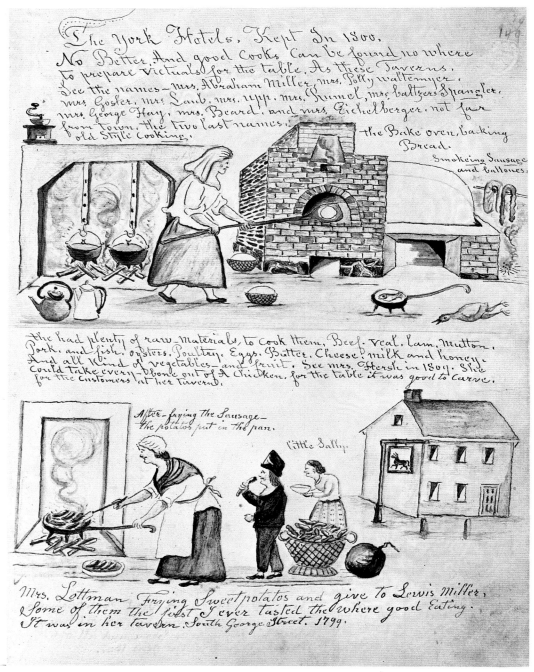

5.6 *The York Hotels, 1800,* c. 1820. Lewis Miller. Watercolor and ink on paper, 9⅞ × 7⁷⁄₁₆ inches. Historical Society of York County, York, Pennsylvania

CHEAP FARMLAND, gold and furs for the taking, religious freedom, escape from the law, the chance for a new start—the reasons for traveling west were many and varied. From the revolutionary war, when "west" meant western New York State, to 1890, when the Superintendent of the Census reported that the good free land in the West was all staked out, countless thousands of people journeyed westward by land and water in search of a better way of life.

The Conestoga wagon, developed in the early eighteenth century by the Pennsylvania Germans, became known as the "prairie schooner" of the frontier. Specially adapted to haul great weights across uneven terrain, these vehicles were sorely tested in a country with few passable roads. The man driving the wagon sat above the left wheel horse and, as legend has it, instigated the "keep to the right" tradition on the roads of this country by pulling this horse to the right. The huge wagons left deep ruts which smaller vehicles followed, thus endowing us with the habit of driving on the right side of the road.

The photograph of *A Typical Boomer Family* (fig. 5.9), camped out during the 1889 land rush, or "boom," in Oklahoma, includes a wagon that successfully completed the journey west. Even the horses and chairs face front in this stiffly posed portrayal of a family that hauled all its worldy goods across the country in a covered wagon.

A number of the paintings in C. C. A. Christensen's "Mormon Panorama" depict the religious odyssey of the Mormons, as the followers of Joseph Smith traveled the country in covered wagons in search of a community that would accept them. The Mormons first tried to build their City of Zion in Jackson County, Missouri, but their neighbors, who opposed Mormon political and economic competition as well as the Mormon religion, destroyed their homes and barns and drove them from the county in 1833. Smith and his group tried settling in a number of other towns in Missouri, all with the same result. Finally, when the governor of Missouri decreed that the Mormons should be "exterminated or driven from the state," Smith ordered the exodus represented in *Leaving Missouri* (fig. 5.8). With all their possessions in wagons, the "Saints," as the Mormons were called, followed the Mississippi northward through the winter of 1838–39 until they arrived at the sparsely settled town of Commerce, Illinois, thenceforth Nauvoo, and began to organize a new city. According to one Mormon interpretation, the menacing tree on the left of this painting and the bleak background symbolize the hostile environment the Mormons were leaving behind in Missouri.

A typical pioneer covered wagon is also seen on a Cheyenne painting on muslin (fig. 5.11). This fascinating piece made by an unidentified artist in Oklahoma in the last quarter of the nineteenth century combines, in delightful pictorial shorthand, elements of Native American life with others that must have been derived from the pioneers. The wagon and a church, for example, symbols of the encroaching white man, occupy one corner of the field, while tepees in the opposite corner stand in deliberate contrast. The Cheyenne are shown riding in wagons that resemble those used by the settlers, as well as on horseback. All are dressed in traditional garb, but the women hold umbrellas, as if protecting themselves from the sun as fashion-conscious pioneer women might.

Overland travel by wagon was long, uncomfortable, and dangerous. True roads were scarce, so that most people preferred using navigable waterways whenever possible. A system of canals and locks was developed to connect the various rivers and lakes that formed the main routes. The Erie Canal, begun in 1817 and opened in 1825, became the nation's most important man-made waterway. The 360-mile canal connected Lake Erie in the west to the Hudson River and New York Harbor in the east; by providing that city with direct means of transport to and from the western frontier, the Erie Canal made New York City the greatest marketplace in the country. Canal boats carried produce from Ohio, Illinois, Indiana, and Wisconsin to New York; when the freight was unloaded, immigrants boarded the vessels for the westward journey.

The impact of the canals was felt not only in the ports of origin and destination, but in the many towns that developed along the routes to serve the canal boats and their passengers. *Lockport on the Erie Canal* (fig. 5.12) by Mary Keys shows one of those new towns. According to a contemporary publication, Lockport consisted of only two houses in 1821. As seen in this 1832 watercolor, the town has grown significantly. Well-dressed men and women watch the passing scenery as their boat is pulled up to the locks by horses on the shore. The settlement, which now includes a church and a number of houses and other buildings, has grown up on the hill alongside the lock.

Lockport may also have been the site of the young ladies' seminary where Mary Keys was instructed in watercolor painting. Watercolor gained in popularity early in the nineteenth century, largely because of the development of a wide range of colors in solid form, an improvement over the earlier, hand-ground pigments, which had to be dissolved in water. Amateur painters found the small boxes of colors inexpensive, easy to carry, and simple to use. It was

5.7 Ship, c. 1880. Artist unknown. Painted wood, string, and tin, dimensions unknown. Present location unknown

a medium that lent itself to rapid, informal work; it was considered especially suitable for girls and ladies. In 1840 Mrs. A. H. L. Phelps noted: "Painting in water colors is the kind of painting most convenient for ladies; it can be performed with neatness, and without the disagreeable smell which attends oil painting."

New York City, the home port for many of the boats that traveled the Erie Canal, is shown in *Situation of America, 1848* (fig. 5.13), originally an overmantel in the Squire Phillips house in Brookhaven, Long Island. An "overmantel" was the painted section of wall over the parlor fireplace, a decorative custom that came from England. These scenes were usually painted directly on the plaster or on a paneled wall that covered the chimney, although occasionally a painted canvas was set into the woodwork. In New York and New England, the overmantel usually consisted of one or several wide boards held in place by moldings so that the painting formed a part of the architectural structure of the fireplace wall. Overmantels frequently depicted local scenes: in this painting, the view of Manhattan, most likely from Brooklyn across the East River, shows the dome of City Hall and the spire of Trinity Church. At dockside, the paddlewheeler *Sun* has either just unloaded the freight shown on the wharf, or is about to take it on. In either case, the "situation of America" in the election year 1848 appears to be good.

5.8 *Leaving Missouri*, 1865–90. C. C. A. Christensen.
Tempera on linen, approximately 78 × 114 inches.
Brigham Young University Art Museum Collection, Provo, Utah

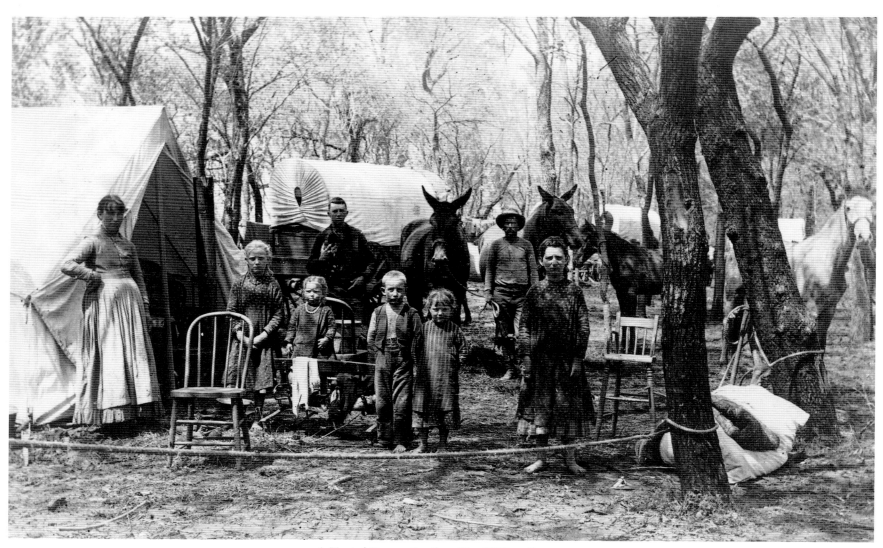

5.9 *A Typical Boomer Family*, 1889. William Prettyman.
Photographic print, 7 × 9½ inches.
Thomas Gilcrease Institute of American History and Art, Tulsa, Oklahoma

5.10 Sleigh, c. 1850. Artist unknown.
Painted wood, 26 inches long.
Collection of Isobel and Harvey Kahn

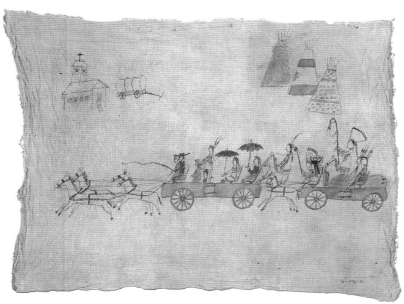

5.11 *Wagon trip*, c. 1885. Unknown Indian, probably Cheyenne.
Ink and watercolor on muslin, 17½ × 23⅝ inches.
Collection of Harrison Eiteljorg

5.12 *Lockport on the Erie Canal*, 1832. Mary Keys.
Watercolor and ink on paper, 14⅜ × 19⅜ inches.
Munson-Williams-Proctor Institute, Utica, New York

5.13 (*overleaf*) *Situation of America, 1848*, 1848. Artist unknown.
Oil on wood overmantel, 34 × 57 inches.
Private Collection

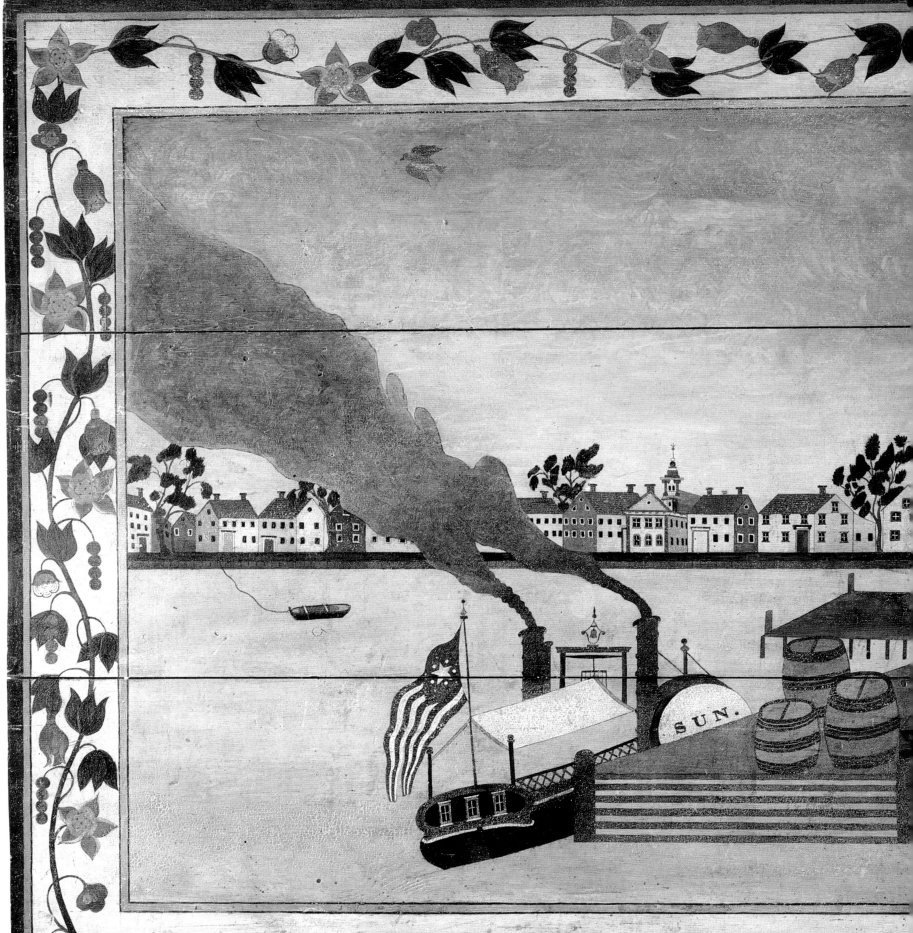

SITUATION OF

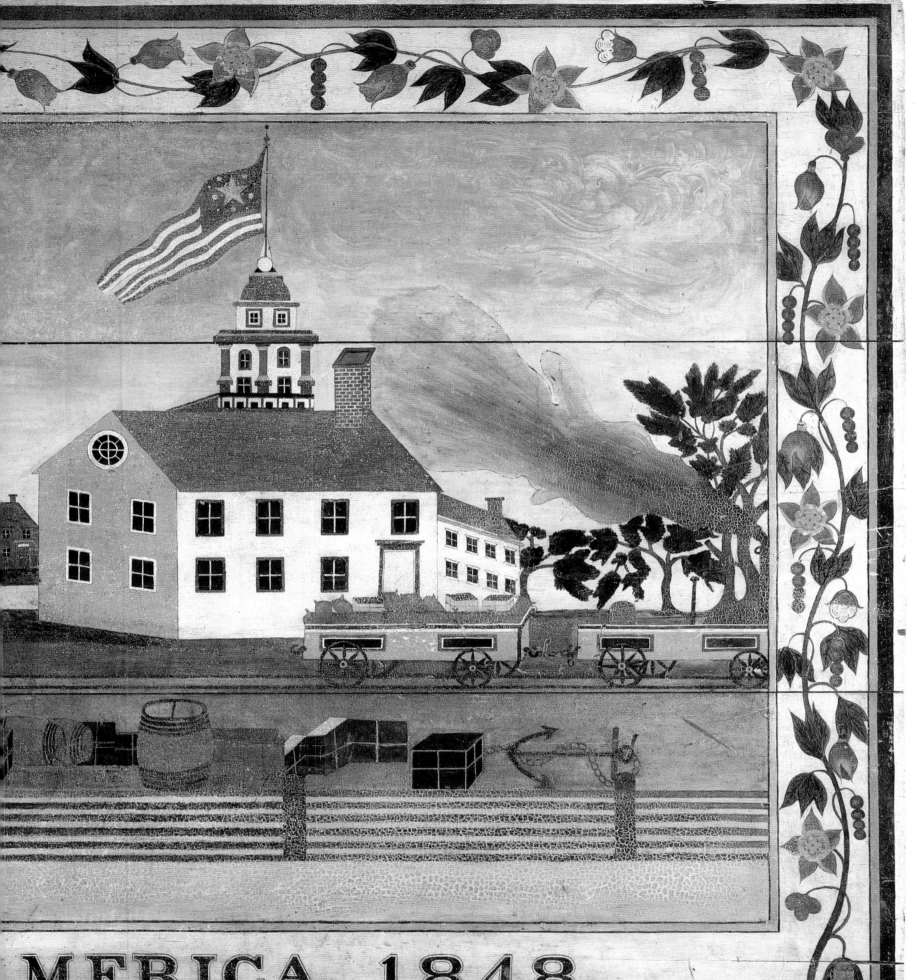

MERICA, 1848.

B Y THE 1840s, America was train-mad. Though dirty, crowded, noisy, and sometimes dangerous, the railroad captured the imagination of the people. As it opened up the West and unified the country east to west, it seemed a symbol of progress, speed, a new mobility, new horizons. Everyone was impressed, including the folk artists who used representations of the "iron horse" for everything from walking sticks to weathervanes (figs. 5.14 and 5.15).

The first trains were not steam-powered, but relied on horses to pull carriages along tracks, thereby enabling one horse to do the work of many. Even when the steam engine came into use, the passenger cars—as seen in a mid-nineteenth-century painting on a tin tray (fig. 5.18)—often resembled stagecoaches. This tray, similar to many others of the period, was made by a tinsmith, or "whitesmith," as these craftsmen were called, who sold great quantities of decorated tinware either directly to the public or through itinerant peddlers. In the earliest days of this country, tinware such as trays, pots, lanterns, and candelabra were undecorated, but by the time of the Revolution tin was being japanned, a technique by which colored decoration was applied over a black ground in imitation of Oriental lacquerware. In the first half of the nineteenth century, country tinsmiths (or sometimes their wives or daughters) decorated their wares with freehand painting or, as in this case, stencils.

At first, the railroads were intended to move produce from out-

5.15 *Locomotive*, c. 1840. Artist unknown. Sheet zinc, brass, and iron weathervane, 34 inches high. Shelburne Museum, Shelburne, Vermont

lying rural areas into a specific city, and competing rail lines deliberately laid different gauge tracks to prohibit use by each other. But the advantage of a rail system that would connect cities and, eventually, the Atlantic and Pacific coasts, was soon evident. Congress aided this gargantuan task by allocating substantial sums of money and large tracts of land to the Union and Central Pacific companies. With the Pacific Railway Act of 1862, surveying could begin for a transcontinental railroad, and in 1865 the first miles of track were laid. Competition between the two lines was fierce, and great numbers of immigrant laborers were put to work to lay tracks farther and faster. The Central Pacific Railroad, which started the cross-country race from the West Coast, imported Chinese workers for the task. This aspect of American history is recorded in Joseph Becker's painting (fig. 5.16), inscribed on the back "The

First Transcontinental Train Leaving Sacramento, Cal. in May 1869," which shows Chinese laborers cheering a Central Pacific train. In a surprisingly short time, considering the difficulties posed by the American landscape, the continent was spanned and the Union and Central Pacific lines were joined. The occasion was marked by a golden spike driven into the ground at Promontory Point, Utah, on May 10, 1869.

One folk artist was ahead of the railroad companies when it came to developing new methods of rail transportation. Artist-inventor Rufus Porter, discussed in chapter three, proposed a *Broadway Elevated Railroad* (fig. 5.20) in the January 1, 1846, issue of *Scientific American*—two decades before the first "El" was built.

The impact of the railroad on the American scene cannot be overstated. Railroads altered the social, economic, and political life of America. In towns, the railroad terminal became, along with the local tavern, an important source of news of the outside world and a center of activity and commerce. Much of the bustling activity engendered by the railroad and its local depot is captured in an appliqué quilt (fig. 5.17) dated 1888 and made in Peru, Indiana. This unique example of textile folk art was stitched by an invalid who observed the comings and goings at the station from her window. The monogram "E R" on the quilt stands for the Erie Railroad.

Another textile shows that the railroad greatly affected the lives of Native Americans as well. Navajo pictorial-style blankets frequently feature objects which, although foreign to the native culture, have had impact on their society. In the example included here (fig. 5.23), two trains traveling in opposite directions—the engines are in the center row—are rendered in the traditional strip design. The top and bottom rows are composed of two-story houses.

5.14 *Rail Road Cane*, c. 1900. Artist unknown. Painted wood, 38 inches high. Collection of Barbara Johnson

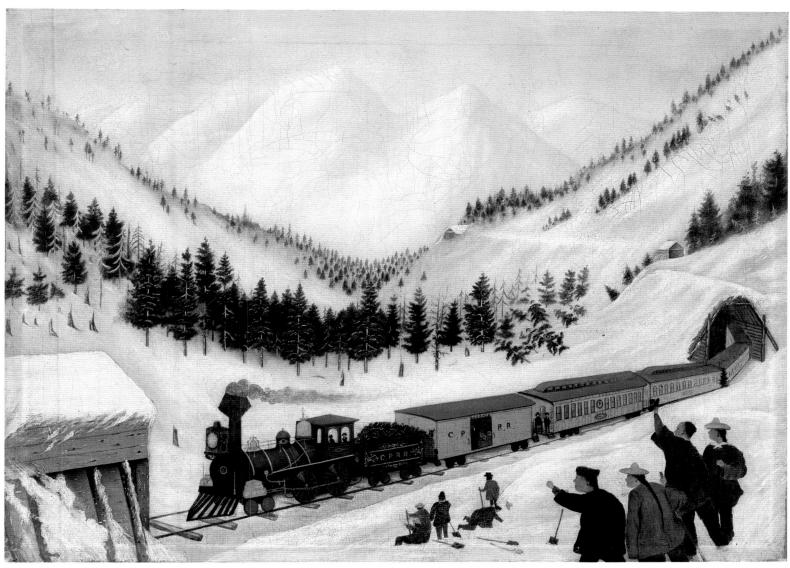

5.16 *Snow Sheds on the Central Pacific Railroad in the Sierra Nevada Mountains, May 18, 1869*, c. 1869. Joseph Becker.
Oil on canvas, 19 × 26 inches.
Thomas Gilcrease Institute of American History and Art, Tulsa, Oklahoma

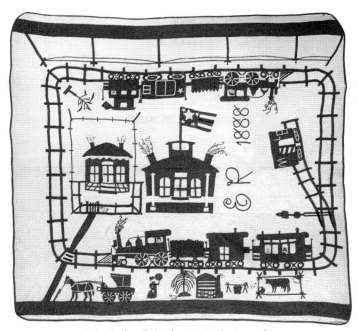

5.17 *Erie Railroad Quilt*, 1888. Artist unknown.
Appliquéd cotton, 78 × 73 inches.
Thos. K. Woodard: American Antiques & Quilts, New York

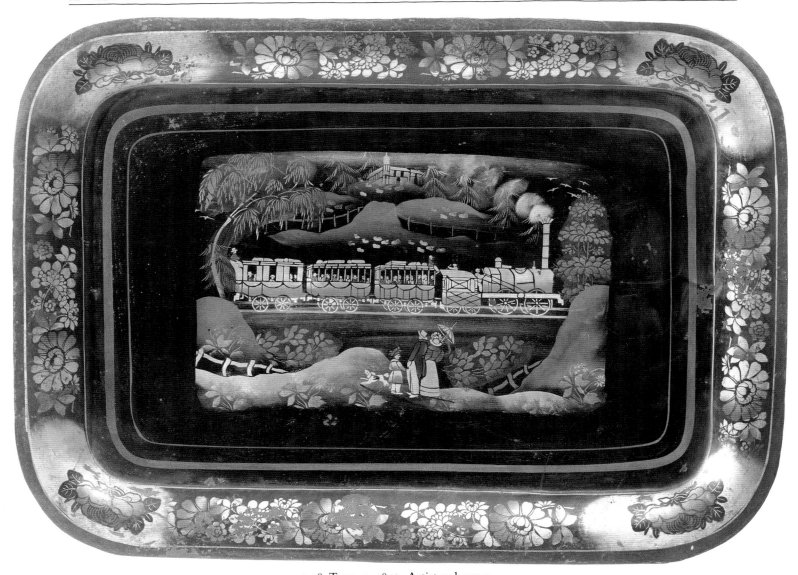

5.18 Tray, c. 1850. Artist unknown.
Painted tin, 24¼ inches wide.
Henry Ford Museum and Greenfield Village, Dearborn, Michigan

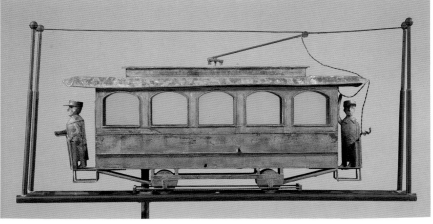

5.19 *Trolley-car*, 1875–1900. Artist unknown.
Sheet copper and iron weathervane, gilded and painted, 49 inches long.
Henry Ford Museum and Greenfield Village, Dearborn, Michigan

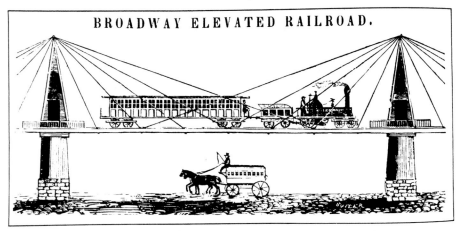

5.20 *Broadway Elevated Railroad*, 1846. Rufus Porter.
Engraving, 3¾ × 7¾ inches.
From *Scientific American*, January 1, 1846

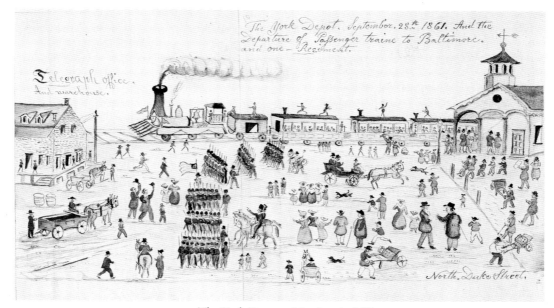

5.21 *The York Depot*, 1861. Lewis Miller.
Watercolor and ink on paper, 7⅞ × 12⁹⁄₁₆ inches.
Historical Society of York County, York, Pennsylvania

5.22 *Gotham 1893* (detail), 1893. Paul A. Seifert.
Watercolor, oil, and gilt on paper, 21 × 28 inches.
Collection of Ellis and Nina Lee

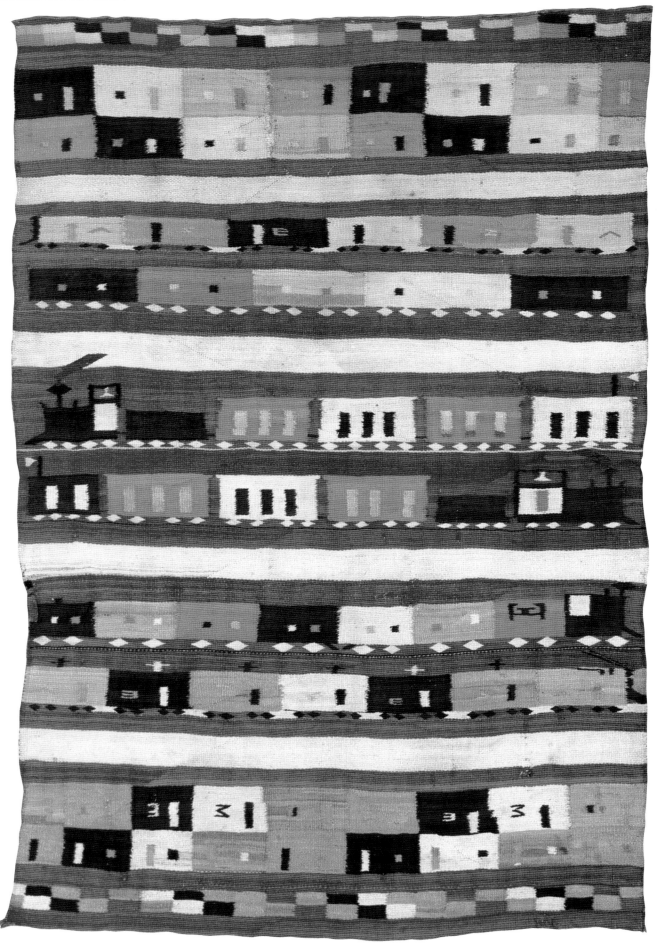

5.23 Navajo blanket, 1880–90. Artist unknown.
Natural and dyed wool, 83¼ × 56¼ inches.
Natural History Museum of Los Angeles County, California

First automobiles

VEHICLE THAT MAY HAVE SEEMED like pure fantasy to readers of Rufus Porter's *Scientific American* in 1845 (fig. 5.24) was, by the end of the nineteenth century, a reality. At first, automobiles were playthings for the very rich, expensive toys enjoyed by European royalty and the American equivalent in Newport and New York. But by the end of the first decade of the twentieth century they had become a necessity—a required possession for all who aspired to the speed and privacy that travel by auto signified.

It was Henry Ford who made this dream a reality. Fifteen million Model Ts came into existence between 1909 and 1928. In 1910 a Ford cost $780, and the price went down to $360 during World War I. Secondhand models were often available for as little as $25, which meant that a "Tin Lizzie" was within the reach of most wage earners.

Farmers particularly took to the new means of transportation. For them, it represented the end of the devastating isolation that rural life frequently entailed: the death knell of rural Amer-

ica, it has been said, was the chugging of the Tin Lizzie. Significantly, an automobile is featured in the early-twentieth-century farmscape by Paul Seifert (fig. 5.26). Painted late in his career, this scene reveals looser brushwork and heavier drawing, and is a bit smaller than Seifert's earlier farm portraits (see chapter three, fig. 3.5). Most features of the artist's style, however, remain. Immediately apparent here is Seifert's use of metallic paints for highlights, typically employed for evening clouds, but, in this case, also used for the metalwork on the car.

5.24 *Steam-Carriage for Common Roads*, 1845. Rufus Porter. Engraving, 5¾ × 7¾ inches. From *Scientific American*, October 2, 1845

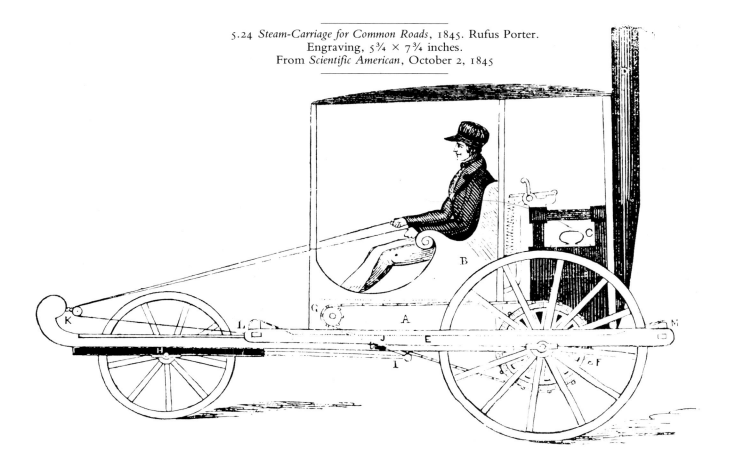

5.25 Touring car, c. 1907. Artist unknown.
Painted wood and metal, 25 inches long.
Collection of Herbert W. Hemphill, Jr.

5.26 *Farmscape with Ford*, c. 1915. Paul A. Seifert.
Watercolor and gilt on paper, 23 × 19 inches.
Collection of Samuel L. Meulendyke

IN THE LATE EIGHTEENTH and throughout the nineteenth centuries, travel by air meant ballooning. A craze in France, ballooning was less popular here, although more than eight thousand adventurers took part in three thousand ascensions before 1860. Balloons were used, briefly, to carry mail, and were successfully employed for spy missions during the Civil War, but, for most, their value was as entertainment, not as a viable means of fast transportation.

As seen in the black-and-white drawing *Balloon Flight* (fig. 5.28) and the photograph of a balloon ready for takeoff (fig. 5.30), flying was a novelty that attracted great attention, with cannon firing and cheering crowds often a part of the ceremonies attending a flight. *Balloon Flight* represents a popular type of nineteenth-century folk art known as "monochromatic drawings." Often based on prints, these charcoal-and-chalk sketches were easy to do and produced an effective result, and were therefore often favored by amateur artists. The best examples of this art form, like *Balloon Flight,* have an elegance and simplicity that place them on a par with other forms of fine folk art.

Balloons were not the only kind of flying machines enterprising Americans envisioned. In 1889, inventor Reuben Spalding of Rosita, Colorado, created a patent model (fig. 5.29) to demonstrate how his flying machine operated. Made of wood, metal, leather, and feathers, this amusing figure can now be admired as folk sculpture.

The discovery of gold in the West encouraged

5.27 Back cover of *Aerial Navigation,* 1849.
Rufus Porter.
Engraving, 6 × 9½ inches.
Minnesota Historical Society, St. Paul, Minnesota

inventors to find ever faster means of cross-country transport. Rufus Porter first published his plans for a steam-powered airship in 1834, and exhibited a working model in New York in 1847. The gold fever of '49 accelerated the search for speed, and Porter, unimpressed with the clipper ships' claims of a journey to the West Coast in three months, wrote a sixteen-page booklet designed for the gold-seeking forty-niners. *Aerial Navigation,* published in 1849 (fig. 5.27 shows the back cover of this publication), described the practical possibilities of Porter's airship for a cross-country trip from New York to California in three days! Porter

announced that fifty to one hundred passengers would be carried at a speed of sixty to one hundred miles per hour; the machine, he said, was to be in operation about April 1, 1849, at a cost of fifty dollars per passenger, including board. Elsewhere, this great promoter also described delightful jaunts in his "aerial locomotive" from New York to the scenic Connecticut River Valley, and then back to New York to dine, as well as a low-flying sightseeing cruise above the Rocky Mountains. His optimistic dreams did not stop there, however. "We have discovered no apparant difficulty," he wrote, "in passing over the Atlantic to London or Paris." He concluded the practical specifications and visionary plans for his invention with a dramatic prophecy: "These things are indeed but fancies at present, but in a few months these fancies may become pleasant realities in America, while the proud nations of Europe are staring and wondering at the soaring enterprise of the independent citizens of the United States."

Porter's plan for air travel was, indeed, just a fancy, but he was a true visionary, and the reality was not long in coming. Gliders were successfully tested in the last decades of the nineteenth century, and on December 17, 1902, at Kitty Hawk, North Carolina, Orville Wright soared for twelve seconds of controlled flight—long enough to introduce the age of the airplane. By World War I, battles were fought in the air, communication between cities and even countries was rapid and reliable, and, with its loss of isolation, America lost all but vestigial remains of its young innocence.

5.28 *Balloon Flight,* c. 1860. Artist unknown.
Charcoal and chalk on paper, 12½ × 15 inches.
Collection of James Thomas Flexner

5.29 (*opposite*) Patent model for flying device, 1889. Reuben Spalding.
Wood, metal, leather, and feathers, 14 inches high.
Destroyed

5.30 *The Big Balloon*, c. 1900. Artist unknown.
Photographic print, dimensions unknown.
Present location unknown

5.31 *Miss Todd in the Cockpit of a Plane*, 1909. S. N. Birdsall.
Photographic print, 8 × 10 inches.
Library of Congress, Washington, D.C.

6.1 *Whaling off the Coast of California*, c. 1858. Coleman.
Black, white, and colored chalk on prepared board, 20³/₁₆ × 29¹/₈ inches.
Museum of Fine Arts, Boston
M. and M. Karolik Collection

At Sea

F OR THE CITIZENS of Young America, the sea was a source of food, whale oil for lighting, and adventure, as well as a means of transportation for both passengers and cargo. At first, most communities, even those inland, depended on water routes for carrying goods and people, as roads were few and poorly maintained. Even when land routes improved, the sea remained the lifeline of the coastal states, providing employment for their men, income for their towns, and excitement for all the inhabitants.

A number of folk artists were a part of life at sea. Some were sailors themselves, seamen on long voyages who used their idle hours to record their maritime adventures or to create gifts for loved ones at home. Others lived in the port cities and towns and produced the decorative and practical items—figureheads, sternboards, sea chests—without which no ship was considered fit to sail. Still others made a living by painting portraits of the vessels for captains and owners who wanted visual records of their ships to hang in cabins or parlors.

EVEN BEFORE THE REVOLUTION, America—blessed with great quantities of wood and locked by seas that had to be crossed for contact with the rest of the world—was a center of shipbuilding and shipping, especially in the New England colonies. During the Revolution, nearly all American ships were drydocked or captured, but with peace Americans returned to the sea in an important way. In 1784, just six months after the Treaty of Paris formally ended the Revolution, the first American ship left for Macao to start the China trade.

Nearly every town on the Atlantic seaboard had a shipyard, and near many of these shipyards were the shops of the artisans who carved the figureheads, sternboards, and various other ornaments that decorated the oceangoing sailing ships. The trade card of Levi L. Cushing (fig. 6.2) shows such a carver at work creating a figurehead.

Figureheads were placed under the bowsprit where the sides of a ship converge. They were meant to be a visual extension of the bow, appreciated as works of art as they soared above the water. Throughout the seventeenth century and the first half of the eighteenth, Colonial figureheads generally followed English animal prototypes and were in the shape of "lyons" and other "beasts." By the end of the eighteenth century, however, human figures, often symbolizing the vessel's name or portraying the captain's wife or daughter, had become the most popular form of American figurehead. *Lady with a Scarf* (fig. 6.3) is an example of the kind of figurehead that most often graced our sailing vessels on their voyages around the world. Made by Isaac Fowle of Boston in the first quarter of the nineteenth century, this shawled lady was probably a shop sample, for she wears only one unweathered coat of white paint.

These were not the only carved embellishments aboard sailing ships. After the figureheads, the chief category of marine decoration was the sternboard, a broad, flat surface, fitted to the back of the ship, that frequently sported a carving of an eagle. A sternboard could also, however, serve as a surface for portraits. *Man at Desk* (fig. 6.5), for example, could have been the owner of the vessel or, more probably, the captain, a studious man shown surrounded by books, charts, compass, and globe.

Ironically, at the very time that America's wooden sailing fleets were expanding in size and increasing in speed, a new mode of water transportation was attracting the chief interest and excitement of the public. Robert Fulton's 1807 voyage up the Hudson River in his *North River Steamboat of Clermont*, later known simply as the *Clermont*, introduced steam-powered transportation to the nation's inland waterways. Soon the steamboats—easily able to transport both cargo and passengers upstream against the currents—were journeying not only along the great river systems such as the Hudson and the

6.2 Trade card of Levi L. Cushing, c. 1825. Engraved by N. Dearborn, Boston. Woodcut on paper, 4¹¹⁄₁₆ × 3⅜ inches. American Antiquarian Society, Worcester, Massachusetts

Mississippi, but all along minor tributaries as well.

In 1838 the S.S. *Sirius*, the first ship to cross the Atlantic wholly by steam power, arrived in New York, after making the journey from Cork in just nineteen days. In the years that followed, sailing ships and steamships battled for ocean trade but, by the end of the nineteenth century, ships made of iron and powered by steam had relegated the wooden sailing ships to the tasks of transporting such humble cargo as coal and farm produce, while most passengers and luxury goods were carried on the regularly scheduled steamship lines.

When the steam-powered vessels began to replace sailing ships in the mid-nineteenth century, ship carvers lost an important segment of their business. The projecting prow with its elegant figurehead no longer had a place. To make up for this lost commerce, some ship carvers turned to creating elaborate inboard ornaments, such as pilot-house eagles and paddle-box decorations, as well as shop figures and trade signs, especially for those businesses that served the shipping and shipbuilding industries. These three-dimensional carvings were produced in the same workrooms as the figureheads and other ship decorations and usually displayed the

same broad-planed carving style that typified American figureheads.

A successful shop figure or trade sign is not only eye-catching, but also immediately identifies the business advertised. The little navigator using a quadrant (fig. 6.6), for example, was first installed over the shop door of James Fales, a maker of nautical instruments in Newport, Rhode Island, in the early nineteenth century. Similarly, the shop sign (fig. 6.8) for a ship chandlery, a business that supplied marine equipment, is a figure of a sea captain using another necessity for life at sea, a telescope.

A second sea captain holding a telescope is a painted copper and iron weathervane (fig. 6.7) that may originally have stood atop a ship chandler's shop in Newburyport, Massachusetts. Besides predicting the weather—important information for life in a seacoast town—a weathervane like this also functioned as a trade sign, enabling the sailors on board ships in the harbor easily to spot the provisioner's store.

The frame for the painting of *Newburyport Harbor* (fig. 6.10) is topped by an eagle carved in the same manner as those used for decorating ships, and was undoubtedly made by a ship carver; the framed painting may have been part of the furnishings of a captain's cabin. Painted by Thomas A. Hamilton, *Newburyport Harbor* is especially interesting not only because of its frame, but also because of the information it provides about life in a New England coastal town. Newburyport, once a major shipping town, was a center of commerce for the surrounding Massachusetts communities. In this painting, we see the many shop signs—including a sign advertising Hamilton himself as a paperhanger—that indicate the extensive number of commercial establishments the shipping industry supported. Of the large sailing vessels moored in the harbor, however, we see only the spars: Hamilton may have chosen to place the ships behind buildings to eliminate the difficult and time-consuming task of painting elaborately rigged ships.

The *Trade and Commerce Quilt* (fig. 6.9) tells a story in fabric about the business relations between the sea and the land that are also portrayed in *Newburyport Harbor*. The early-nineteenth-century appliquéd quilt, attributed to Hannah Stockton Stokes of Stockton, New Jersey, includes an inner border of seagoing vessels, ranging from simple rowboats to steamboats, and an outer border of land vehicles and enterprises, including a number of labeled buildings. At one point on the quilt (not seen here), the borders are connected by the passing of cargo between ship and shore.

Another business engendered by the shipping industry was the painting of ship portraits. This specialized type of folk painting came into fashion with representations of sailing vessels in the late eighteenth century and remained popular through the age of steam and into the beginning of the twentieth century. The ship portrait

painter was usually an artist familiar with the construction of ships and the ways of the sea who was commissioned by an owner or captain to produce an accurate likeness of a vessel. Unlike the itinerant portrait painters, these artists lived in the major port cities along the American seacoast and painted the ships that made those cities their home ports.

Jurgan Frederick Huge, whose town paintings are discussed in chapter four, was an artist who specialized in the painting of ships. Huge's descendants say that both the artist and his brother were sea captains, and that as young men they worked their way over to America from Ger-

many on ships. This would account for Huge's interest in and technical knowledge of ships, displayed here in his *New York Ballance Drydock* (fig. 6.14). Completed in 1877, a year before Huge's death, this is an example of the artist's mature work: he has created a scene of enormous overall scope, yet without sacrificing any of his precisionist attention to detail. As in his painting of the Burroughs Building (chapter four, fig. 4.5), all the signs are lettered legibly, from the number of the East River Drydock offices ("241 South St.") to the route of the horse-drawn trolley ("White Hall & Central Park"). One can distinguish every stone used to pave the street in front of the dock and, of course, every line in the riggings of the vessels portrayed. The ship in the drydock is the bark *Ocean King*, which Huge depicted at sea in another watercolor.

The twin brothers James and John Bard also specialized in ship portraits, particularly of the steamboats that traveled up the Hudson River from their home port of New York City. For twenty years the brothers painted together, producing such works as the portrait of the *Robert L. Stevens* (fig. 6.15). After John's death in 1856, James continued painting steamboats in the same characteristic manner. Like the portrait of the *Robert L. Stevens*, ships painted by the Bards are almost always shown from the port side—traveling from the right to the left of the canvas—and none is shown at anchor or next to a dock. Although the brothers had difficulty in accurately portraying anything on a ship that called for perspective drawing, such as a steering wheel viewed through a window, the details of construction are almost always exact. James Bard, at least, is known to have made preliminary drawings, complete with notes and measurements, which he submitted to the client for corrections and approval before starting his final painting on canvas. James Bard's talent for authenticity was evidently well known during his lifetime and was commented on in his obituary, written by Samuel Ward Stanton, historian, friend, and fellow steamboat artist, in the April 1, 1897, issue of *Seaboard* magazine:

From 1827 to within a few years of his death Mr. Bard made drawings of almost every steamer that was built at or owned around the port of New York, the total number of these productions being about 4,000. Probably Mr. Bard was without a parallel in the

6.4 *Portrait of a Sailor*, c. 1800. Artist unknown. Watercolor on ivory mourning pin, 1 ½ × ⅞ inches. Collection of Catherine and Howard Feldman

faithfulness of delineation in his drawings of vessels. His methods of work, the minuteness of detail, and the absolute truthfulness of every part of a steamboat which characterized his productions, cannot but cause wonder in these days of rapid work. His pictures were always side views, and this often made faulty perspective, yet a Bard picture will ever be held in esteem for its correctness and the beauty of drawing.

Beautiful pictures of well-outfitted ships like those painted by the Bards and Huge probably induced many young men, such as the sailor pictured in figure 6.11, to run away to sea in search of wealth and adventure. What they most often found, however, was a harder life than they had anticipated. As an item in the April 2, 1849, issue of *The Friend*, a Honolulu newspaper, noted, "Life at sea is a severe test of character. It is a rare circumstance for a voyage to commence & end without more or less the occurring of an unpleasant nature. . . ." The miniature watercolor pin showing a sailor and a fully rigged ship in the background (fig. 6.4), probably painted for the mariner's loved ones after his death on a voyage, suggests the events of an "unpleasant nature" that were all too likely to happen aboard ship.

Violent storms and the resulting shipwrecks were the most feared of the incidents that occurred at sea, and they inspired many dramatic folk paintings. One of the greatest is *Ship in a Storm* (fig. 6.16) by William H. Coffin. In this emotional picture, the turbulent waves and ominous clouds speed toward the wind-tossed vessel, and even the grained painting of the frame seems to focus attention from all sides onto the foundering ship.

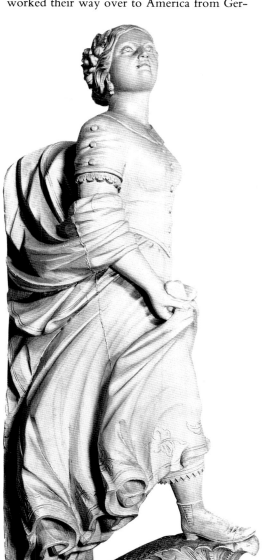

6.3 *Lady with a Scarf*, c. 1820. Isaac Fowle. Painted wood, 74 inches high. Bostonian Society, Old State House, Boston

6.5 *Man at Desk*, 1865. Artist unknown.
Polychromed wood sternboard, 75 inches long.
Collection of J. Bruce Bredin

6.6 *The Little Navigator*, 1810–20. Attributed to Samuel King.
Painted wood, 25¾ inches high.
Old Dartmouth Historical Society, New Bedford, Massachusetts

6.7 *Sea Captain*, c. 1860. Artist unknown.
Molded and painted copper and painted and gilded iron weathervane, 39 inches high.
Cohen Collection

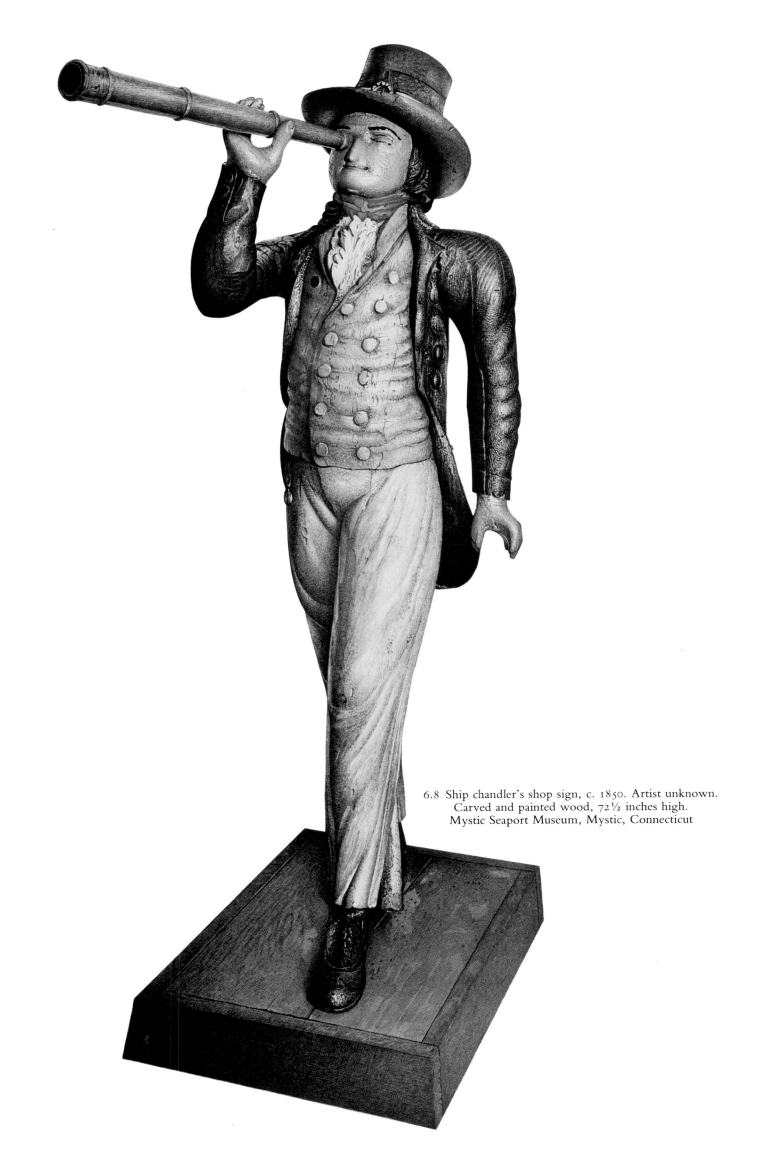

6.8 Ship chandler's shop sign, c. 1850. Artist unknown.
Carved and painted wood, 72½ inches high.
Mystic Seaport Museum, Mystic, Connecticut

6.9 *Trade and Commerce Quilt* (detail), c. 1830. Attributed to Hannah Stockton Stokes.
Appliquéd cotton chintz, 103 × 91 inches.
New York State Historical Association, Cooperstown

6.10 *Newburyport Harbor*, c. 1875. Thomas A. Hamilton.
Oil on canvas, carved and painted frame, 19¾ × 32 inches.
New York State Historical Association, Cooperstown

6.11 *Portrait of a Sailor*, c. 1825. Artist unknown.
Oil on canvas, 23½ × 16½ inches.
Whitney Museum of American Art, New York
Gift of Edgar William and Bernice Chrysler Garbisch

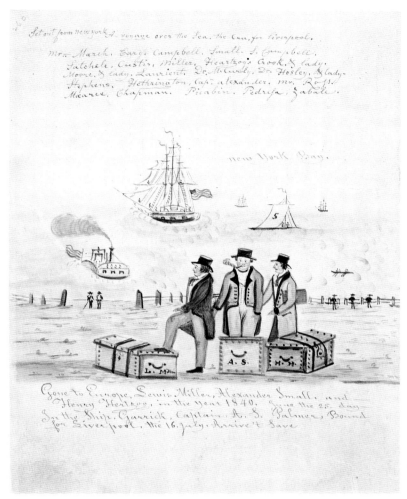

6.12 *Gone to Europe*, 1840. Lewis Miller.
Watercolor and ink on paper, 9¾ × 7⅝ inches.
Historical Society of York County, York, Pennsylvania

6.13 Sea chest, c. 1850 (decoration c. 1875). Artist unknown.
Painted wood, approximately 46 inches long.
Present location unknown

6.14 *New York Ballance Drydock*, 1877. Jurgan Frederick Huge.
Watercolor and ink on paper, 23½ × 35½ inches.
Collection of Mr. and Mrs. J. Matthew Davidson

6.15 *Robert L. Stevens*, c. 1836. James and John Bard.
Oil on canvas, 22 × 35½ inches.
The Mariners' Museum, Newport News, Virginia

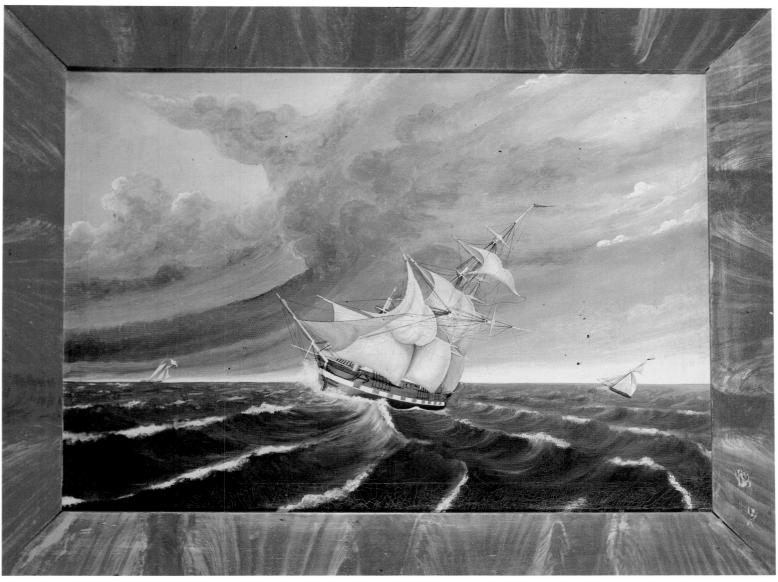

6.16 *Ship in a Storm*, 1846. William H. Coffin.
Oil on canvas, 21½ × 30 inches.
Private Collection

6.17 *The Sinking Titanic*, c. 1912. Artist unknown.
Oil and mother-of-pearl on glass, 13¾ × 29½ inches.
Yale University Art Gallery, New Haven, Connecticut
The Selden Rodman Collection

EW ACTIVITIES OF LIFE in nineteenth-century America caught the imagination of both artists and writers as much as whaling. Although the voyages were usually so perilous and the conditions aboard ship so wretched that few men signed on for repeat trips, whaling was, nevertheless, profitable and adventuresome, and there were always new men ready to sign up to try their luck and seek their fortune. From the mid-eighteenth to the mid-nineteenth centuries, towns all along the New England coast and Long Island—even up the rivers of the East Coast—sent whaling fleets around the world in search of spermaceti for candles and blubber for whale oil, the best means of lighting then available.

Whaling voyages frequently lasted three or four years, usually combining intervals of intense activity with long periods of enforced leisure when no whales were in sight. To alleviate their boredom, many sailors made scrimshaw, articles crafted from the teeth, bones, or baleen of a whale. An unwritten law gave the lower jaw of the sperm whale, with its teeth and bone, to the crew, who turned it into a wide variety of objects. Many of these items, such as busks for corsets, pie crimpers and jagging wheels for baking, swifts for winding yarn, watchstands, candlesticks, and gameboards, were made as gifts for loved ones at home. For example, the panbone of a sperm whale provided the material for an oval "ditty" box (fig. 6.18), used to store small sewing materials.

It took long hours of patient labor to produce a piece of scrimshaw. The tooth, for instance, first had to be cut from the gums of the whale's enormous lower jaw. The next steps were drying, soaking in brine, filing, smoothing the tooth with an abrasive such as sharkskin, and finally, polishing. Designs for decorating the tooth were often original and, like *Sperm Whaling in the South Pacific* (fig. 6.19), based on the whaler's everyday experiences; other times, they were adapted from prints. These scenes were incised with simple tools such as jackknives, sail needles, and various improvised devices. Once a tooth was engraved with a design, lampblack or colored ink

with a varnish fixative was rubbed over it and then wiped away, thus filling the design with pigment.

Some sailors spent their leisure time painting or writing in journals, or both. These firsthand visual and verbal accounts provide us with an accurate understanding of the excitement—and the fear—that were part of the whaling experience. The illustrated journal of John F. Martin, kept on board the *Lucy Ann* out of Wilmington, Delaware, from 1841 to 1844, includes the following entry for July 27, 1843:

lowered in the forenoon after Right whales, the Larboard fastened to a Right whale & killed him. . . . the Larboard & bow boats then left the first whale and fastened to another the Larboard boat killed him. he breeched over the Bow boat & stove her. . . . we had them both fast along side by dark. . . . in the forenoon a whale breached entirely out of the water with the exception of his flukes—

This entry was accompanied by the watercolor painting *A Right Whale Breaching* (fig. 6.22). The term "right whale" means the right kind of whale to kill—the species that contained the most oil and was therefore the most valuable. "Breaching" means leaping out of the water.

Martin's whaling experience, as reported in his journal and as seen in his painting, was successful. Other whalers faced tragedy. Another watercolor, *Stove Boat* (fig. 6.21), shows what often happened when men in small boats tried to kill a mammoth sperm whale: the whale won. *Stove Boat*, also originally part of a logbook kept on a whaling voyage, was painted by

an unidentified artist, probably out of New Bedford, Massachusetts, known as the whaling capital of the world.

Also from New Bedford is *The Whaling Voyage*, a 1,275-foot panorama on cotton sheeting by Benjamin Russell and Caleb Purrington, one scene of which is shown here (*Whaling on the Northwest Coast*, fig. 6.23). Russell, a ship's carpenter and painter of whaling pictures, kept a sketchbook during a three-year voyage out of New Bedford. When he returned home, he persuaded Purrington, a local house painter, to help him create a panoramic painting recording the daily activities and the landscapes of his travels. After mounting the enormously long painting on rollers, Russell and Purrington took their work on tour, traveling as far west as Chicago and as far south as Louisville, Kentucky.

The scene reproduced here shows much of the excitement involved in whaling. A number of ships have found a herd of whales and are in various successful and unsuccessful stages of capture. At the far left, two ships are shown with whales tied up against them so that the blubber can be cut from the whales in strips, then minced, boiled, cooled, and strained into casks. In the center, a whale is breaching, causing some men to jump overboard from their boat. At the right, a harpooned whale has already crushed a boat in two, causing the crewmen to be wildly tossed about.

The whaling industry, at its peak in the 1850s, was in decline a quarter of a century later. The advent of cheap kerosene made the whale-oil lamp obsolete, and a business that had amounted to one-third of one billion dollars for the period between 1804 and 1876 was no more. Once-thriving ports such as New Bedford, Nantucket, and Edgartown, Massachusetts; Mystic and New London, Connecticut; and Sag Harbor, New York, also declined in fortune. Luckily, however, museums in these areas, like the Old Dartmouth Historical Society Whaling Museum in New Bedford, and Mystic Seaport in Connecticut, have been successful in preserving the many forms of folk art associated with this fascinating chapter in the life of Young America.

6.18 Ditty box, c. 1855. Artist unknown.
Shaped and engraved panbone,
7^{15}/16 × 10¼ inches.
Mystic Seaport Museum, Mystic, Connecticut
Gift of Harold H. Kynett

6.19 *Sperm Whaling in the South Pacific*, c. 1825. Artist unknown.
Engraved whale's tooth, 8 inches long.
Collection of Barbara Johnson

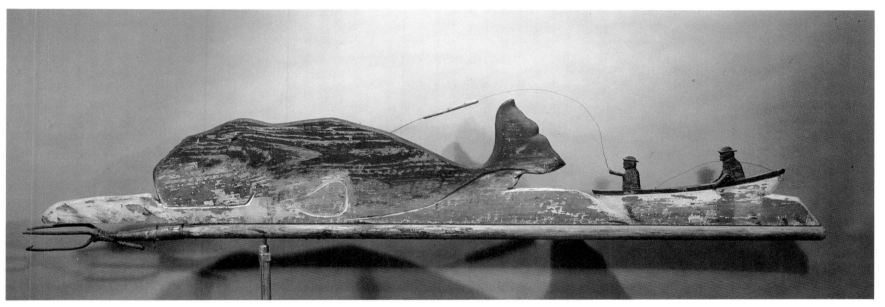

6.20 *Whale and Whalers*, c. 1880. Artist unknown.
Painted wood, 76 inches long.
Guennol Collection

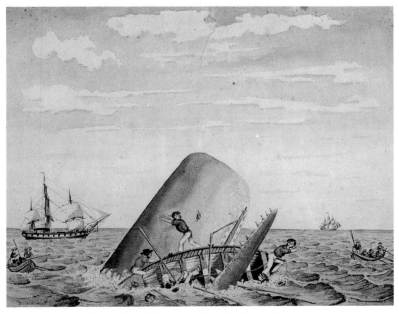

6.21 *Stove Boat*, c. 1840. Artist unknown.
Watercolor and ink on paper, 9 × 11½ inches.
Old Dartmouth Historical Society, New Bedford, Massachusetts

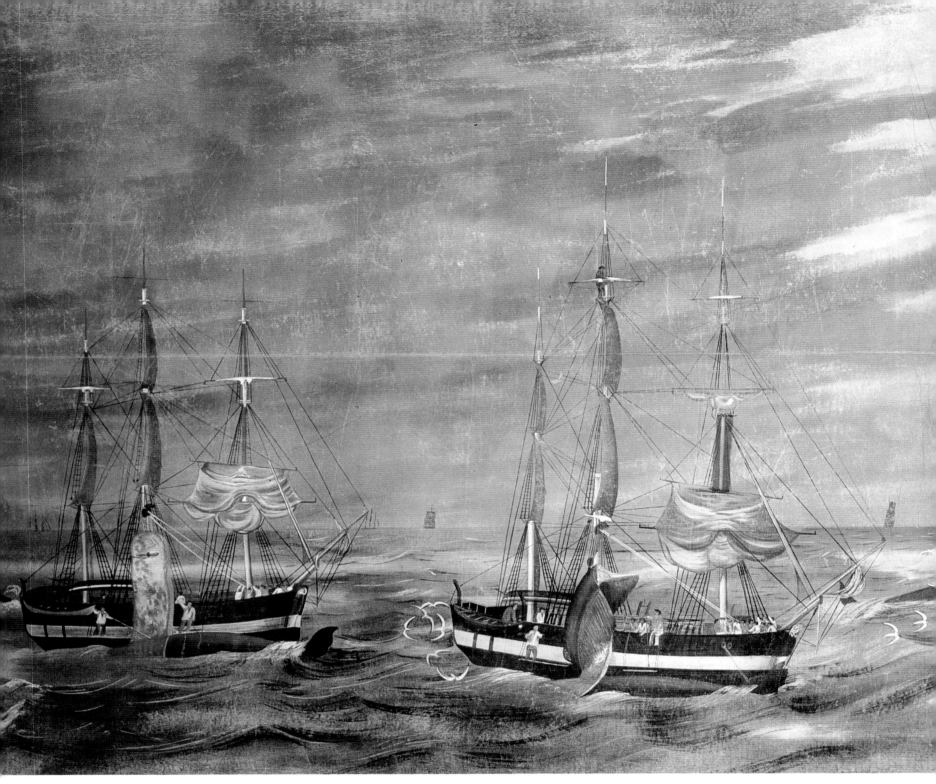
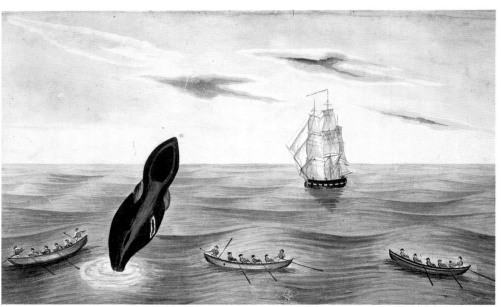

6.23 *Whaling on the Northwest Coast* (detail), 1848. Benjamin Russell and Caleb Purrington.
Water-base paint on cotton sheeting, 8 ½ × 1,275 feet.
Old Dartmouth Historical Society, New Bedford, Massachusetts

6.22 (*opposite*) *A Right Whale Breaching*, 1841–44. John F. Martin.
Watercolor and ink on paper, 8 × 12⅝ inches.
The Kendall Whaling Museum, Sharon, Massachusetts

7.1 *General Washington*, c. 1810. Artist unknown.
Gouache, watercolor, and ink on paper, 9¾ × 8 inches.
Private Collection

War

Y OUNG AMERICA, as a period of art history, is bounded by wars. By starting our survey of the everyday life of the folk with the Revolution and continuing to World War I, we are acknowledging how much these conflicts have influenced our society, including the folk artists.

The revolutionary war ushered in a period of increased freedom from Europe not only in the political sphere, but in the artistic as well. Of course, immigrants continued to bring the art forms of their native cultures with them to the New World and, in academic circles, the winds of artistic fashion continued to blow across the Atlantic. But the seeds of an American folk-art tradition, planted during Colonial days, began to flower and grow in the climate of relative isolation that followed the signing of the Declaration of Independence.

In contrast, World War I reintroduced the world to America. Fads, fancies, events, and inventions from Europe and beyond became major influences on all levels of American society. The naïve folk art that had flowered in isolation was now clearly beyond its prime.

The Native American population also recorded its experience of war in its art. For many tribes, success in battle assured status in the society, and these exploits were frequently retold in paintings and drawings. Those included here describe battles and preparations for war—both intertribal and between Indians and whites—from the point of view of the Native Americans.

In between these two delimiting wars, other conflicts also affected our country's outlook and its folk art. Working either from their own experiences or from hearsay, folk artists recorded the battles, the heroes, the common soldiers, and the drama of combat, often drawing on these themes for inspiration well after the war itself was over.

MUCH OF THE NATIVE AMERICAN folk art shown here is in the form of pictographs, a form of storytelling in pictures that was common among the Plains Indian tribes. Pictography frequently includes symbols or shorthand drawings that would have been immediately understood by tribes all across the Plains: a knowledge of these traditional conventions and a mastery of techniques for their execution was part of a man's education.

The earliest pictograph reproduced in this book is a buffalo hide describing a battle between two tribes (fig. 7.2). It comes from the Dakotas and was painted in the late eighteenth century by an Indian of the nomadic Mandan tribe. For many years it was the custom for the Plains Indian warrior to portray his feats of war in pictographs on his robe made of hide. Then, when he wrapped his robe around him, all assembled could read his biography and accord him the place that he had earned in a society that valued such exploits. Sometimes, his deeds were also painted as a mural on the hide lining or exterior of his tepee.

More than a century after the unknown Mandan painted his battle scene, an Indian named White Bird created his pictograph of part of one of the most famous conflicts in American history: Custer's last stand at the Battle of Little Big Horn in 1876. Titled *An Indian Version of Reno's Retreat* (fig. 7.5), this watercolor drawing on muslin shows Major Reno's troops, ordered to flank Custer, being routed by Native American warriors rebelling at being forced off their legally reserved lands.

Pictographs were also painted on shields, like the Kiowa dance shield (fig. 7.3), used on the Plains and in the Southwest. Made of thick hide, these shields once functioned as defensive weapons, but when European firearms were introduced to this country, the shields could no longer provide physical protection. Thereafter, they provided only symbolic protection: on the Plains, talismans were often attached to the shields in order to keep the warriors in touch with their shields' spiritual qualities. Many Plains Indian shields that survived the battles of the nineteenth century were buried along with their owners. In the Southwest, especially among the Zuni and Hopi, those shields that

survive are cherished relics that still play an important part in ceremonial activities.

This Kiowa dance shield, dating from the end of the nineteenth century, is a painting on muslin, a material that became a necessary substitute when buffalo hide was no longer easily available, and that the Indians by then regarded as a reflection of the poverty of reservation life. Made to be carried at dances and other social occasions, symbolic shields such as this one generally depict past exploits or events that the "old-timers" remembered and wanted to preserve. This particularly well-balanced design, which shows a battle between the Kiowa and the Pawnee, places the opposing forces at opposite sides of the shield, as if an imaginary line bisected the circle.

The pictographic style of the Plains Indian artists was occasionally influenced by outside forces. Between 1832 and 1834, the Prussian naturalist Prince Maximilian of Wied-Neuwied and the Swiss artist Karl Bodmer traveled through America recording the life-style of the tribes and painting their everyday activities. During their five-month stay at Fort Clark, North Dakota, the pair became acquainted with Mató-Tópe, a respected Mandan chief from the northern plains of North Dakota who had previously sat for painter George Catlin. Mató-Tópe was a great source of information about the Mandan for Bodmer and the prince. He was also a painter himself, and his later style was admittedly influenced by watching Bodmer, whom he called "the one who makes pictures."

The Europeans gave Mató-Tópe and a fellow Mandan paper, pencils, and watercolors and encouraged them to employ these white-man's tools to make pictures for them. Their drawings, including *Mató-Tópe Battling and Killing Cheyenne Chief* (fig. 7.7), clearly reveal Bodmer's influence on the native art form. Indeed, the Indians had followed Bodmer's example, first making a precise pencil drawing of their subject, then adding the watercolors. The works of the two artists also show, to some degree, realistically proportioned, fully clothed human figures with precisely drawn facial features; and Mató-Tópe's scene even reveals some application of color modeling. As is apparent when this work is compared to the other pictographs included here, these characteristics are com-

pletely alien to the traditional Plains Indian style of painting.

Mató-Tópe Battling and Killing Cheyenne Chief tells the story of one of the artist's most significant coups, the killing of an enemy (the figure on the right) in hand-to-hand combat, a scene Mató-Tópe had also painted on a hide robe that he presented to George Catlin. Catlin described the scene:

Mah-to-toh-pa, or four bears, kills a Shienne chief, who challenged him to single combat, in presence of the two war-parties; they fought on horseback with guns, until Mah-to-toh-pa's powder-horn was shot away; they then fought with bows and arrows, until their quivers were emptied, when they dismounted and fought single-handed. The Shienne drew his knife, and Mah-to-toh-pa had left his; they struggled for the knife, which Mah-to-toh-pa wrested from the Shienne, and killed him with it; in the struggle, the blade of the knife was several times drawn through the hand of Mah-to-toh-pa, and the blood is seen running from the wound.

The pencil-and-crayon drawing, *A Kiowa Chief Getting up a War Party* (fig. 7.6), like Buffalo Meat's drawing of *A New Married Man Receiving His Friends* (chapter one, fig. 1.3), also shows evidence of outside influences. Although the Kiowa were located in Oklahoma in the 1870s, a group of their chiefs was imprisoned in Fort Marion, Florida, from 1875 to 1878 for their roles in encouraging Indian uprisings. At Fort Marion, outside a tribal societal structure, art could not serve to assure social status. Instead, new concepts entered the Indians' pictorial drawings—self-expression and the desire to create art simply for its own sake. They were free to concentrate on making pictures that appealed only to their eyes and emotions, and they chose to express themselves with artwork that recreated a way of life that existed only in their memories. In these nostalgic drawings, an outgrowth of the pictographic style but executed with white-man's tools in a white-man's prison, the Indians' homesickness is clear—their drawings reproduce their lives on the Plains down to the smallest detail. *A Kiowa Chief Getting up a War Party*, an example of this kind of nostalgic "memory" picture, was probably painted after its unidentified artist returned to a reservation in Oklahoma with his new materials and his new concepts about art.

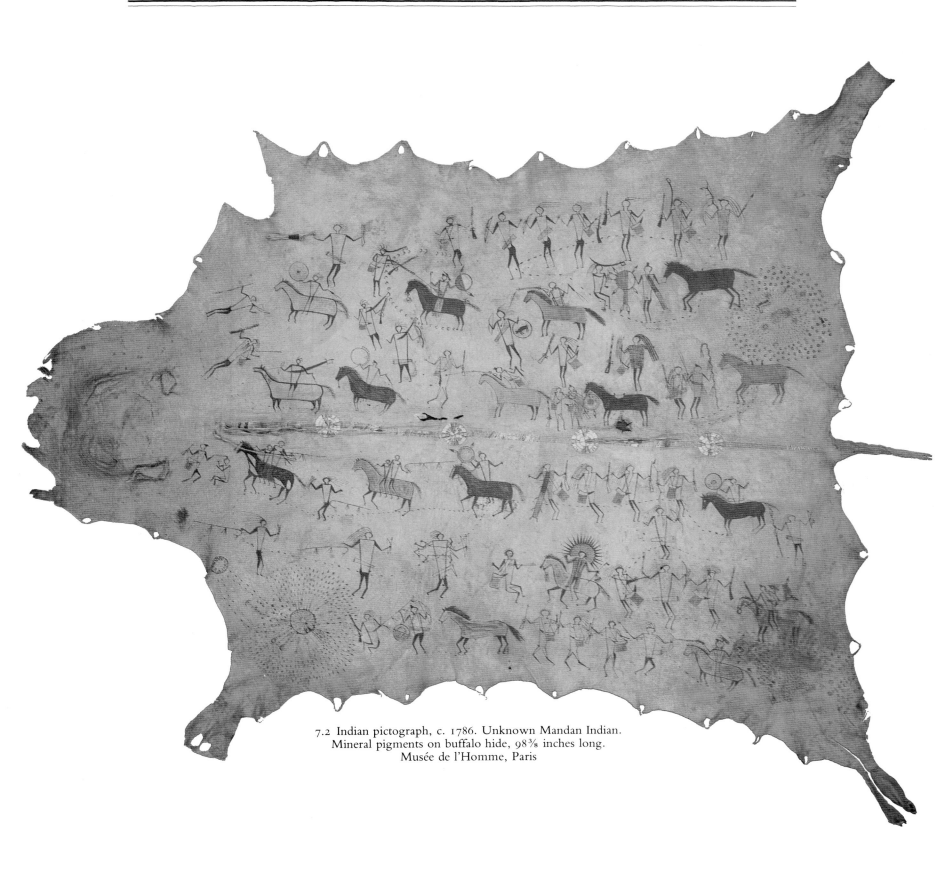

7.2 Indian pictograph, c. 1786. Unknown Mandan Indian.
Mineral pigments on buffalo hide, 98⅜ inches long.
Musée de l'Homme, Paris

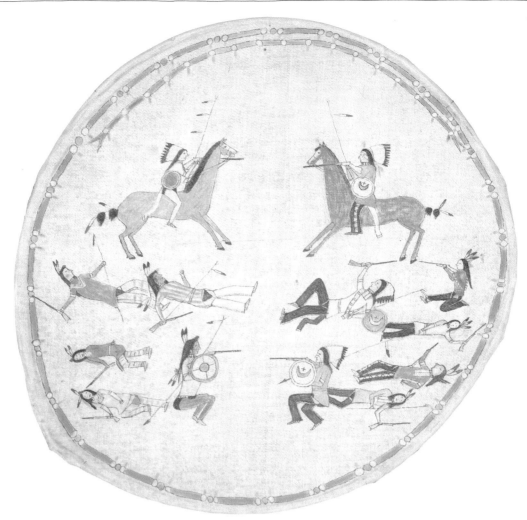

7.3 *Dance Shield*, c. 1890. Unknown Kiowa Indian.
Watercolor and ink on muslin mounted on wood hoop, 18½ inches high.
Morningstar Gallery, Santa Fe, New Mexico

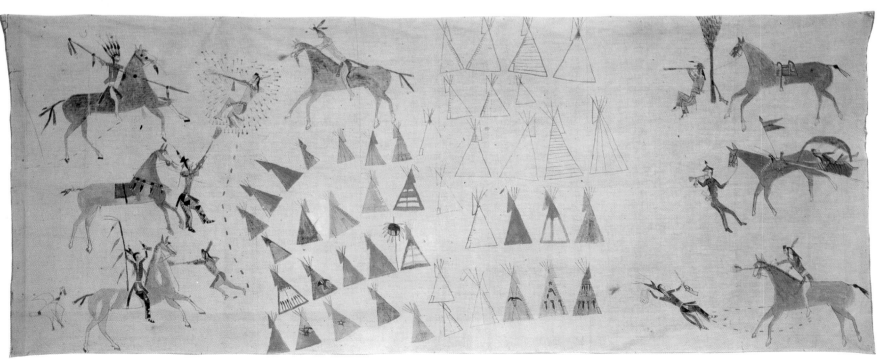

7.4 Pictographic painting, 1880. White Swan, Crow Indian.
Watercolor and ink on muslin, 35 × 87 inches.
Denver Art Museum, Denver, Colorado

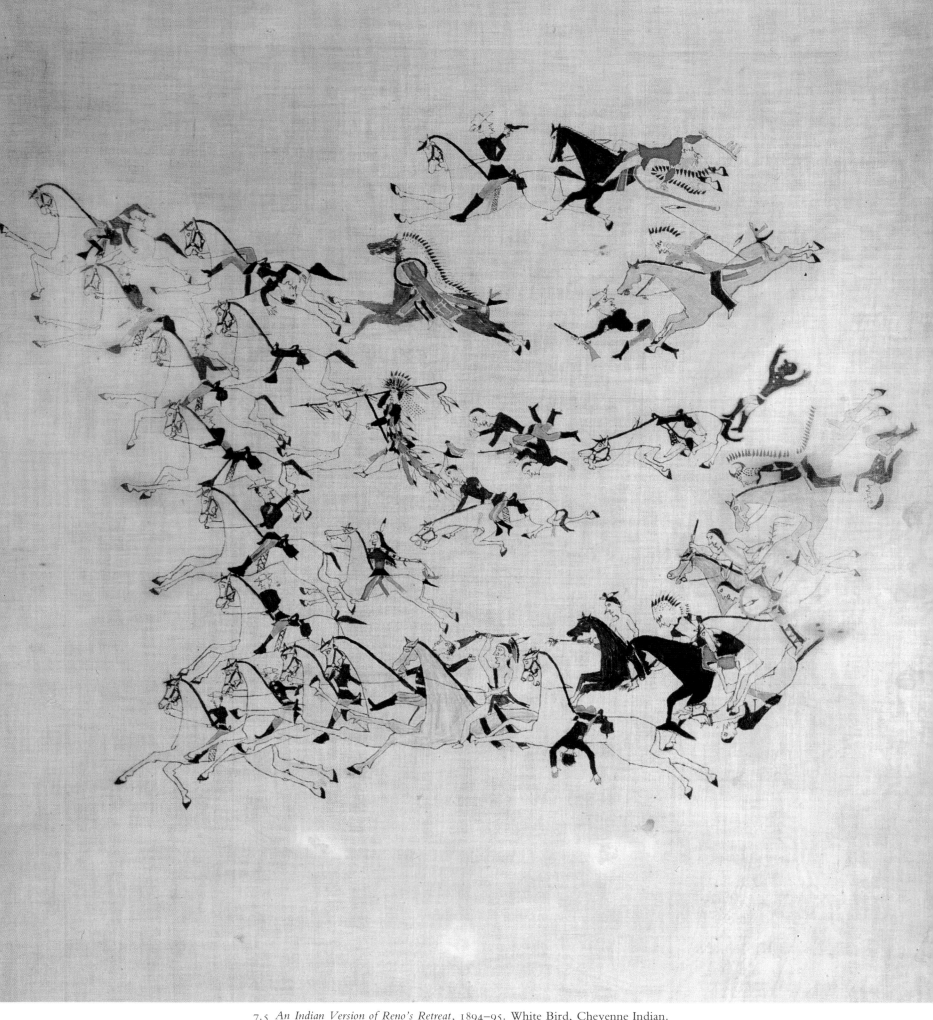

7.5 *An Indian Version of Reno's Retreat*, 1894–95. White Bird, Cheyenne Indian.
Watercolor and ink on muslin, 30 × 25 inches.
United States Military Academy, West Point Collections, West Point, New York

7.6 *A Kiowa Chief Getting up a War Party* (detail), c. 1880. Unknown Kiowa Indian.
Pencil and crayon on paper, 7 × 10 inches.
Cincinnati Art Museum, Cincinnati, Ohio
Gift of Merrit A. Boyle

7.7 Box, c. 1830. Artist unknown.
Painted and stenciled wood, 18 inches wide.
Collection of Howard and Jean Lipman

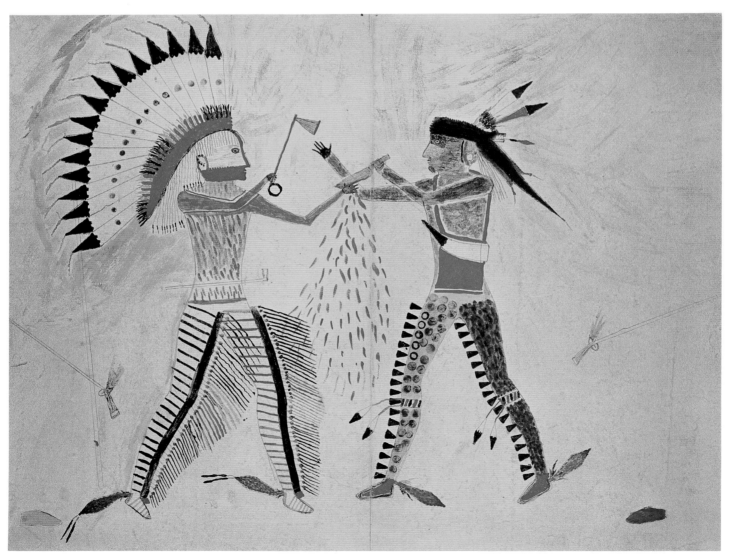

7.8 *Mató-Tópe Battling and Killing Cheyenne Chief*, 1834. Mató-Tópe (Four Bears), Mandan Indian.
Watercolor and ink on paper, 12 × 15½ inches.
The InterNorth Art Foundation/Joslyn Art Museum, Omaha, Nebraska

7.9 *Indian Warrior*, c. 1875. Artist unknown.
Carved and painted wood weathervane, 22½ inches long.
Private Collection

OF ALL THE SOLDIERS who ever fought in an American war, no one has been glorified by folk artists as much as George Washington. Images of Washington have appeared in every medium, and date from the Revolution right up to the present day. Paul Petrovich Svinin, a Russian diplomatic secretary and artist writing about the arts in the United States in 1829, commented on the image of Washington as an icon: "Every American considers it his sacred duty to have a likeness of Washington in his home, just as we have images of God's saints. He would fain keep before his eyes the simulacrum of the man to whom he owes his independence, happiness and wealth!"

7.10 Presentation pin, c. 1865. Artist unknown. Watercolor on ivory, 1¼ × 1 inches. Museum of American Folk Art, New York Joseph Martinson Memorial Fund Frances and Paul Martinson

The earliest representation of Washington shown here, and the only one in this book by an artist who could have actually seen Washington in person, is Frederick Kemmelmeyer's *General George Washington Reviewing the Western Army at Fort Cumberland the 18th of October, 1794* (fig. 7.14), which is believed to have been painted from a sketch done from life. Kemmelmeyer, who was known as a portrait, miniature, and historical painter in Baltimore at the end of the eighteenth and the beginning of the nineteenth centuries, has portrayed the general in his best-known pose: larger than life and astride a mighty charger. Washington and his horse dwarf the neat row of soldiers that have lined up for his inspection, and while great care has been given to creating an accurate likeness of the general, all the troops look exactly alike. The handsomely lettered title is a device that appears on many engravings of the period, and was adopted by a number of folk artists.

Mary Ann Willson's very "primitive" portrait of George Washington (fig. 7.13) shows the father of our country in the act of shooting a pistol. This amusing watercolor (note the plant-like plume growing out of Washington's hat and the decorative, dotted saddle blanket and harness) was painted in Greene County, New York, sometime between 1810 and 1825 by a most unusual woman about whom very little is known.

Willson's watercolors, rediscovered in 1943, were accompanied by a letter written by "An Admirer of Art" that provides a firsthand account of the household and partnership of two women pioneers, Miss Willson and a Miss Brundage. The letter, written about 1850, tells us all we know of the artist's life and can be considered one of the earliest comments on American folk painting:

The artist, Miss Willson, and her friend, Miss Brundage, came from one of the Eastern States and made their home in the Town of Greenville, Greene County, New York. They bought a few acres and built, or formed their house, made of logs, on the land. Where they resided many years.—One was the farmer and cultivated the land by the aid of neighbors, occasionally doing some ploughing for them. This one planted, gathered in, and reaped, while the other made pictures which she sold to the farmers and

others as rare and unique "works of art."—Their paints, or colours were of the simplest kind, berries, bricks, and occasional "store paint" made up their wants for these elegant designs.

These two maids left their home in the East with a romantic attachment for each other and which continued until the death of the "farmer maid." The artist was inconsolable, and after a brief time, removed to parts unknown.

A third painting of Washington on horseback (fig. 7.1) reveals how icons of the general were translated into the traditional folk art of the ethnic groups that settled in America. In this Pennsylvania German watercolor, the painting style is similar to that seen on frakturs—illuminated manuscripts—of the area. Traditional frakturs, such as birth and baptismal certificates, combined a good deal of writing, usually in German, with decorative drawing. Here, the inscription is limited to two lines at the top that translate as "General Washington and the city built in his name," and the labeling of the "Con Gress House," but the colorful picture of Washington is obviously the important subject. The artist has also added his own bit of excitement to the scene—Washington's epaulets, buttons, and the buckle on his hat have been enhanced by gold sparkles applied to the paper.

Although Washington was the most famous, he was by no means the only revolutionary war soldier to be commemorated for his exploits. The portrait of *Captain Samuel Chandler* (fig. 7.17), painted by his younger brother, Winthrop Chandler, proudly portrays the elder Chandler in his blue uniform with gold epaulets. During the Revolution, Samuel Chandler kept a tavern near the present town of Fabyan, Connecticut. As captain of the Eleventh Company, Eleventh Regiment of the Connecticut Militia, he marched to West Chester in 1776, but the location of the battle scene visible through the window in this painting—if, indeed, it is a specific engagement—has not been determined.

Winthrop Chandler was a house and general "fancy" painter who also painted overmantel landscapes. However, his work rarely supplied sufficient funds to support himself and his family; the approximately fifty known portraits that he painted for family, neighbors, and friends in and around his hometown of Woodstock, Connecticut, were an unsuccessful attempt to remain solvent. Eight weeks before his death in Thomson, Connecticut, in 1790 Chandler executed a quitclaim deed in which all his personal property was left to the local selectmen in full

7.11 *Union Soldier*, c. 1861–65. Artist unknown. Painted sheet-iron weathervane, 48 inches high. Collection of James and Kathryn Abbe

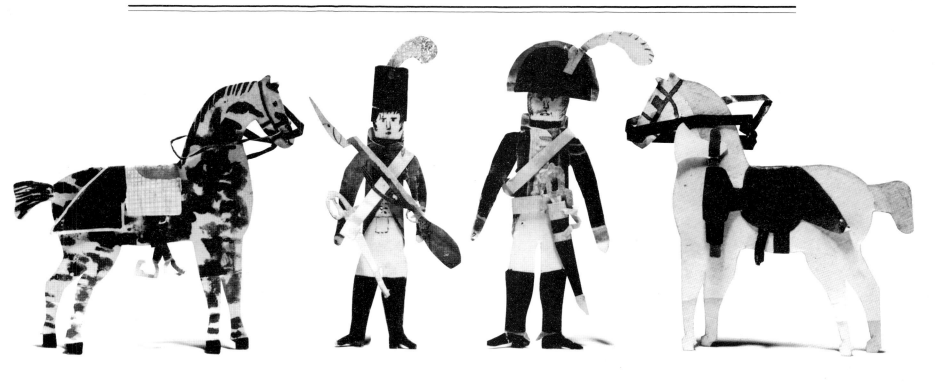

compensation for the town's future expenses in caring for him in his last illness and burial. Ironically, Chandler's powerful, dignified portraits are regarded today as among the most important paintings of the revolutionary period.

The folk artists, obviously inspired by the order and designs formed by neat rows of uniformed men, commemorated proud regiments as well as individual soldiers. *Joseph Mustering the Nauvoo Legion* (fig. 7.16), part of C. C. A. Christensen's "Mormon Panorama," glorifies the militia of the Church of Jesus Christ of Latter-day Saints, organized by the Mormon leader, Joseph Smith. Although the Mormons had founded Nauvoo in an effort to escape persecution, wild raids against the group continued. Smith petitioned the state for permission to organize and drill the "Nauvoo Legion" as a military unit of the Illinois militia. Numbering nearly two thousand men, all of whom carried on their military training in addition to their work and church duties, this uniformed and armed force was dedicated to protecting the Mormon population from further persecution.

Paintings of regiments were sometimes commissioned by their officers, much as the farmers, ship owners, and captains discussed previously paid folk painters to record their homes and ships. *The Gettysburg Blues* (fig. 7.15) is such a commissioned work. Created by an unidentified artist in the middle of the nineteenth century, the painting belonged to Colonel C. H. Buehler, Commander of the Blues in 1850. The scene shows Buehler, at the lower

7.12 Paper dolls, 1840–50. Artist unknown. Watercolor and ink on cut paper; soldiers 4 × 2 inches, horses 4 × 4¼ inches. Museum of American Folk Art, New York Gift of Pat and Dick Locke

left of the picture, and his company parading in front of the stone and brick houses of Gettysburg, Pennsylvania, many of which still stand.

Gettysburg, of course, is most famous today for the Civil War battle that was fought there. The Civil War was the first in American history to be documented by photographers as well as professional battle artists, whose on-the-scene sketches were reproduced as wood engravings in newspapers and illustrated weeklies. One such illustration may have been the inspiration for the painting *Civil War Battle* (fig. 7.18).

7.13 *George Washington*, 1810–25. Mary Ann Willson. Watercolor and ink on paper, 12¼ × 15⅜ inches. Museum of Art, Rhode Island School of Design, Providence Jesse H. Metcalf Fund

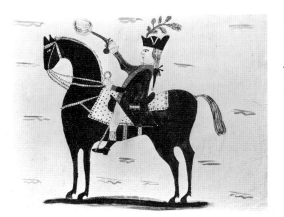

Whatever the source of the scene or the location of the battle, the folk artist, with his sure instinct for color and design, has captured the excitement—and the horror—of war. Union forces are charging from the right of the picture and are met by Confederate troops on the left. In the foreground, the dead and wounded are being carried off the field. Action explodes in the center, where a Union officer is being thrown from his horse. Exciting and busy as the turmoil of a battle scene must be, there is still a dominating sense of order. The artist has organized all the action, selectively featuring events and details that suit the centrally focused overall design.

Just as the uniformed regiments of soldiers and the heroes of the wars were subjects that appealed to folk painters, so, too, did the military man inspire the folk sculptor. Especially during times of war, when patriotism ran high, representations of soldiers were in particular demand. Two examples believed to have been made during the Civil War are a sheet-iron weathervane (fig. 7.11) and a child's toy (fig. 7.21). The latter, a scene of marching Union soldiers, is actually an animated tableau: when the ratchet mechanism is operated by hand, the soldiers proceed in formation. Other forms of sculpture, such as whirligigs, cigar-store figures, and carved portraits, commemorated important military heroes, including Washington, Andrew Jackson, and Ulysses S. Grant, as well as those fighting men who, like most of the artists who sculpted them, remain anonymous.

GENERAL GEORGE WASHINGTON. Reviewing the Western army at Fort Cumberland the 18th of Octobr. 1794.

7.14 *General George Washington Reviewing the Western Army at Fort Cumberland the 18th of October 1794*, c. 1794. Frederick Kemmelmeyer.
Oil on paper backed with linen, 18⅛ × 23⅛ inches.
The Henry Francis du Pont Winterthur Museum, Winterthur, Delaware

7.15 *The Gettysburg Blues*, c. 1850. Artist unknown.
Oil on canvas, 21¼ × 37 inches.
Henry Ford Museum and Greenfield Village, Dearborn, Michigan

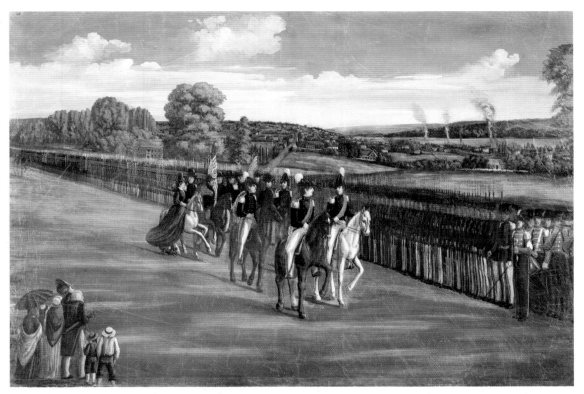

7.16 *Joseph Mustering the Nauvoo Legion*, 1865–90. C. C. A. Christensen.
Tempera on linen, 78 × 114 inches.
Brigham Young University Art Museum Collection, Provo, Utah

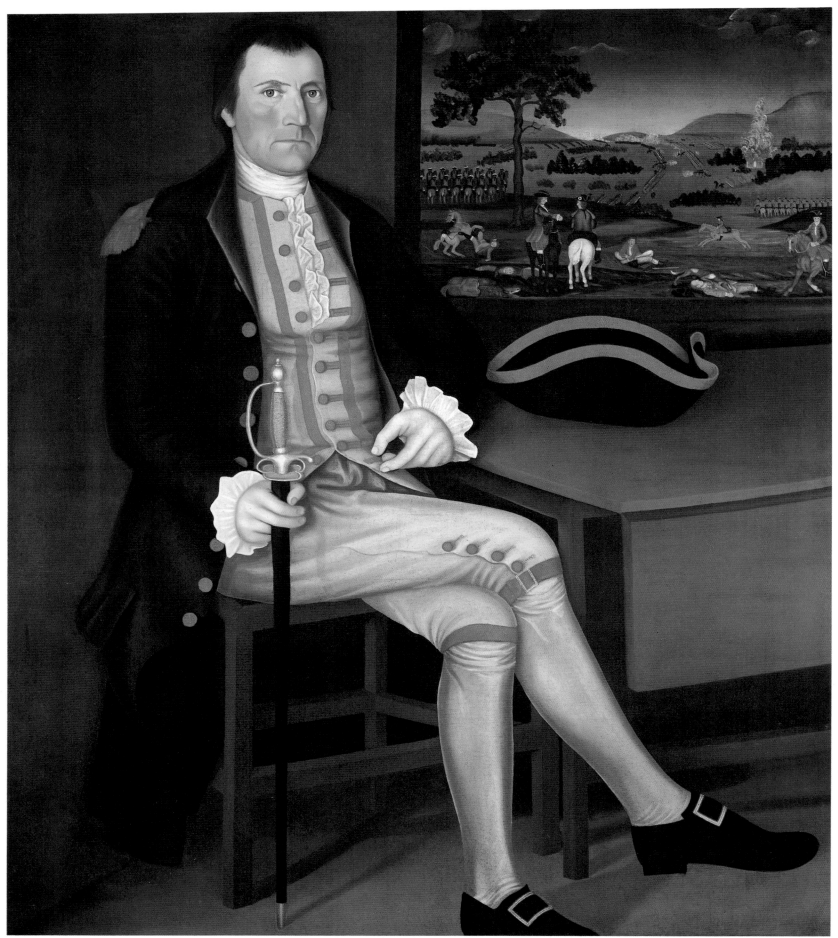

7.17 *Captain Samuel Chandler*, c. 1780. Winthrop Chandler.
Oil on canvas, 54⅞ × 47⅞ inches.
National Gallery of Art, Washington, D.C.
Gift of Edgar William and Bernice Chrysler Garbisch

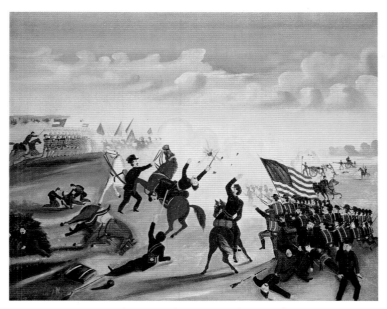

7.18 *Civil War Battle*, c. 1865. Artist unknown.
Oil on canvas, 36 × 44 inches.
National Gallery of Art, Washington, D.C.
Gift of Edgar William and Bernice Chrysler Garbisch

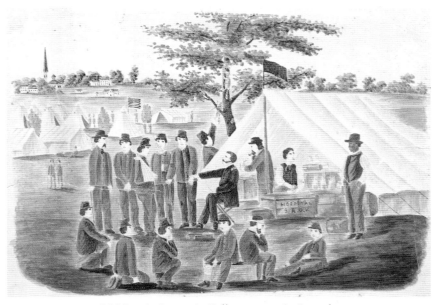

7.19 *McMeens's Surgeon's Call*, c. 1862. Artist unknown.
Watercolor and ink on paper, 8½ × 11½ inches.
Present location unknown

7.20 *Three Horsemen*, 1849. Artist unknown.
Watercolor and ink on paper, 7⁹⁄₁₆ × 12⁵⁄₁₆ inches.
Abby Aldrich Rockefeller Folk Art Center, Williamsburg, Virginia

7.21 Civil War toy, 1861–65. Artist unknown.
Wood and metal, 30 inches long.
Collection of George H. Meyer

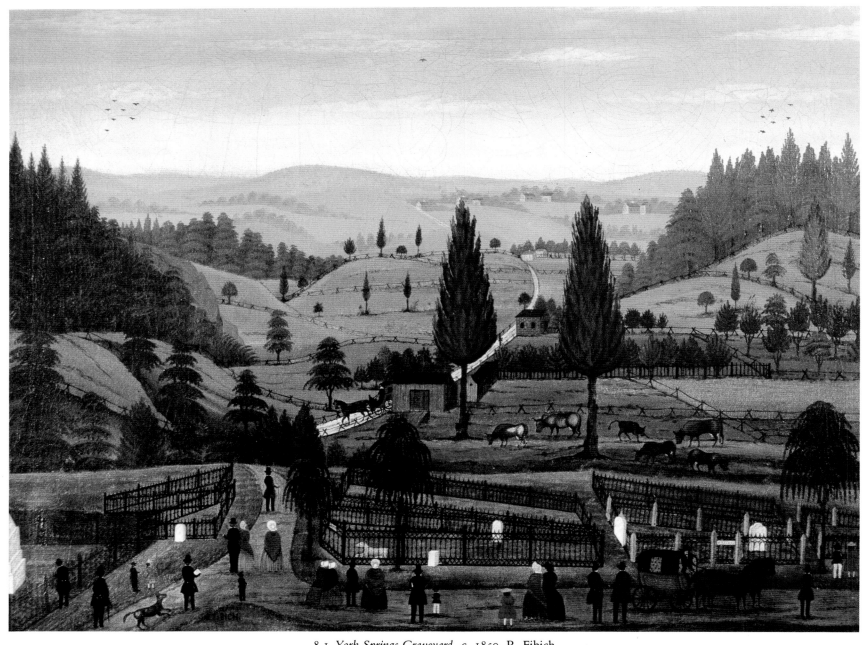

8.1 *York Springs Graveyard*, c. 1850. R. Fibich.
Oil on canvas, 24½ × 30½ inches.
New York State Historical Association, Cooperstown

Weddings, Births, and Deaths

I T WAS NOT JUST the public activities—attending church and school, fighting fires and wars—but also the private times that inspired the folk artists of Young America. Courtship and marriage, birth, and death are personal events that have been captured in the folk art of yesterday, often in a manner so memorable that it still has the power to touch the emotions of those who view it today.

Some of this art was created to commemorate the rites of passage of an artist's own life: a memorial painted in honor of a departed relative or a quilt made to celebrate an upcoming marriage, for example. Other pieces are the work of professionals, who supplied the public with artistic documents, such as wedding portraits or baptismal certificates, that recorded the happy events, as well as those, such as gravestones, that recalled the sorrows.

I N THE EIGHTEENTH CEN-
TURY, a couple often had
to overcome great obstacles
if they desired to marry for
love. Even well into the nine-
teenth century, many marriages
were arranged because they
were judged "suitable," rather
than for romantic reasons. But,
because the married state had
so many economic and social,
as well as psychological, ad-
vantages over the single life,
both men and women were
glad to enter into it, even if not
with a person of their own
choosing.

Romantic attachments, how-
ever, were certainly not un-
common, and they supplied
great inspiration for much of
the art and literature of the
day. Some of the most endear-
ing letters of the early nine-
teenth century record the
courtship of the itinerant folk
artist Deborah Goldsmith
(whose work is shown in chap-
ter one) by one of her subjects
and her future husband, George
Throop. The couple met when she was com-
missioned to paint his portrait, and in the series
of letters exchanged by Deborah and George
during their courtship in 1832 we get a glimpse
of the same charm and candor that distinguish
her paintings. In reply to George's proposal by
mail, she raises several modest doubts about
whether her suitor will remain steadfast through
long years of prosperity and adversity, and
whether he will bear with all her weaknesses.

*Some things I want to remind you of, that you may
weigh them well (even now, before it is too late), I
do not know but you have, but permit me to name
them. Your religious sentiments and mine are differ-
ent. Do you think that this difference will ever be the
cause of unpleasant feeling? Your age and mine dif-
fer. I do not know your age exactly, but I believe
that I am nearly two years older than you. And
now, permit me to ask, has this ever been an objec-
tion in your mind? And another thing which I expect
you already know is, that my teeth are partly artifi-
cial. Nature gave me as many teeth as she usually
gives her children, but not as durable ones as some
are blessed with. Some people think it is wrong to
have anything artificial, but I will let that subject go.*

Some of the sentiment inherent in the letters
between George Throop and Deborah Gold-
smith can be sensed in a watercolor by another
early-nineteenth-century artist, Eunice Pinney.
In her painting titled *The Courtship* (fig. 8.5),
Mrs. Pinney displays the robust style and bold
design that distinguish the work of this mature
woman from the schoolgirl watercolors of the
period. Pinney, a well-born, well-educated, and

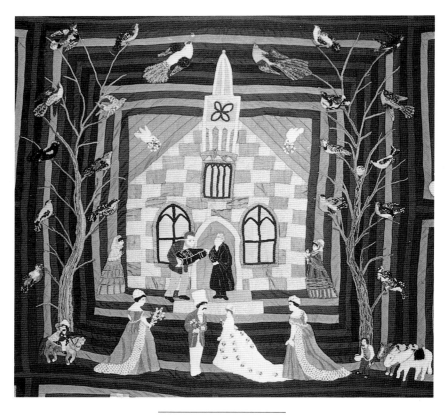

8.2 *Wedding Quilt* (detail), 1876. Artist unknown.
Pieced, appliquéd, and embroidered cotton,
approximately 80 × 80 inches.
Present location unknown

influential Connecticut woman, turned to paint-
ing as a hobby during the early years of the
nineteenth century. She seems to have been ac-
quainted with at least one of the interests of ac-
ademic painting: the reflections in the pond in
this watercolor appear to be an attempt at pro-
ducing the kind of mirror image that, while
seen in nature, is generally disregarded in folk
painting. This scene, with its mirrorlike reflec-
tions, may have been inspired by some late-
eighteenth-century engraving, as much of Pin-
ney's work was, but the overscaled grapevine
that hangs above the suitor's head was certainly
Mrs. Pinney's own addition to the bucolic
setting.

A second courting scene, *The Proposal* (fig.
8.4), is an unusual carved sperm-whale tooth
with a jawbone base. As discussed in chapter
six, most whalebone was transformed into
household objects or other functional items, or
left intact and incised with a scene of life at sea
or at home. Rarely was a tooth shaped, as here,
into a decorative carving in the round. Un-
doubtedly, the homesick "scrimshander" who
created this sculpture meant it as a very special
gift for his intended.

A formal engagement, an important event that
follows upon a successful courtship, may be the
occasion celebrated in Henry Young's water-

color portrait lettered "Miss
Frances Taylor's Picture
Bought A.D. 1831" (fig. 8.8).
Young, a parochial-school
teacher who came to the
United States from Saxony in
1817 and settled in Union
County, Pennsylvania, special-
ized in the drawing of birth,
baptismal, marriage, and con-
firmation certificates, and mini-
ature portraits. His work falls
into a number of distinct cate-
gories, each with its own iden-
tifying characteristics. *Miss
Frances Taylor* is typical of the
"Man and Woman with Wine-
glass" group, though these
were usually drawn, according
to their inscriptions, to com-
memorate the birth of a child.
Besides the proposing of a
toast, these fraktur pieces con-
tain, as here, eight-pointed
stars, a tiny yellow and green
bush, and heart-shaped turn-
ings on the tripod stand. The
costumes of both the men and
the women in the group are
also very similar to the blue suit and flowered
dress seen here.

Young created fraktur to supplement his teach-
ing income from about 1823 until his death in
1861. A few of the works identified as his have
blanks where the dates and county remain to be
filled in, indicating that the artist drew his cer-
tificates during leisure hours, then completed
the inscription when he received a commission.

In Henry Young's watercolors, as in fraktur
painting in general, the subjects were identified
in writing, and attention was not paid to creat-
ing accurate likenesses. A much more lifelike
portrait commissioned, according to a descen-
dant, in honor of an upcoming wedding is the
painting of Martha Eliza Stevens Paschall (fig.
8.10), who was married in St. Louis in 1833.
The pair of painted Sheraton "fancy" chairs that
are shown so prominently in the picture—the
bride-to-be is seated on one, the other is left
empty for her intended—were said to have been
prized gifts for the happy couple.

Besides gifts given by friends and relations,
such as the watchstand shown in figure 8.3, it
was a custom in some areas for a girl to bring
to her marriage a "baker's dozen" quilts. Girls,
taught to sew at an early age, began fashioning
quilts for their dowries from scraps of fabric
they saved or from special pieces purchased for
a very important quilt. Often, a girl sewed only
the top of the quilt herself; the top, stuffing,
and backing were then sewn together at a social
event: the quilting bee. Quilts were either
pieced—made up of fabrics precut into small
geometric shapes that were joined to make
larger blocks that were, in turn, sewn to-

gether—or appliquéd, like the two quilts shown here (figs. 8.2 and 8.6). To make these pictorial quilts, each element of the design was cut out, its edges carefully turned, as if making a hem, then stitched to a plain backing with a fine hemming or buttonhole stitch.

The festive scenes shown on these quilts could have illustrated the wedding attended by folk artist Ruth Henshaw Bascom, and described in her diary in the summer of 1828:

. . . and at two we attended the wedding of Emerson Green and Clarisa (?) Wright (at her mothers 1 1/2 N. west.) Their parents, brothers and sisters, Mr Isaac Lawner (?) & wife, Alford Spaulding & wife & Mrs Ramsell present in all about 30. Bride dressed in plain white muslin with several wide tacks or

tucks (a foot or two in all), long and full sleeves being the latest 'fashion' ——— black shoes, lace tucker, etc. etc. Groom dark clothing . . . had punch & toddy—tea, cake—cider . . . all in abundance.

The wife who brought a dowry, including quilts, linens, and other household goods, and, in some cases, money, to a marriage was following an Old World custom that survived in the New World for varying lengths of time, depending on the cultural group. But Europeans were not the only ones to bring their wedding customs with them to America. *The Old Plantation* (fig. 8.9), a watercolor found in South Carolina and probably painted about 1800, depicts surviving African tribal customs among a group of slaves of the American South. During the eighteenth century, slaves from the Hausa and Yoruba tribes of northern and southwestern Ni-

geria and British West Africa were brought directly to Charleston. In this painting, which probably depicts a slave wedding, the lively dance shows steps that reflect African influence. Tribal dances in Africa often incorporated the use of canes and head scarves, and a part of some slave marriage ceremonies involved jumping over a stick. In Africa, bandannas, called "head ties," were colored and tied in ways that indicated status in the society. The blue and white head scarves shown here resemble West African Yoruba cloth. One musician plays an African *molo*, a precursor of the banjo; the drum of Yoruba origin was called a *gudugudu*. The plantation house in the background of the painting is believed to have stood between Orangeburg and Charleston, South Carolina.

8.3 Watchstand, 1800–50. Artist unknown.
Painted wood, 14⅝ inches high.
The Henry Francis du Pont Winterthur Museum,
Winterthur, Delaware

8.4 *The Proposal*, c. 1830. Artist unknown.
Carved sperm-whale tooth with jawbone base, 3½ inches high.
Old Dartmouth Historical Society, New Bedford, Massachusetts

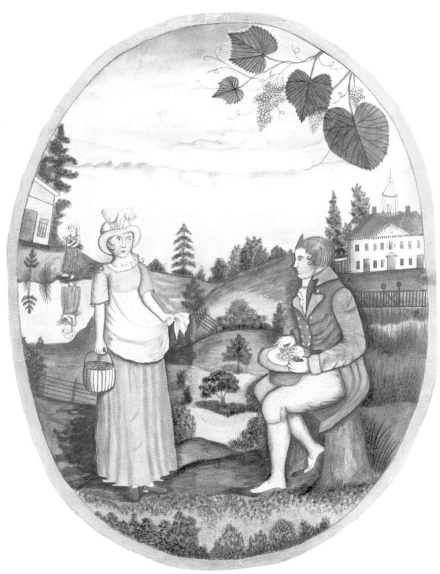

8.5 *The Courtship* (detail), c. 1815. Eunice Pinney.
Watercolor and ink on paper, 12½ × 9¼ inches.
Collection of Mr. and Mrs. Erving Wolf

8.6 (*opposite*) *Greenfield Hill Coverlet* (detail), c. 1800. Sarah Furman Warner.
Appliquéd and embroidered cotton, 105 × 84 inches.
Destroyed

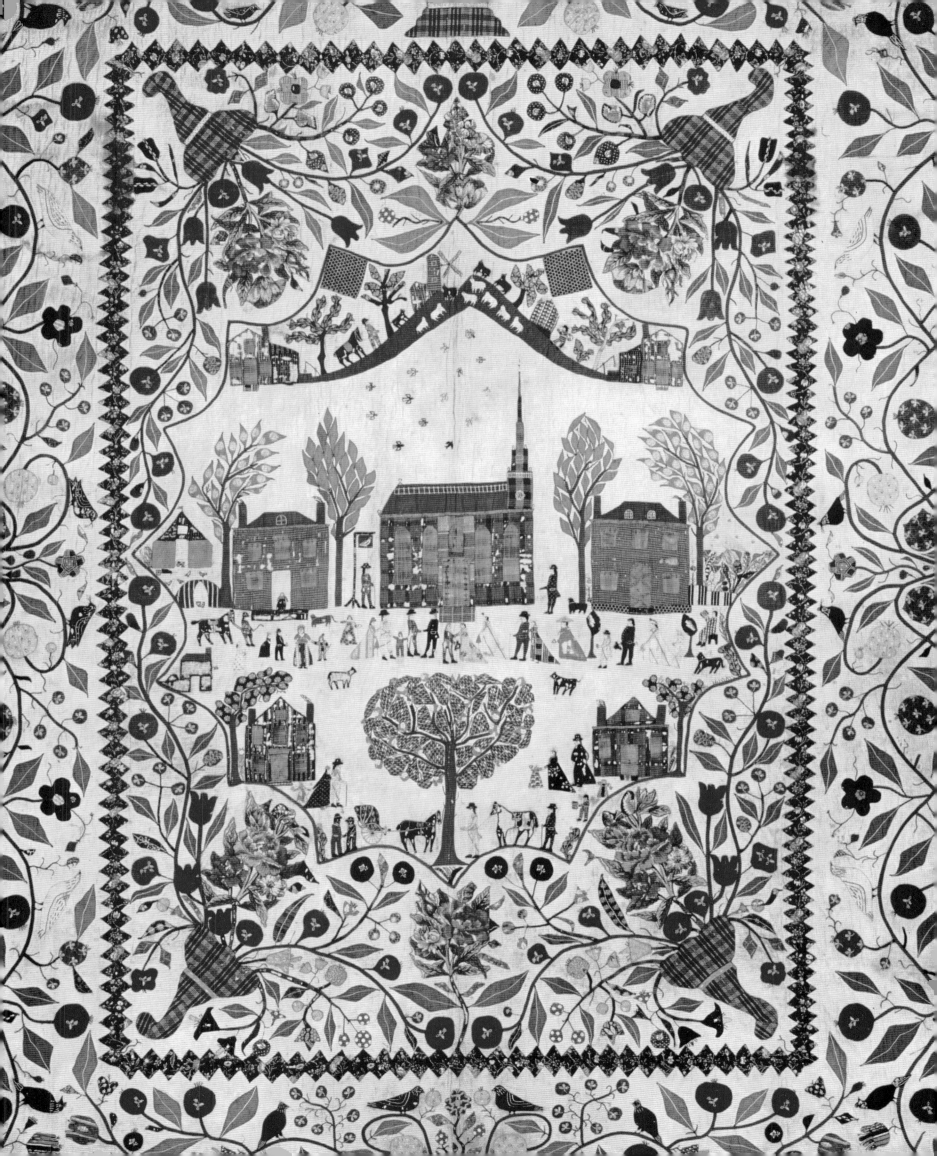

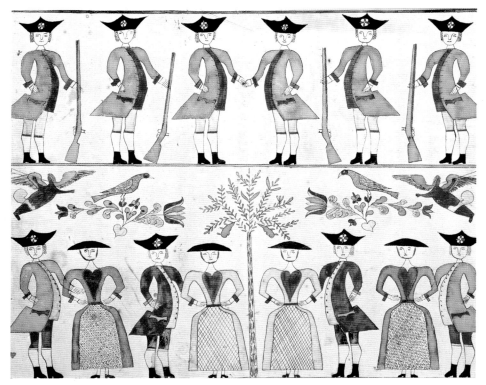

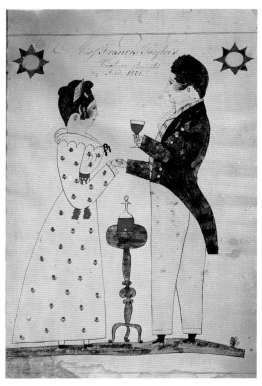

8.7 *Military Wedding*, 1800–1820. Attributed to Johann Adam Eyer.
Watercolor and ink on paper, 12⅜ × 15½ inches.
The Henry Francis du Pont Winterthur Museum, Winterthur, Delaware

8.8 *Miss Frances Taylor*, 1831. Henry Young.
Watercolor and ink on paper, 12 × 7⅞ inches.
The New-York Historical Society, New York

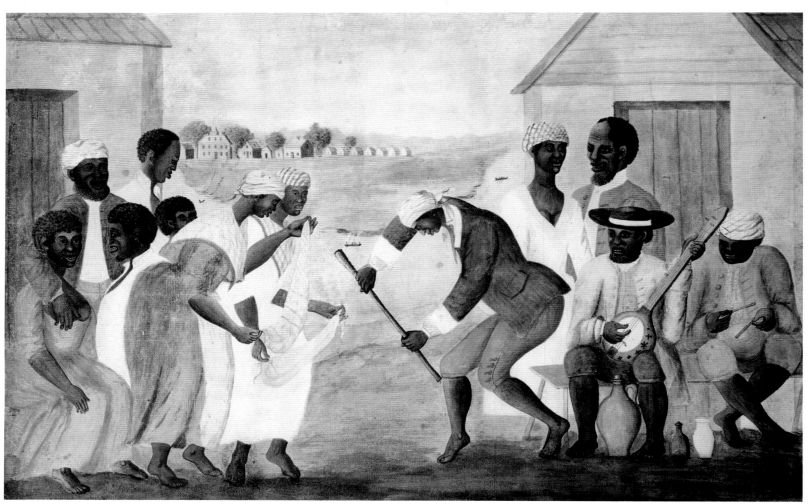

8.9 *The Old Plantation*, c. 1800. Artist unknown.
Watercolor on paper, 11¹¹⁄₁₆ × 17⅞ inches.
Abby Aldrich Rockefeller Folk Art Center, Williamsburg, Virginia

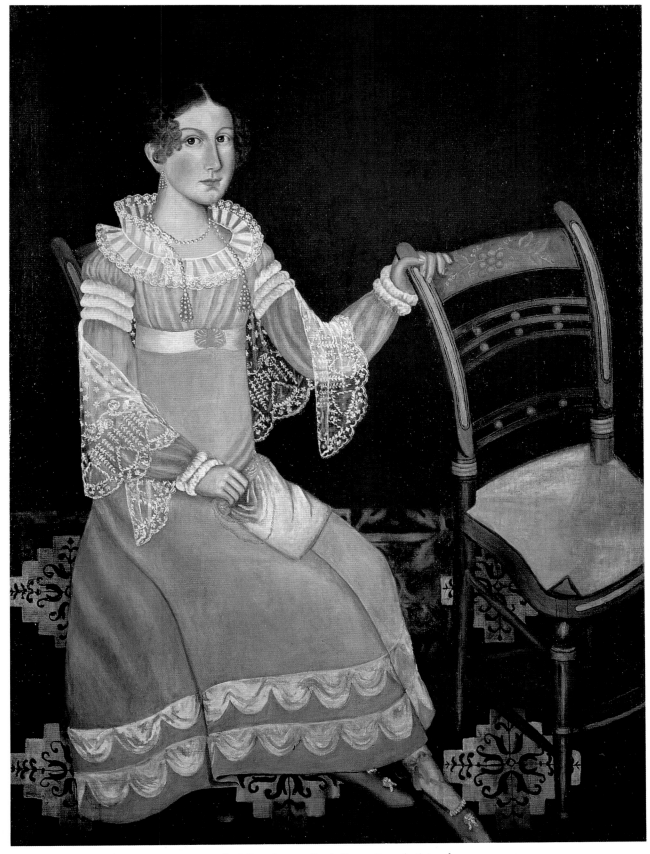

8.10 *Martha Eliza Stevens Paschall*, c. 1833. Artist unknown.
Oil on canvas, 51 × 39 inches.
National Gallery of Art, Washington, D.C.
Gift of Mary Paschall Young Doty
and Katharine Campbell Young Keck

WHEN, AROUND THE START of the Revolution, Prudence Punderson stitched a needlework picture showing herself in *The First, Second, and Last Scene of Mortality* (fig. 8.12), she might have been thinking about the dangers of childbirth for both mothers and infants in her time. Childbearing frequently ended in death for both mother and child, and even young women like Miss Punderson realized how short the trip from cradle to grave could be. In her own case, it was indeed brief, lasting only twenty-six years.

High infant mortality rates demanded that, among some religious groups, baptisms be performed as soon as possible after birth to insure the redemption of the soul of the child should it die. *Presenting Baby* (fig. 8.13), an early-nineteenth-century painting by an unidentified artist, probably shows one such infant, taken from a warm bed and brought into the cold world for baptism.

Despite the awareness of the high rate of infant mortality, births were joyous occasions. Many cultural groups recorded the happy events with birth and baptismal certificates, family registers, and family trees. The *Taufschein*—the birth and baptismal certificates of the Pennsylvania German Protestant churches that practiced infant baptism—comprise the largest body of surviving family documents and some of the most beautiful.

These certificates are part of the fraktur tradition, a term that is broadly defined as illuminated manuscripts, an art form that can be traced back to medieval Europe. *Fraktur-schriften*, "fraktur writing," was one of the arts the German-speaking immigrants brought with them from the Old World. Almost every eighteenth-century group of German-speaking Protestants migrating to America included a minister or schoolmaster who was skilled in fraktur writing. To add to their

incomes, these men and their successors (such as Henry Young, discussed earlier) prepared the certificates of birth, baptism, marriage, and death that had been required by law in Europe and continued to be made by tradition-loving Germans in their new home.

Schools in German communities throughout Pennsylvania continued to teach manuscript il-

8.11 Andrew Mayberry–Margaret Trott Family Record, 1850.
"Heart and Hand" artist.
Watercolor and ink on paper, 13⅜ × 9⅜ inches.
Museum of American Folk Art, New York
Gift of Mr. and Mrs. Philip M. Isaacson

lumination and fraktur writing well into the nineteenth century. Many of them were still instructing their pupils in this ancient craft at the time of the establishment, in the 1850s, of the English school system, a development that virtually ended the art of fraktur. Although printed certificates had been available as early as the end of the eighteenth century, as the printing press became more widely used during the second quarter of the nineteenth century, the fraktur-maker was forced from his trade. From then on, ready-made certificates, designed to be colored at home and filled in as required, were mass-produced. Handmade examples were simply too expensive to compete.

Birth and baptismal certificates are the most common, but not the only form of fraktur. *Vorschrift*, a penmanship example (usually a Biblical passage) prepared by a schoolmaster for his pupils to copy, is the next most numerous type. Other kinds of fraktur are "rewards of merit," drawn by teachers for diligent students, bookplates and illustrations for hymnals, house blessings, and various other presentation pieces.

Traditional motifs drawn from European sources and applied to other Pennsylvania pieces, such as painted furniture, were also used to embellish fraktur. Unicorns, stags, mermaids, lions, and a variety of birds, including doves, peacocks, and parrots, as well as favorite flowers, such as tulips, are common themes. A bird is prominent on the birth and baptismal certificate for Johannes Dottern (fig. 8.14), born December 25, 1831. Painted by an artist identified only as "the Northampton County artist," the inscription on this beautiful fraktur translates: "One bird in the hand is worth two in the forest." In *A Baptism* (fig. 8.15), attributed to Durs Rudy of Broadheadville, Pennsylvania, a Biblical quotation accompanies the scene of the child's baptism.

8.12 *The First, Second, and Last Scene of Mortality*, c. 1775. Prudence Punderson.
Silk thread on satin, 12¾ × 17 inches.
Connecticut Historical Society, Hartford

8.13 *Presenting Baby*, c. 1825. Artist unknown.
Oil on canvas, 20 × 14 inches.
New York State Historical Association, Cooperstown

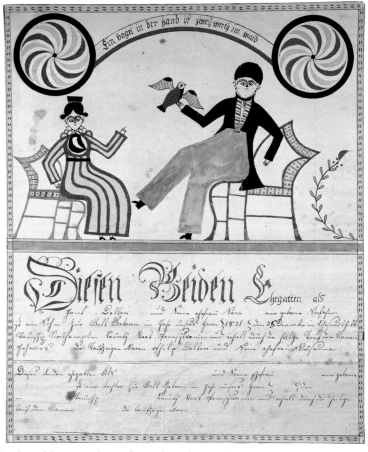

8.14 Birth and baptismal certificate for Johannes Dottern, c. 1835. Artist unknown.
Watercolor and ink on paper, 15 × 11⅞ inches.
Private Collection

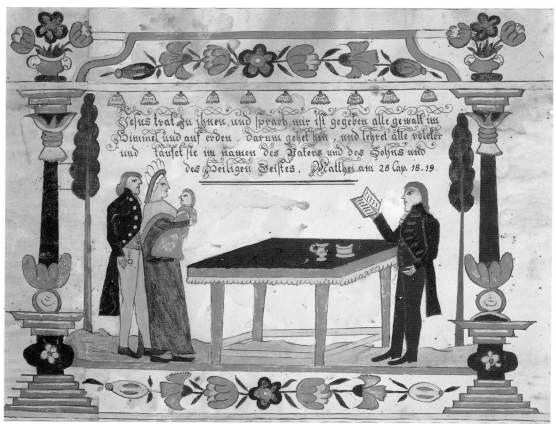

8.15 *A Baptism*, c. 1825. Attributed to Durs Rudy.
Watercolor and ink on paper, 7⅞ × 9¹³⁄₁₆ inches.
Museum of Fine Arts, Boston
M. and M. Karolik Collection

THE ODDS AGAINST SURVIVING to an old age in early America were great. Mortality rates, especially among children, were high, and medical practices of the time often did more harm than good. The old adage "If the disease doesn't kill you, the cure will" could easily be applied to such unpleasant eighteenth-century remedies as leeching, purging, and induced vomiting.

Throughout most of the eighteenth century, the attitude toward death was quite matter-of-fact. A list of friends, neighbors, and even family members who had died might be included in the final paragraphs of letters without other comment than, perhaps, a mention that one must accept God's will. Death was too common to romanticize and too frequent to permit elaborate mourning practices. Toward the end of the eighteenth century, however, as the death rate began to decline somewhat, mourning, especially for the young, became more elaborate. It also became fashionable to commission memorials, such as posthumous portraits of the departed, for the home.

Mortality statistics for children did not significantly improve in the nineteenth century. Far from being shielded from the concept of death, children grew up to accept its inevitability. Verses in samplers made by young girls often alluded to the maker's mortality, and even nursery rhymes spoke of the possibility that death could snatch a child from play at any time. Children's toys sometimes took forms that we would consider morbid: toy coffins, as in figure 8.16, were acceptable playthings. In some cases, the figure of the deceased in this kind of toy was a removable doll; in this example, the man was made to spring up when the coffin was opened.

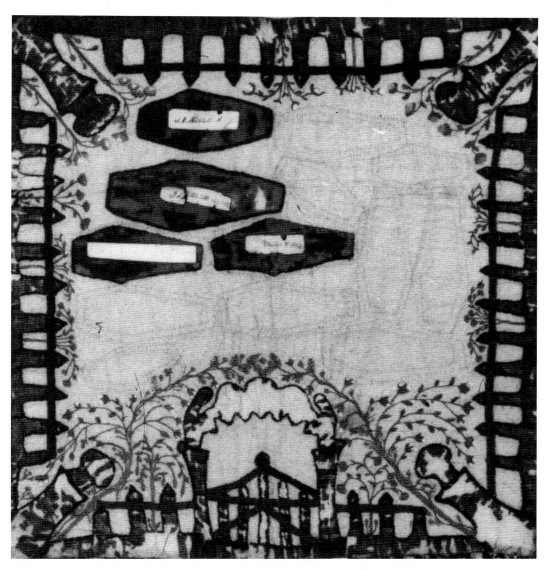

8.17 *The Graveyard Quilt* (detail), 1839. Elizabeth Roseberry Mitchell. Pieced, appliquéd, and embroidered cotton, 79½ × 80 inches. Kentucky Historical Society, Frankfort

8.16 Toy coffin, c. 1875. Artist unknown. Carved and painted wood, 7 inches long. Present location unknown

While children had verses to stitch or rhymes to chant or toys to play with that helped them deal with the subject of death, adults could turn to traditional crafts to help them express their feelings and accept the inevitability of death. The unique *Graveyard Quilt* (fig. 8.17), stitched by Elizabeth Roseberry Mitchell of Lewis County, Kentucky, in 1839, was created to commemorate deceased members of her family. The coffins placed along the border of the quilt bear the names of relatives. When a family member died, his symbolic fabric coffin was moved to the graveyard in the center of the quilt.

Graveyards are excellent sources of information about attitudes toward death and dying. The stonecutters of Colonial New England carved gravestones that bore stark symbols of death and resurrection: hollow-eyed death masks, skulls, and emptying hourglasses. Grad-

ually, these macabre images were replaced by less menacing angels, and, by the end of the eighteenth century, portraits of the deceased were used in some areas instead of symbolic figures. The gravestone of Mary Harvey and her child (fig. 8.19) of Deerfield, Massachusetts, includes an abstract representation of the pair, along with the following epitaph: "In memory of/Mary the Wifeof/Simeon Harvey/Who Departed this/Life December 20th/1785 In 39th yearof/Her age on her left/Arm lieth the Infant/which was ftill/Born."

Jabez Smith's 1780 gravestone (fig. 8.18) presents a benign attitude toward death. Above a remarkably detailed carving of a ship at sea (indicating that Smith was a seagoing man) is the inscription: "Anchor'd in the haven of Reft."

Other epitaphs, now regarded as part of American folklore, reveal the wit and humor of people often thought of as sober New Englanders.

8.18 Gravestone of Jabez Smith (detail), 1780. Artist unknown.
Slate, 32 inches high.
Photograph, collection of Daniel and Jessie Lie Farber

8.20 *Father Time*, c. 1910.
Artist unknown.
Carved and painted wood, metal, hair,
52⅛ inches high.
Museum of American Folk Art,
New York
Gift of Mrs. John H. Hemingway

The stone of a Cape Cod fisherman, Captain Thomas Coffin, succinctly describes his life and death: "He has finished catching cod/And gone to meet his God." A brisk, prosaic epitaph on a stone at Oxford, New Hampshire, reads: "To all my friends I bid adieu/A more sudden death you never knew./As I was leading the old mare to drink/She kicked and killed me quicker'n a wink."

At the beginning of the nineteenth century, elements of the Romantic movement, first popular in Europe, began to influence American mourning practices. Part of the Romantic attitude, an adulation of country life and a rejection of the cities, was reflected in the movement away from city burial grounds and toward rural cemeteries, such as the one shown in R. Fibich's mid-nineteenth-century landscape, *York Springs Graveyard* (fig. 8.1). These country cemeteries, including New York City's famous Greenwood Cemetery in then rural Brooklyn, were regarded as parks where a family could go for a peaceful drive or stroll on a Sunday afternoon. Often, the grounds were beautifully landscaped and ornamented with statuary to make the atmosphere more pleasant.

York Springs Graveyard displays much of that Romantic, contemplative mood. Cows graze peacefully while the people in the picture all stand facing the cemetery with their backs to the viewer. This convenient pose was a practical arrangement: a back view of the group was relatively easier to paint.

The camera, however, had no such trouble recording frontal poses. The late-nineteenth-century photograph of the Harvey Andrews family of Nebraska at the grave of their nineteen-month-old son, Willie (fig. 8.21), clearly shows the somber faces of the surviving family members. Then, as now, the loss of a child was especially painful, but it was often even more difficult on the frontier, where medical and spiritual help were hard to come by. In a letter dated December 2, 1912, quoted by Luchetti and Olwell, Elinore Rupert Stewart wrote of this sad situation:

As there had been no physician to help, so there was no minister to comfort, and I could not bear to let our

8.19 Gravestone of Mary Harvey
and child (detail), c. 1785.
Artist unknown.
Slate, 32 × 19⅛ inches long.
Photograph,
collection of Daniel and Jessie Lie Farber

baby leave the world without leaving any message to a community that sadly needed it. His little message to us had been love, so I selected a chapter from John and we had a funeral service, at which all our neighbors for thirty miles around were present. So you see our union is sealed by love and welded by great sorrow.

8.21 Harvey Andrews family, date unknown. Solomon D. Butcher.
Photographic print, 6½ × 8½ inches.
Nebraska State Historical Society, Lincoln
Solomon D. Butcher Collection

8.22 *Catholic Funeral Procession*, c. 1910. Artist unknown.
Carved wood, leather, metal, and bone, 15¾ inches long.
Abby Aldrich Rockefeller Folk Art Center, Williamsburg, Virginia

THE INFLUENCE OF ROMANTICISM, which began to be felt in American arts and literature at the end of the eighteenth century, is also evident in the large number of needlework and watercolor memorial pictures created from about 1800 through the 1830s. Educated young ladies, introduced to the tenets of Romanticism through the popular English authors of the day, were expected to indulge in sentimentality; they frequently took such themes as "Memories of Love," as well as memorials, for their needlework projects at school. This was a great change from just a few years earlier, when such sentiment was not popular in the needle arts and young girls stitched bright floral designs, happy scenes, and lively samplers.

In general, mourning pictures, whether embroidered or painted, are composed of a number of standard motifs. The most common are mourning figures, usually female, bowed in the classical posture of grief, classical urns mounted on inscribed tombs, and weeping willows. While visual representations of mourning women at tombstones are known from ancient times, this specific combination of elements can be traced to the late-eighteenth- and early-nineteenth-century European practice of memorializing public figures in textiles, ceramics, and prints. In particular, prints of Swiss-born artist Angelica Kauffmann's painting *Shakespeare's Tomb* were widely circulated in this country, where in 1799 the composition was adapted to commemorate the death of the greatest American hero, George Washington.

In the following years, schoolgirls and their teachers drew on these and other sources to create pictures that memorialized relatives as well as national heroes. Silk embroideries—silk threads on silk backgrounds—were the vogue at the beginning of the century, but soon thereafter women began to combine ink and watercolor with stitchery on these beautiful but costly and time-consuming creations, as is seen in the *Memorial for Mrs. Ebenezer Collins* (fig. 8.24). Eventually, these were replaced by memorials executed entirely in watercolor, a medium that was easier to use and less expensive. Interestingly, however, needlework remained the inspiration for a number of watercolor artists, such as the unidentified creator of the memorial for *Polly Botsford and Her*

Children (fig. 8.25), who painted with short, precise strokes—especially for the foliage—in imitation of embroidery stitches.

The Polly Botsford memorial is an especially effective composition. Starting with the conventional elements—willows, cypresses, church, mourners, tomb—the anonymous artist created an impressive example far removed from the common genre. The stylized scene with the church reduced to a skeleton framework relates to various aspects of today's abstract painting. The paper itself, as in Paul Seifert's farm scene (chapter three, fig. 3.5), is an important abstract element of the design; it is left uncolored for the interior of the church and the tomb inscription. The effective use of arbitrary scale is another element of the unselfconscious abstraction, as are the formal design repeats—triangles of church arches, triangular figures, showers of triangular willow leaves, and conical cypresses. The twentieth-century poet Stanley Kunitz has written some moving verses for Polly Botsford, a literary memorial dedicated to a painted one:

Mourn for Polly Botsford, aged thirty-nine,
and for her blossom Polly, one year old,
and for Gideon, her infant son, nipped in the bud.
And mourn for the mourners under the graveside
* willow,*

8.23 Memorial locket, 1820–30.
Artist unknown.
Oil on ivory, hair, metal, and glass,
2¾ × 2⅛ inches.
Museum of American Folk Art, New York
Promised gift of Howard and Jean Lipman

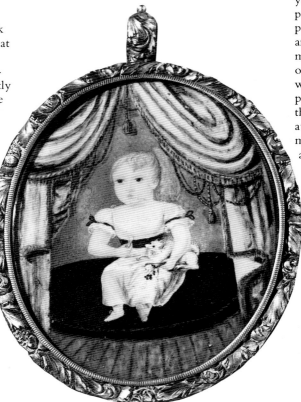

trailing its branches of inverted V's,
those women propped like bookends on either side of
* the tomb,*
and that brace of innocents in matching calico
linked to their mother's grief with a zigzag clasp of
* hands,*
as proper in their place as stepping-stones.
Mourn, too, for the nameless painter of the scene
who, like them all, was born to walk a while
beside the brook whose source is common tears,
till suddenly it's time to unlatch the narrow gate
and pass through the church that is not made with
* walls*
and seek another home, a different sky.

Memorials were generally made by relatives of the deceased as gifts for family or close friends; a girl might stitch or paint a mourning picture in honor of a relative she had never even known. These memorials were frequently made long after the death occurred: a letter from Isaac Clark to his daughter at school, dated September 11, 1806, includes the following request: "I wish you now to work in embroidery a mourning piece in memory for your brother Strabo—who died June 29, 1799, aged 8 months and 13 days."

Schoolgirls sometimes also painted miniature memorials, as in figure 8.23, although most often these were done by professional portrait artists. Most of these miniatures were executed on thin sheets of ivory, encased in gold or silver frames, and worn as jewelry.

By the late 1830s, the popularity of mourning pictures had begun to decline. Many of the young ladies' seminaries had been replaced by public schools, where more emphasis was placed on academic subjects than on needlework and watercolor painting. The Romantic movement was also waning, and by midcentury elaborate displays of mourning and sentimentality were no longer fashionable. But the most important factor in the decrease in popularity of the art form was, beginning about 1835, the availability of the inexpensive, mass-produced mourning lithographs made by Currier & Ives and D. W. Kellogg & Co. When anyone could buy a mourning print designed much like the elegantly stitched and painted ones and simply fill in the blanks, the lovely handmade mourning picture became obsolete.

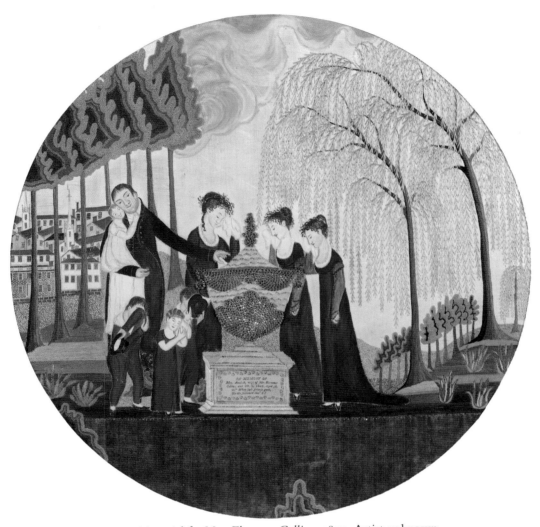

8.24 *Memorial for Mrs. Ebenezer Collins*, 1807. Artist unknown.
Velvet, metallic braid, ink on paper, embroidery, and watercolor on satin, 17½ × 17½ inches.
Museum of American Folk Art, New York
Eva and Morris Feld Folk Art Acquisition Fund

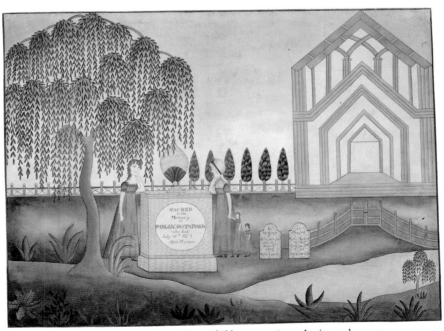

8.25 *Polly Botsford and Her Children*, c. 1815. Artist unknown.
Watercolor and ink on paper, 18 × 23½ inches.
Abby Aldrich Rockefeller Folk Art Center, Williamsburg, Virginia

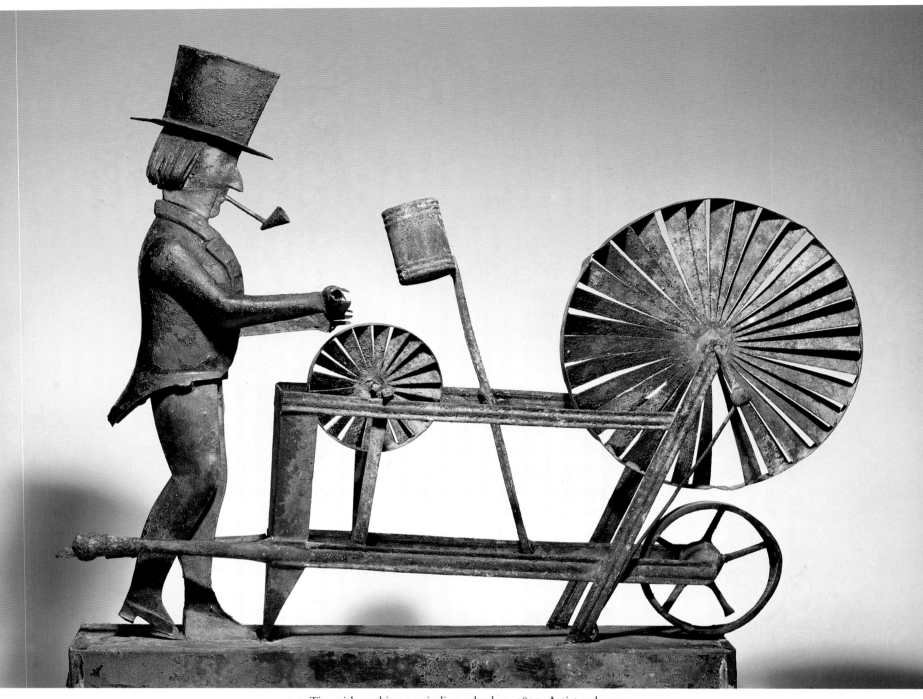

9.1 Tinsmith pushing a grinding wheel, c. 1825. Artist unknown.
Painted tin, 13 inches high.
Private Collection

Work

AMERICA'S ECONOMY, from the early days of the new republic until well into the nineteenth century, has been characterized as "homespun." In this mostly pastoral country, people met their own needs to a great extent: craftsmen were also farmers, and farmers had to be, if not jacks-of-all trades, then at least competent at many. Often, these craftsmen-farmers, and women as well, were also artists, fashioning such necessary items as weathervanes, decoys, household utensils, and bedcovers with such an innate sense of design and desire to create something beautiful that the finished object goes beyond the purely functional and into the realm of art.

As the nineteenth century progressed, so did the specialization of labor. In the growing villages and cities, artisans like carpenters, cabinetmakers, and smiths found ample patronage for their skills and began to concentrate on making specific items. Shops replaced itinerant peddlers in these towns, although the new businesses often kept the time-honored peddlers' tradition of swapping goods for services. These shops often needed means of advertising their wares, and folk artists were prepared to make trade signs and shop figures, including the ubiquitous cigar-store Indian.

In the years immediately preceding the Revolution and after World War I, women were more often employed in other than domestic activities than during the period considered here. Between these two wars, as is indicated by the illustrations in this section, most, although certainly not all, women were engaged in the unending round of domestic chores that were traditionally believed to be their domain.

THE SCULPTURAL FORMS of folk art are particularly well suited to showing craftsmen at work on the job. Weathervanes and whirligigs, for example, made to move in the wind, clearly convey the action involved in the activities they represent. Besides indicating the direction of the wind, weathervanes sometimes also served as trade signs (fig. 9.4 may be one of these). Whirligigs, like the dapper figure of a tinsmith pushing a grinding wheel (fig. 9.1), were more of a luxury. Made with parts set in motion by the wind (in this case, the wheels turn and the man bends down to the wheel), whirligigs often had no more purpose than to entertain (see chapter ten).

9.2 *Protect Home Industry*, 1840.
William and Thomas Howard.
Bar iron political emblem, 84 inches high.
Chester County Historical Society,
West Chester, Pennsylvania

Another sculpture, the *Protect Home Industry* political emblem (fig. 9.2), is a wonderfully inventive object. Made by William and Thomas Howard of Charlestown, Chester County, Pennsylvania, the metal banner was described in the *West Chester Daily Local News* for August 4, 1888:

Harry Howard, of Charlestown township, has in his possession a banner which was made for the Harrison campaign of 1840. . . . Each square represents by appropriate tools, some particular industry, the broad axe, saw and hammer, the carpenter, the shoemaker's awl and last are here, the tanner's tools are represented, and a blacksmith's anvil and a hammer that automatically strikes a bell as it is carried in a procession, make it the most striking banner that remains to tell the mute story of its use in the campaign to promote home industries, waged in 1840.

As the industrialization of America progressed, the American labor union movement, originally started as workers' benevolent societies, began to play a more important role in the lives of the men and women on the job and in the economy of the country. The painted screen (fig. 9.5), one of a number of similar pairs, was executed in Philadelphia in the mid-nineteenth century for the Order of United American Mechanics through their office of the State Council of Pennsylvania. The screens were probably commissioned from a local artist named Eastlack who was asked to create teaching or demonstration aids that could be used by union members in their recruiting efforts. This organization was one of many that, during the nineteenth century, attempted to represent the working class in its struggle to achieve a sense of dignity and independence, and a measure of security. The companion screen, showing a comfortable interior with a happy family scene, was intended to inspire workingmen to seek a better way of life for their families.

In some areas, work on the farm was as specialized as work in the shops. In the South particularly, the plantation system permitted commercial farming on a large scale. These enterprises concentrated on a few important crops, such as tobacco or cotton, raised primarily for export to Europe. A steady demand from

9.3 *Tinsmith*, c. 1895. J. Krans.
Tin, 72 inches high.
Collection of Elaine Terner Cooper

abroad—and a steady supply of slave labor—kept the system profitable until the Civil War.

Part of the back-breaking labor involved in getting cotton to market is portrayed in a panoramic series of paintings, represented here by the scene of *Hauling the Whole/Weeks Picking* (fig. 9.6). This watercolor and paper collage was made in the 1840s by the silhouette artist William Henry Brown. Silhouette cutters sometimes made "pasties," usually collages of pictures cut out of trade magazines and pasted onto painted landscapes. In this instance, Brown himself executed the parts to be collaged. These scenes were made for the young children of Mr. and Mrs. William Henry Vick of Nitta Yuma Plantation, north of Vicksburg, Mississippi, and were known as "The Nitta Yuma Pasties."

9.4 *Woodsman*, c. 1900. Artist unknown.
Painted wood and lead weight weathervane, 32 inches high.
Collection of Sybil and Arthur Kern

9.5 Painted screen, 1860–80. Eastlack.
Oil on canvas, 59 × 59 inches.
Jay Johnson: America's Folk Heritage Gallery, New York

9.6 *Hauling the Whole/Weeks Picking*, c. 1842. William Henry Brown.
Watercolor on paper collaged on heavy paper; two parts: 19¼ × 28⅛ inches and 19⅜ × 24⅞ inches.
The Historic New Orleans Collection, New Orleans, Louisiana

AS THE NUMBER of manufactured items in stores increased and the number of shops selling similar merchandise grew, shopkeepers came to rely more and more on advertising. This frequently took the form of eye-catching signs, both two- and three-dimensional. As discussed previously, the ideal trade sign was one that immediately caught the attention of passersby and was totally self-explanatory. Most often, the only words on a sign were the name of the establishment and/or the proprietor. E. Fitts, Jr., who ran an inn and general store near Shelburne, Massachusetts, in 1832 had a two-sided sign painted for his business: one side advertised the inn while the other (fig. 9.11) showed the contents of his shop, featuring the important shelf of hats. To make his sign even more noticeable and sturdy, Fitts had an elaborate wrought-iron frame made for it.

The best-known of all American trade signs is the cigar-store Indian. No self-respecting nineteenth-century tobacconist would have considered opening up shop without a figure of some kind to stand by the front door. Most often, these were Indians, such as the robust maiden shown here (fig. 9.7), believed to have been carved in Freehold, New Jersey, in the early nineteenth century by a slave named Job. The African heritage of the carver is evident in the sculpture's face, which is distinctly different from the chief (fig. 9.14), probably carved by Thomas V. Brooks and pictured in a late-nineteenth-century photograph of a Brooklyn tobacconist's shop. As exemplified in the Brooklyn figure, by the end of the nineteenth century, the carving had become conventional—everyone knew what a cigar-store Indian should look like and the carvers produced to suit. In contrast, Job's earlier version is simple, powerful, and original.

The identification of the Indian with tobacco appears to have originated in seventeenth-century England, where Indians were first depicted as "Virginians" with Negroid features, feathered headdresses, and kilts of tobacco leaves. This odd character reflected the fact that the English had confused the American Indian, who introduced tobacco to the Europeans, the Virginian, from whom it was imported, and the plantation black, who raised it. Firmly established in America by the nineteenth century, the cigar-store Indian was in its heyday from the 1850s to the 1880s. Many of the earliest wooden Indians were made by the same men who carved ship figureheads and who, with the decline of the sailing-ship industry, lost their jobs and turned to making shop signs, carousel figures, and decorations for circus wagons.

Although Indians were the most popular, other figures were also used to advertise cigar stores. Carved wooden images of soldiers, sailors, fashionable ladies, popular heroes, exotic foreigners such as Turks and Egyptians, characters

out of literature, and even patriotic symbols like Uncle Sam were all mounted on bases and placed on the sidewalks in front of the shops. Finally, their very numbers led to the demise of the cigar-store figures. Hordes of city Indians were banished from the sidewalks as objectionable obstructions to pedestrian traffic, and the creation of an American popular art form came to an end.

Tobacco shops were not the only businesses that used three-dimensional sculpture for advertising. As seen in chapter six, a ship's chandlery might display a figure of a seagoing man, and such forms as oversized eyeglasses, boots,

9.7 Cigar-store Indian, c. 1825. Attributed to Job, a slave. Polychromed wood, 48 inches high. New York State Historical Association, Cooperstown

watches, teeth, and bicycles, all obvious advertisements for different trades, were common sights on nineteenth-century streets. A less obvious sign is seen in the drawing of an apothecary shop by William Henry Emerton (fig. 9.9) that was used as an advertisement in the *Salem Directory* of 1851. Directly over the storefront is a wooden bust of Paracelsus, the Swiss-born alchemist and physician who lived from 1493 to 1591.

In the nineteenth century, the apothecary was often the local doctor as well. Jacob Maentel's portrait, known as *The Apothecary* (fig. 9.10), is a painting of Dr. Christian Bucher of Schaefferstown, Lebanon County, Pennsylvania. Bucher is shown in his prosperous and well-stocked shop in Schaefferstown where he, and his three sons after him, were known as merchants as well as doctor-apothecaries.

Another medical man recorded for posterity with his place of business was one Dr. Hopkins, shown in the 1909 photograph of his Junction City Veterinary Hospital (fig. 9.16). The picture was taken by J. J. Pennell, who worked in Junction City, Kansas, from the 1880s until his death in 1922. Although Pennell was primarily a studio portrait photographer, he supplemented his income by going out into the community and to nearby Fort Riley, a large army post of cavalry and artillery units, to record the social, personal, and business life of the area. His photographs show the growth and change of a turn-of-the-century community over a period of thirty years: the most striking example of this evolution was the arrival of the automobile and its eventual displacement of the horse, a change implied by the presence of both horses and a car in the photograph of Dr. Hopkins's hospital.

Also evident in Pennell's photo, as well as in others featured in this book, is the fact that while the photographers that we consider folk artists were recording the events, business activities, and everyday life of a growing nation, they were also creating an informal descriptive art. Instinctively, they posed their subjects much as the folk painters arranged theirs: to create a well-ordered and interesting composition. In the photograph of the Veterinary Hospital, the horse and buggy on the left and the automobile on the right, both shown horizontally, balance each other, as do the pair of horses and pair of men in the doorway. Presumably, it is Dr. Hopkins who stands alone, hands on hips, in a position of prominence in front of the scene, providing a central focal point for the composition. If this were a folk painting instead of an accurate camera's-eye view, no doubt Dr. Hopkins, the proud owner of the establishment, would have been portrayed as the largest and most important figure in the picture. The intention here is the same; it is only the medium that produces the more realistic result.

9.8 Thomas Potter with his children and grandchildren in front of his blacksmith shop, c. 1899. George Edward Anderson.
Photographic print from glass-plate negative, 5 × 7 inches.
Collection of Rell G. Francis

9.9 *James Emerton's Apothecary Shop*, c. 1850. William Henry Emerton.
Ink and gray wash on paper, 12½ × 9¾ inches.
Essex Institute, Salem, Massachusetts

9.10 *The Apothecary*, c. 1840. Jacob Maentel.
Watercolor and ink on paper, 16⅝ × 10½ inches.
Private Collection

9.11 *E. Fitts, Jrs. Store*, 1832. Artist unknown.
Painted wood and wrought iron shop and inn sign, 46⅞ × 46⅜ inches.
Museum of American Folk Art, New York
Gift of Margery and Harry Kahn

9.12 *Leonard Bond's Hat Store on Chatham Street, New York,*
c. 1828. Alexander Jackson Davis.
Watercolor and ink on paper, 7⅜ × 9 inches.
Museum of the City of New York, New York

9.13 *J. Prouse Cooper's Down Town Store, New York*, c. 1880. Artist unknown.
Watercolor and ink on paper, 12⅛ × 16¼ inches.
Collection of Herbert W. Hemphill, Jr.

9.14 Tobacconist's shop in Brooklyn, 1869–77. Artist unknown.
Photographic print, 8 × 11 inches.
Culver Pictures, Inc., New York

9.15 Massachusetts tobacco sign, c. 1860. Artist unknown.
Oil on wood, 23¾ × 27¼ inches.
The Metropolitan Museum of Art, New York
Bequest of Edgar William and Bernice Chrysler Garbisch

9.16 *Dr. Hopkins' Veterinary Hospital*, 1909. Joseph Judd Pennell.
Photographic print from glass-plate negative, 8 × 10 inches.
University of Kansas Libraries, Lawrence
Pennell Collection

THE GREAT SHORTAGE OF LABOR in preindustrial America helps to explain the fact that almost all the crafts and trades practiced by men included at least a few women. Colonial newspapers printed advertisements for women in virtually every business, from the intellectual pursuits of law and publishing to the physical labor of the blacksmith, the shipwright, and even the undertaker. Women were shopkeepers, doctors, printers, farmers, servants, and, reportedly, highway robbers. Although most of these women were involved in family enterprises, widows and spinsters often carried on alone in their business ventures. Women were still responsible for the home, however, and even those who found employment outside had to supervise, if not actively participate in, the running of the household.

When, in the nineteenth century, the center of economic activity moved away from the home and the family-run business and into factories and offices, most occupations came to be viewed as unsuitable for women or incompatible with their work in the home. As the labor shortage eased with immigration and population growth, economic opportunities for women narrowed even more. Girls of the middle and lower classes might still leave home to work in factories, but these were regarded as unskilled, temporary jobs, to be abandoned as soon as the girls were married.

9.17 Wool winder, c. 1875. Artist unknown.
Carved, turned, and painted wood,
39¼ inches high.
Museum of American Folk Art, New York
Eva and Morris Feld Folk Art Acquisition Fund

For most of the period of Young America, therefore, women's work was chiefly domestic. In preindustrial times—and even after—this meant, for all but a few wealthy ladies, a never-ending round of chores in the house and on the farm. As has been recorded by Linda Grant DePauw and Conover Hunt, at the end of the eighteenth century the wife of Stephen Rogers merited a notice in the local newspaper when, on a single day, she "milk'd 8 cows in the morning—made her cheeses—turned and took care of fourscore cheeses—made a number of beds—swept her house, consisting of three rooms—spun six skains of worsted yarn—baked a batch of bread—churned a quantity of butter—and milked 7 cows in the evening."

Domestic chores were often made, if not easier, at least more pleasant, by utensils and tools that were attractive as well as functional. A wool-winder constructed of simple sticks of wood might work as well as the example included here (fig. 9.17), but how much more cheerful this one, shaped like a woman, would be for the lady who had to spin her own yarn.

Decorating food was another way to make kitchen chores more enjoyable. Baked goods and butter could be turned into a variety of shapes with cutters or molds, or impressed with designs carved into wooden molds, such as *Fire Engine Superior* (chapter four, fig. 4.31). In some areas, such as the German-speaking counties of Pennsylvania, butter molds with motifs such as cows, eagles, flowers, and geometric designs were employed not only for decoration but also to identify the product of a particular farm at market. The making and selling of butter was almost always a woman's job, and frequently the income from the sale of her butter was hers as well. The unique mold in figure 9.18, however, was probably not made to use on butter that was for sale: its scene, showing a woman involved in a dull domestic task, would be too strong a reminder that women's work is never done.

Women's work at home or on the farm could also be pleasantly eased by communal activities. "Quilting at Mr. Andrews'. Had a number of gallants. 'Wool break' at Mr. Southgate's, spinning frolic at Mr. Green's. Had a Cappadocian Dance. Mr. Shaw played for us," wrote Ruth Henshaw Bascom in her diary, indicating the kinds of work parties women could look forward to in early-nineteenth-century New England.

Quilting bees were the most common of these social events. Knowing how to piece a quilt was a necessary skill for many women, but it was one that could provide a great deal of satisfaction—and comfort.

Marguerite Ickis quotes her great-grandmother as saying, about 1875: "It took me more than twenty years, nearly twenty-five, I reckon, in the evenings after supper when the children were all put to bed. My whole life is in that quilt. It scares me sometimes when I look at

9.18 Butter mold (detail), c. 1850. Artist unknown.
Carved wood, 6 inches long.
Private Collection

it." Women did, indeed, stitch into the quilts the milestones of their lives, their weddings, children, even coffins.

At the turn of the twentieth century, the words of a woman known as Aunt Cynthy were recorded by Elizabeth Daingerfield as Aunt Cynthy recalled the role quilting had played in her life:

I'd rather piece as eat, and I'd rather patch as piece, but I take natcherally delight in quiltin'. . . . Whenst I war a new-married woman with the children round my feet, hit 'peared like I'd git so wearied I couldn't take delight in nothing; and I'd git ill to my man and the children, and what do you reckon I done them times? I just put down the breeches I was patchin' and tuk out my quilt squar'. Hit wuz better than prayin', child, hit wuz reason.

A woman like Aunt Cynthy might piece her quilt alone, but a bee like the one illustrated in the anonymous painting of *The Quilting Party* (fig. 9.23) provided a woman with an opportunity to get her pieced squares quilted—to have the top, stuffing, and backing of her quilt sewn together—as well as a chance to socialize with her neighbors. After a day's work, the women were often joined by men for supper, singing, and dancing, as mentioned in Mrs. Bascom's diary.

The composition for *The Quilting Party* was derived from a black-and-white illustration that appeared in *Gleason's Pictorial* for October 21, 1854. The scene reveals that much more goes on at a bee than quilting: one young couple is holding hands under the table while, at the other end of the quilting frame, a young man offers sweets to a girl. Across the room, a bearded man reaches out for a young woman who raises her arm as if to slap him. If we are reading the clues in this scene correctly, within

9.19 *Portrait of Jane Marshall Wood*, 1836.
Ruth Henshaw Bascom.
Pastel and graphite on paper, 16 × 12 inches.
Pocumtuck Valley Memorial Association,
Memorial Hall Museum
Deerfield, Massachusetts

the year there will be more brides with quilts to finish in time for their weddings!

Communal activities also made work on the farm more pleasurable. Part of the lengthy process involved in turning flax into linen—a task so complicated and long that a man's shirt often wore out before his wife could make him a new one—is seen in Linton Park's *Flax Scutching Bee* (fig. 9.24). Here the dreary task of beating the seeds from the flax plant has been turned into a celebration that not only gets the work done, but provides a party atmosphere and fun for all.

Even when communal farm work was not fun, it could be extraordinarily efficient, as is seen in Olof Krans's painting of *Women Planting Corn* (fig. 9.22), one of a number in which he recalled his childhood as a member of the Bishop Hill, Illinois, community. In 1846 a small band of pietist Swedes, dissenting from the orthodox Lutheran sect, arrived in western Illinois with their leader, Erik Jansson, from whom they took the name "Janssonists"; they called the religious community that they founded "Bishop Hill" after his birthplace, Biskopskulla. Soon it numbered twelve hundred immigrants—the first Swedish settlement in the Middle West. Communal principles governed the buildings they

erected, the farming in the surrounding countryside, and their entire way of life.

At the age of twelve, in 1850, Olof Krans was brought from Sweden to Bishop Hill, where he worked first as an ox boy and later in the paint shop and blacksmith shop. While serving in the Illinois Voluntary Infantry, he was injured; shortly after being mustered out he settled in nearby Galva, where he became a house painter and decorator. It was not until he was almost sixty and recuperating from a leg injury that he began to paint pictures. He recorded from memory his recollections of the manner in which labor had been shared by men and women at Bishop Hill in his boyhood—by 1860 the community, like many other utopian settlements, had begun to fall into decline owing to dissent and mounting debt. Krans also painted portraits of citizens of the village from photographs he had taken earlier. In 1912 he presented ninety-six of his paintings to the Old Colony Church, where they are carefully preserved; thanks to the concern of some of its native sons, Bishop Hill is now an Illinois State Memorial, listed in the National Register of Historic Places, and many of its buildings have been restored.

Esther Sparks, formerly a member of the Illinois Arts Council, has described *Women Planting Corn*, explaining Krans's recollection of the activity it records:

It shows a Janssonist principle: Men and women must share equally in labor. It also records Janssonist ingenuity. Twenty-four women, dressed in the Colony uniform, advance over the field in a row. They follow a rope tied with twenty-four knots of colored thread to mark each planter's position. . . . After the hole is filled, the men move the rope forward and the women plant the next row. The horizon seems limitless, just as the young Olof would have remembered it. Some furrows did stretch unbroken for miles across the fertile prairie.

Women Planting Corn shows the stringent organization that marked all aspects of life at Bishop Hill. All dressed alike. All worked in teams for eighteen hours a day—whether in the fields, the shops, or the kitchens.

Olof Krans's subject is magnificently interpreted in a stylized composition that by its boldness and simplicity communicates to us today a moving purity and unity of intention and expression.

In *Women Planting Corn* and in *Flax Scutching Bee*, American folk art seemingly comes close to the European tradition of genre painting. These American folk counterparts of the paintings of Brueghel, or such academic American genre painters as William Sidney Mount, or even the mass-produced prints published by Currier & Ives are set apart by the motivation that inspired them and the backgrounds of the artists who painted them. Generally, the folk artists were not simply observers of, but participants in the society they portrayed. Farm work or domestic

tasks were part of their lives—not activities they wished to glorify or reproduce for an art-buying audience. For the most part, they produced art for their own pleasure, and drew their inspiration from the world they saw around them.

Farm and domestic work were the main occupations for most women in Young America, but a few were also able to pursue artistic careers professionally. While women in the eighteenth and nineteenth centuries generally expressed their creativity by making or ornamenting items for their families, some, like Deborah Goldsmith, discussed in previous chapters, made their living by painting professionally.

According to family tradition, early-nineteenth-century Massachusetts artist Ruth Henshaw Bascom never sold her portraits in pastel, but her diary proves that she occasionally traded her art for services. An entry for November 8, 1828, states: "Mrs. Austin brot home first washing (1 doz.) towards paying for her likeness—a good bargain." An entry on February 23, 1839, makes it clear that while the "likeness" was free, the cost of framing was not: "Rev. Annah Allen came in AM & sat for the last time for his copy which I finished PM & he came at eve & took it, paid for glass & frame &c $1—the rest gratis."

Bascom worked by posing her subjects, such as Jane Marshall Wood (fig. 9.19), drawn in 1836, against the paper which was to form the background of the portrait, traced the shadow in profile, and later filled in the details from notes she made at the time of the sitting. Occasionally she cut the profile from paper, colored it with pastels, and mounted it on another, prepared background or one made from wallpaper. Hands, however, were a problem: whenever possible she avoided drawing them or tucked them out of sight. Little Jane, for example, has thrust her hands into the bib of her pinafore.

Curiously, although few women were able to earn a living painting in the nineteenth century, by the end of the century a large number discovered in photography a rewarding professional career. Several thousand women photographers practiced their skills in America, and every European country also had successful women photographers. Some were widows or relatives of men who were professionals, and some began as assistants to men, but a growing number were women who paid for instruction in photography in order to find employment or to establish their own business in the field.

Mrs. M. E. Tyler, for example, worked in Ashland, Oregon, at the end of the nineteenth century. She specialized in portraiture, mostly on printed 4½-by-6½-inch cabinet cards like the ones shown sewn to her dress in what may be a self-portrait advertising her skills as a photographer (fig. 9.25).

9.20 At work in Belton, South Carolina, 1899. Artist unknown.
Gelatin-silver photographic print, 5 × 7 inches.
National Archives, Washington, D.C.
Records of the Bureau of Agricultural Economics

9.21 Women at work—washing, c. 1900. Artist unknown.
Photographic print, 8½ × 11 inches.
Collection of Joseph Bocci

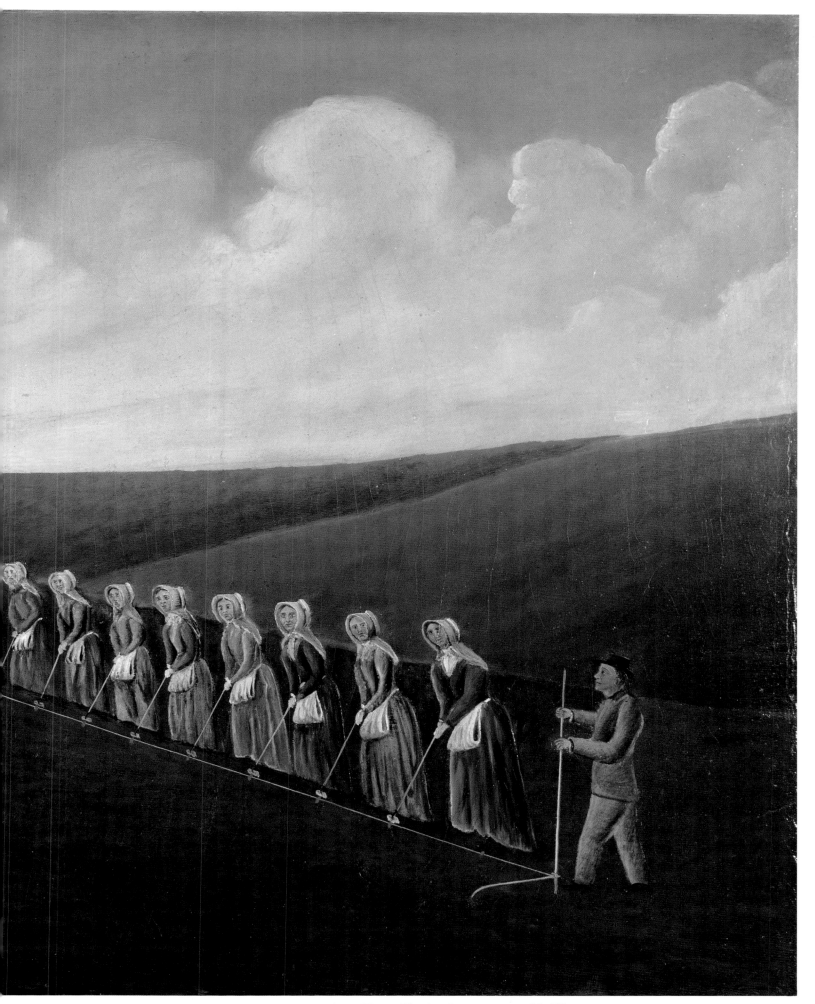

9.22 *Women Planting Corn*, 1894–96. Olof Krans.
Oil on canvas, 25 × 40⅛ inches.
Bishop Hill State Historic Site, Bishop Hill, Illinois

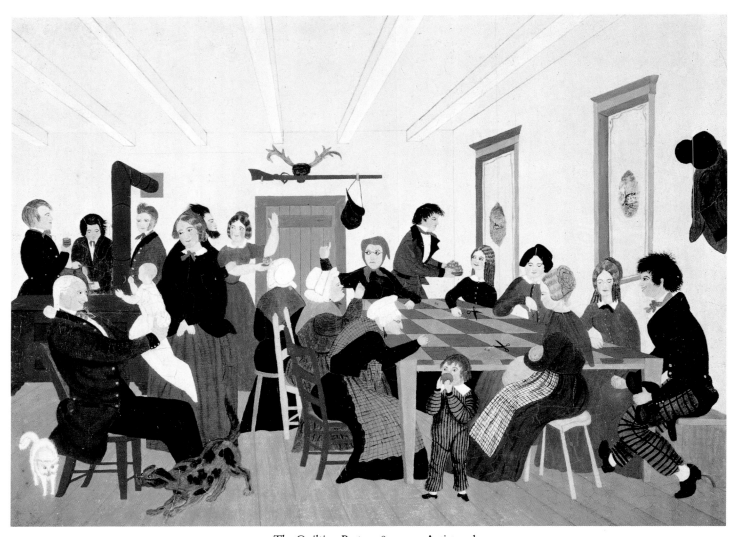

9.23 *The Quilting Party*, 1854–75. Artist unknown.
Oil and pencil on paper mounted on plywood, 19¼ × 26⅛ inches.
Abby Aldrich Rockefeller Folk Art Center, Williamsburg, Virginia

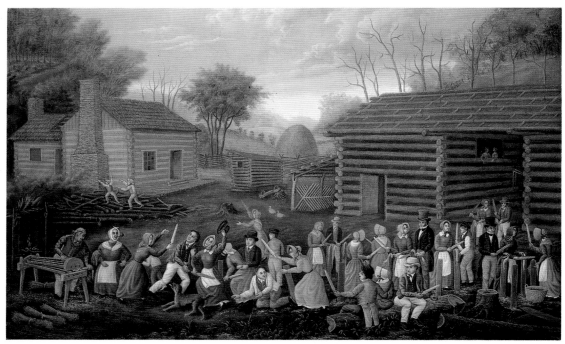

9.24 *Flax Scutching Bee*, 1885. Linton Park.
Oil on bed ticking, 31¼ × 50¼ inches.
National Gallery of Art, Washington, D.C.
Gift of Edgar William and Bernice Chrysler Garbisch

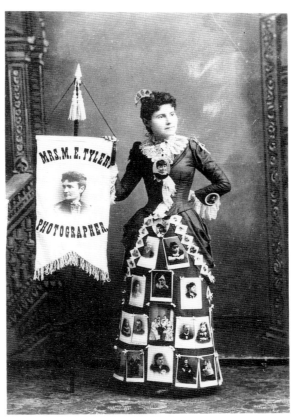

9.25 Mrs. M. E. Tyler in Ashland, Oregon, 1890–92. Attributed to Mrs. M. E. Tyler.
Cabinet card, 6½ × 4½ inches.
Private Collection

9.26 Photographers' encampment, c. 1893. C. R. Monroe or N. L. Ellis.
Photographic print from glass-plate negative, 6½ × 8½ inches.
State Historical Society of Wisconsin, Madison
Charles Van Schaick Collection

The hunters

FOR A PRIVILEGED FEW in Young America, hunting was a sport. But for most of those who pursued game, it was work, a means of feeding those who might otherwise go hungry and clothing those who might otherwise be cold.

It is hard for us to imagine how plentiful game was in the early years of this country. The forests were thick with deer, the plains teemed with buffalo, and, during migratory periods, the skies were black with wildfowl. The Indians, especially, relied on this bounty for food, clothing, and the shelter of buffalo-hide tepees. The image of the Indian as picturesque hunter—the noble savage—appealed to artists in all media. Rural craftsmen might fashion a simple weathervane of an Indian on a hunt out of pieces of wood and wire (fig. 9.32), or a more elaborate example might be made from copper and zinc (fig. 9.33).

The composition used in *Buffalo Hunter* (fig. 9.31), a painting by an unknown artist, has a long history. Although a great number of American and European naturalists, illustrators, and artists were captivated by the theme of the Indian buffalo hunt, this particular scene can be traced directly back to the well-known drawings and writings of George Catlin, which influenced the early work of mid-nineteenth-century illustrator F. O. C. Darley. In 1844 *Graham's Magazine* featured an engraving, *Hunting Buffaloe*, after "an original drawing" by Darley, and this engraving was the source for the folk painting included here. In the painting,

9.28 Priming flask, 1825–1900. Artist unknown. Horn, wood, and brass, 5⅞ inches high. The Henry Francis du Pont Winterthur Museum, Winterthur, Delaware

however, background detail and incident have been simplified to focus interest on the hunter, horse, and buffalo. An unexceptional engraving has been transformed into an exciting painting.

The Indians themselves also chose hunting as a subject for their artwork. A unique appliqué quilt (frontispiece), sewn at the turn of the twentieth century in a style that clearly resembles the pictographic drawings discussed in chapter seven, includes scenes of Indians hunting buffalo and birds, and cooking the game. There is also a touch of fantasy in this quilt: among the animals portrayed are kangaroos! No doubt the Sioux woman who made this textile masterpiece as a gift of friendship for a South Dakota homesteader relied on contemporary magazines or books, as well as on tradition, for her images.

The history of white-Indian relations in America, in fact, is by no means entirely a history of conflict. Although acts of violence have unfortunately overshadowed acts of cooperation in the public memory, many a settler's diary attests to the fact that the pioneers would not have lasted in their new homes without help from the Native Americans. The recollections of one early settler, recorded by Joanna Stratton, includes the following comment: "Mrs. Campbell has said, if it had not been for the friendship of the squaws she does not know how she would have survived those first years of loneliness in the little new town on the Smoky."

The Native Americans were also a source of information for whites on certain kinds of hunting. Decoys, for example, employed in hunting wildfowl, were first used by the American Indians. Indian hunters had observed that migrating birds tend to land where others of their species are gathered, and realized that an artificial bird could be used to attract wildfowl within the range of a concealed hunter. In Europe, caged birds were used to attract wildfowl: the word "decoy" is believed to derive from the Dutch for "the cage."

The carving of a crane (fig. 9.29) is a "confidence decoy." Birds like cranes, herons, egrets, and swans were once hunted primarily for their feathers, but after legislation prohibited the gunning of wildfowl for their plumage, these decoys were placed among a group of legal prey birds, such as ducks or geese, to give them a false sense of security. A crane was often used with geese, because cranes, in real life, serve as lookouts for geese while they are feeding.

Decoys like this crane were made by hand, but as the shooting of wildfowl became a profitable business during the late nineteenth century, many decoys, especially ducks, were made in factories. Eventually, the slaughter of wildfowl, like that of the buffalo, reached such proportions that a number of species disappeared altogether. By the end of the nineteenth century, conservationists were urging strict control of hunting and finally, in 1918, Congress passed legislation that put an end to the shooting of wildfowl for commercial purposes. Decoys are still made and used for legal hunting by sportsmen, but today the best early examples are collected as folk sculpture.

The Native Americans may have taught the whites about the habits of North American game, but the European colonists changed hunting here forever when they introduced firearms. In the eighteenth and nineteenth centuries hunting with firearms was still more complicated than it is today, requiring a variety of tools and accessories. A priming flask (fig. 9.28), for example, was used to carry the gunpowder that prepared, or "primed," a musket for firing. Priming flasks are much smaller than the more common powder horns, for only a minute amount of powder was needed to prime the musket. Decorated flasks such as this one, engraved with a scene of a man hunting a deer on one side and an eagle on the other, are especially rare, and owning one may have been a sign of status in the community.

9.29 *George Martin's Crane*, c. 1907. Artist unknown. Painted wood decoy, 40½ inches high. Little Collection

9.27 *Deer Hunter*, c. 1875. Artist unknown. Cast iron stove plate, 26½ × 29 inches. The Mercer Museum of the Bucks County Historical Society Doylestown, Pennsylvania

9.30 (*opposite*) *Baltimore Album Quilt* (detail), c. 1850. Artist unknown. Appliquéd cotton and India ink, 109 × 105 inches. Museum of American Folk Art, New York Gift of Mr. and Mrs. James O. Keene

9.31 *Buffalo Hunter*, c. 1844. Artist unknown.
Oil on canvas, 41 × 51½ inches.
Santa Barbara Museum of Art, California
Gift of Harriett Cowles Hammett Graham in memory of Buell Hammett

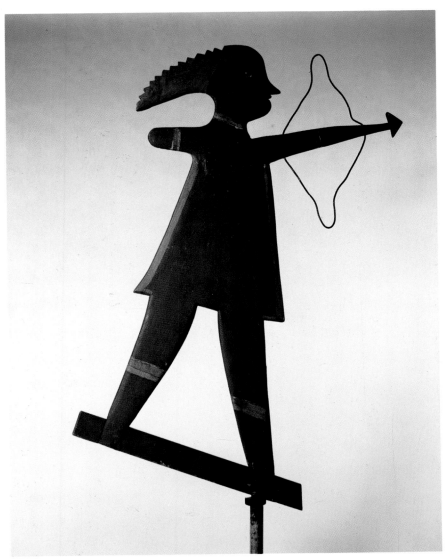

9.32 *Indian Archer*, c. 1880. Artist unknown.
Painted wood and wire weathervane, 36 inches high.
New York State Historical Association, Cooperstown

9.33 *Indian Hunter*, c. 1850. Artist unknown.
Copper and zinc weathervane, 33 inches long.
Present location unknown

10.1 *Fourth of July Picnic at Weymouth Landing*, 1845. Susan Merrett.
Watercolor and collage, 29½ × 39⅜ inches.
The Art Institute of Chicago, Chicago
Bequest of Elizabeth Vaughan

Play

BEFORE THE REVOLUTION, life in America was spent primarily at work. In New England, especially, a strict Calvinism preached that idle hands were the devil's tools, and this, combined with the economic necessity of constant work to ensure survival, severely limited the amount of time that could be devoted to leisure pursuits. Even for several generations after the Revolution, play was not a conspicuous feature of American life, and many of those activities that were regarded as recreational—quilting bees, flax scutchings, barn raisings—combined a good deal of hard labor with the fun.

As the nation's prosperity increased, and the Industrial Revolution spread, more hands and machines were available to do the work, and new attitudes toward leisure time and recreation inevitably evolved. Pleasures once reserved only for the very wealthy few—games, sports, travel—became available to many, as did the time to enjoy these pleasures. Simple homemade amusements such as dolls and toys, often crafted by folk artists, began to be replaced in the nineteenth century by the products of companies that specialized in manufacturing playthings for America's leisure. The new and more sophisticated entertainments, however—carousels, circuses and other spectaculars, amusement parks—still required talented hands to create the mighty wooden steeds, elaborate wagons, and other items that were features of these events.

Americans also had more time to devote to celebrations. Holidays grew in number and importance, and Sundays took on a less serious aspect during the nineteenth century, as workers with money to spend looked for ways to relieve the tedium of their daily jobs.

Games

CHILDREN IN YOUNG AMERICA benefited from the principles of the Enlightenment that had inspired the Revolution, as well as from the economic prosperity that followed it. Freed from many of the moral proscriptions that had curbed Colonial children's natural inclination to play, and from the traditions and necessity that put them to work at an early age, the children of the new republic were able to occupy a much greater part of their growing-up time with games and toys.

Some of the games children enjoyed were the same as those that amused their parents. Cards, dice, and dominoes were popular adult pastimes, and, as the late-eighteenth-century portrait known as *The Domino Girl* (fig. 10.6) shows us, this was an accepted activity for children as well.

Another approved indoor activity for children was "battledore and shuttlecock," a game much like badminton that is seen in the painting titled *The Children of Nathan Starr* (fig. 10.5) by Ambrose Andrews. *Remarks on Children's Play,* published in 1811, comments upon the suitability of this game for indoor play: "This is a kind of amusement that affords an agreeable and healthful exercise for either boys or girls. . . . It is excellently calculated for cold or stormy weather,

as it may be performed in the house. There is little danger attendant on this sport, except the breaking of windows." No doubt this reassurance is responsible for the serene countenance of the eldest girl, who sits quietly with a book while the shuttlecock flies back and forth over her head.

The battledore and shuttlecock, hoop, and stick that the Starr children are holding are typical of the manufactured toys that were available throughout the nineteenth century. Homemade toys, however, remained popular, in an even greater variety of forms. Dolls could be made out of almost anything—rags, wood, dried apples, cornhusks, twigs. Sheet-metal silhouettes, as in figure 10.2, were cleverly jointed so that a child could move its limbs and pretend the doll was walking or dancing.

The skill of the folk artisans who made these amusements as gifts for children, or for sale, is evident in the balancing man (fig. 10.3), a homemade American example of a traditional European toy. The toy is designed so that when the little figure is tipped forward, he swings back into an upright position. This combination of movement and suspended animation was sure to fascinate the child for whom it was fashioned.

Although some eighteenth-century European examples are known, the whirligig, like the weathervane, reached its fullest development in America. It is possible that the whirligig was first made popular in the New World by German immigrants in Pennsylvania, for several of the earliest examples represent Hessian soldiers, the German mercenaries who fought for the British during the Revolution and later settled in America.

The idea for the whirligig can be traced to two distinct prototypes: articulated dolls and windmills. Single-figure, full-bodied whirligigs with propeller-type arms were, like articulated dolls, carved from a block of wood or assembled from various parts cut from a board or thin slab. More complex examples with many parts, like the tinsmith (chapter nine, fig. 9.1) or the even more involved group of boxers (fig. 10.17), are powered by a pinwheellike propeller that catches the wind and, through the action of a series of gears and connecting rods, activates the figure or figures.

Games and toys were often meant to be educational as well as amusing, to prepare children for their future adult responsibilities; they taught social or political attitudes as well. *Game of Chance: Auctioneer and Slaves* (fig. 10.4), made in Maine in the mid-nineteenth century, reflects the abhorrence of the institution of slavery in New England at that time. The game not only invokes horror at the scene it represents, but the individual portrayals of the slaves are also compelling portraits that speak strongly against slavery.

The concept of play for its own sake—not as a means of teaching a skill or a moral lesson—did

10.3 Balancing toy, c. 1860–75. Artist unknown.
Wood and metal, 15½ inches high.
Abby Aldrich Rockefeller Folk Art Center,
Williamsburg, Virginia

not become popular until the nineteenth century. This new idea of the beneficial aspects of games is apparent in the watercolor titled *Children Playing* (fig. 10.7) attributed to Eunice Pinney. The fun of childhood is delightfully captured in this painting, which conveys the activity of a group of children and the freedom those children must have felt when they removed their cumbersome hats and shoes.

10.4 *Game of Chance: Auctioneer and Slaves,*
c. 1850. Artist unknown.
Painted wood, metal, cotton, and paper,
27 inches high.
Museum of American Folk Art, New York
Promised gift of Dorothy and Leo Rabkin

10.2 Jointed Indian doll, c. 1850.
Artist unknown.
Sheet tin, 13½ inches high.
Present location unknown

Although it is likely that this composition was based on an illustration in an early-nineteenth-century children's book, the exact source has not been identified. Similar illustrations of the period indicate that the game being played is "Bait the Bear." One child, the "bear," kneels on the ground and protects himself as best he can from the blows of the other children, who use knotted handkerchiefs or, as here, hats to strike the "bear." A second child, the bear's "keeper," tries to catch one of the strikers to make him the next "bear." *Youthful Amuse-ments,* published by an unknown author in Philadelphia in 1810, called the game "rough play, and hardly proper for children." Evidently, like many games children are told *not* to play, it was immensely popular anyway.

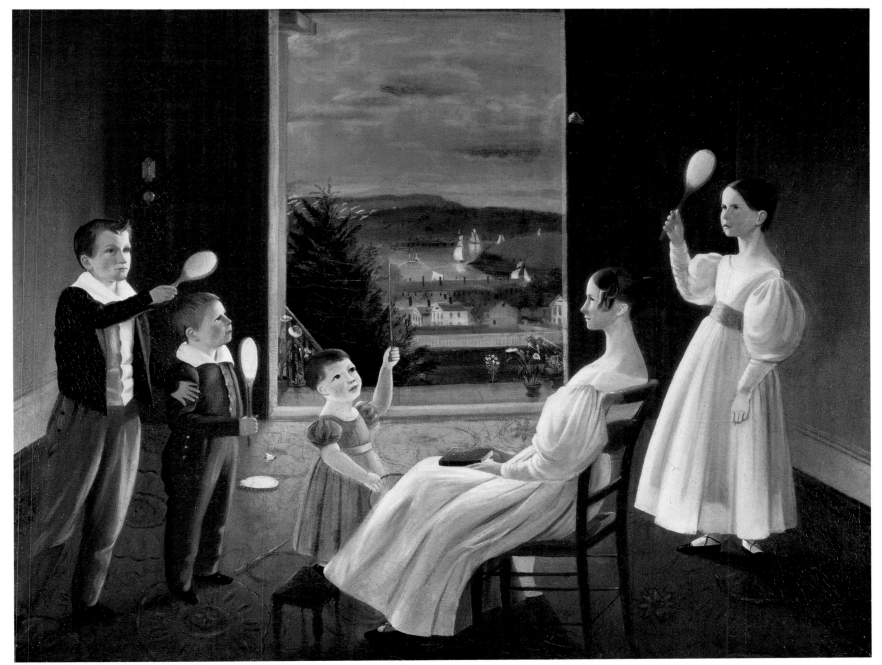

10.5 *The Children of Nathan Starr,* 1835. Ambrose Andrews.
Oil on canvas, 29 × 37 inches.
Private Collection

10.6 *The Domino Girl*, c. 1790. Artist unknown.
Oil on canvas, 23 × 18½ inches.
National Gallery of Art, Washington, D.C.
Gift of Edgar William and Bernice Chrysler Garbisch

10.7 *Children Playing*, c. 1813. Attributed to Eunice Pinney.
Watercolor and ink on paper, 7¹³⁄₁₆ × 9⅝ inches.
Abby Aldrich Rockefeller Folk Art Center, Williamsburg, Virginia

10.8 Box, c. 1820. Artist unknown.
Painted wood, 4¾ × 11½ inches.
Collection of Michael and Betty Howard

THE FIRST COMPLETE circus performance in America took place on April 3, 1793, when Englishman John Bell Ricketts presented his troupe to a Philadelphia audience. President Washington attended a performance on April 22, and was so fascinated that he returned several times, thereby endowing the new pastime with an air of respectability. It was not until the last quarter of the nineteenth century, however, that the circus reached its peak of popularity here and became a favorite entertainment for young and old alike. Much of the excitement generated by these shows with their acrobats, trick riders, and performing wild animals can be sensed in the late-nineteenth-century circus painting (fig. 10.13) by A. Logan.

By the turn of the twentieth century, the traveling circus and its New World relative, the

10.9 Pawnee Bill's Wild West Show bandwagon, 1903. Samuel A. Robb shop, Sebastian Wagon Company. Carved and painted wood, 21 feet, 8 inches long. Circus World Museum, Baraboo, Wisconsin

Wild West show, were American institutions. Part of the tradition was the parade that announced that the show had come to town. Historically, circus parades can be traced back to the triumphal processions of the Romans, but it was a procession of floats during the New Orleans Mardi Gras of 1883 that is credited with inspiring circus owners to stage such events to attract audiences. These parades became elaborate affairs, featuring lavish wagons decorated with colorfully painted and gilded carvings. Frequently, the carved scenes were historical, as in figure 10.9, a representation of Pocahontas saving the life of Captain John Smith. The wagon that this tableau decorated was made for Pawnee Bill's Wild West Show by the Sebastian Wagon Company in New York. The carving was done in the shop of Samuel A. Robb, a multitalented carver also known for his cigar-store Indians and other trade-sign figures, such as the baseball player reproduced in this chapter (fig. 10.19).

Circus parades were common events from the turn of the century until about 1920, lasting in some areas until the 1930s. The wagons used for these grand processionals represent American advertising art at its giddiest and gaudiest.

Rich with their painted and gilded carving, the horse-drawn vehicles dazzled the eyes of the spectators and often caught their ears, too, for some were bandwagons that carried splendidly dressed musicians seated in rows. Today, the small traveling circus has all but disappeared from the American landscape, and only a few of these fabulously carved and decorated floats are preserved in public collections devoted to circus memorabilia, such as the Circus Museum in Sarasota, Florida, and the Circus World Museum in Baraboo, Wisconsin.

Amusement parks, usually conveniently located an exciting trolley ride away from the big cities, also provided late-nineteenth-century Americans with a variety of entertainments. Sundays and holidays frequently saw crowds of people enjoying themselves at the shooting gallery, around the bandstand, or riding that most popular attraction, the carousel.

There were a number of kinds of carousels, or "merry-go-rounds," each with different methods of simulating the excitement of horseback riding that, by this time, was a novelty for many city folk. Charles W. F. Dare's "Galloping Horses," for example, shown in an illustration (fig. 10.12) from the 1878 catalogue of Dare's New York Carousal Manufacturing Company, rode on a revolving platform and had iron wheels that ran on a circular track. Although the earliest merry-go-rounds were pulled by horses, this late-nineteenth-century model was steam-powered.

Primitive "flying horses" and other early carousel animals were first made by men who had once made a living carving ship figureheads and other ornaments. By the close of the nineteenth century, however, they were manufactured, like the circus wagons or the cigar-store Indians, by hand, but in specialty shops that employed assembly-line production techniques. The magnificent steed (fig. 10.11) that carries a feline for a saddle and sports roses in its bridle, for example, was made in the Brooklyn, New York, shop of Stein and Goldstein in the early twentieth century. Dramatic carousel figures like this

10.10 Churn, 1850–75. Artist unknown. Salt-glazed stoneware, 13 inches high. Henry Ford Museum and Greenfield Village, Dearborn, Michigan

10.11 Carousel horse, 1912–16. Stein and Goldstein. Carved and painted wood, 71 inches long. National Museum of American History, Smithsonian Institution, Washington, D.C. The Eleanor and Mabel Van Alstyne American Folk Art Collection

one are characterized by their dynamic poses, their exuberant carving, and their elaborate painted decoration, which was usually refurbished each season. Hand-carved wooden carousel figures—lions, rabbits, camels, and a menagerie of other animals besides the multitude of horses—continued to be made until well into the twentieth century. Unfortunately, the figures were expensive to produce and maintain, and, eventually, metal, plastic, and fiber glass animals fashioned in molds replaced the hand-carved beasts.

Day trips to other destinations besides amusement parks became popular Sunday and holiday activities in the nineteenth century. Trolley cars and steamboats were available to carry city dwellers away from their crowded, noisy towns into the healthful countryside. As evidenced in the painting on cardboard *Outing on the Hudson* (fig. 10.16), families and courting couples could journey on the river to a spot where the view was especially lovely, though, to judge from this picture, few of the couples paid much attention to the view.

County fairs were also suitable destinations for family outings. The journey to such an event and the activities that took place there have been recorded for posterity, stitched into a remarkable all-white quilt by Virginia Ivey. In the center of the quilt—which commemorates the Russellville, Kentucky, fair of 1856—is the judging ring, complete with horses and riders, horses pulling buggies, cows, men, sheep, and pigs. A fence encircles the ring, and directly inside the fence a pair of concentric circles bears the quilted legend "1856 A REPRESENTATION OF THE FAIR GROUND NEAR RUSSELLVILLE KENTUCKY." On the border of the quilt (the detail included here) are horses, carriages, and people on their way to the fair (fig. 10.14), the figures stuffed to raise the designs above the surface of the quilt and give them a three-dimensional look. Tight, stippled background quilting makes the motifs on this spectacular piece of needlework stand out in even greater relief.

10.12 Dare's "Galloping Horses" carousel, c. 1878. Brookhout Bros., New York.
Engraving, 4½ × 6¾ inches.
From Charles W. F. Dare's 1878 catalogue

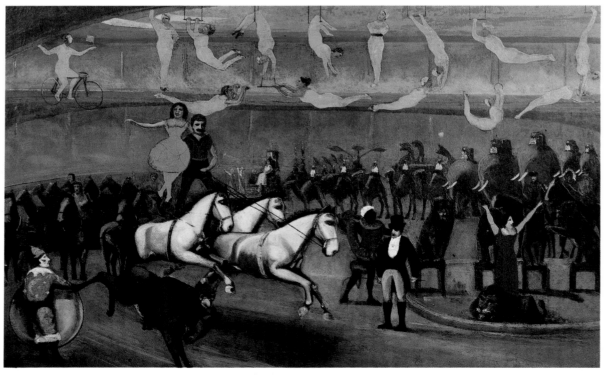

10.13 *The Circus*, 1874. A. Logan.
Oil on canvas, 24¼ × 38¼ inches.
Whitney Museum of American Art, New York
Gift of Edgar William and Bernice Chrysler Garbisch

10.14 *Fair Ground Quilt* (detail), 1856. Virginia Ivey.
Quilted and stuffed cotton, 94 × 94½ inches.
National Museum of American History, Smithsonian Institution, Washington, D.C.

10.15 Beach scene, Seabreeze, Florida, c. 1904. Artist unknown.
Photographic print, 8 × 10 inches.
Library of Congress, Washington, D.C.

10.16 *Outing on the Hudson*, c. 1876. Artist unknown.
Oil on cardboard, 19 × 24¾ inches.
Abby Aldrich Rockefeller Folk Art Center, Williamsburg, Virginia

IN THE MIDDLE of the nineteenth century, Americans began a love affair with organized sports that continues unabated to this day. Before that time, physical activity and outdoor recreation were mostly informal and pursued on an individual level. But as more and more people began to work outside the home and farm, and began to live in cities where areas for physical action were limited, the traditional informal outlets for recreation began to disappear. To replace them, Americans turned to pastimes that had previously been enjoyed primarily by the wealthy. By the end of the century, croquet, skating, tennis, golf, swimming, and what were to be the two most popular sports, baseball and bicycling, had all become favored diversions.

Baseball, especially, has enjoyed a long history of popularity with the American public, both as a participant's and a spectator's sport. The game first appeared here in the 1830s; in 1845 a group of New York business and professional men, players themselves, founded the Knickerbocker Baseball Club, thereby putting the sport on an organized footing. The National Association of Base Ball Players, composed of delegates from more than fifty clubs, was started before the Civil War, and, during the war, baseball games were an important recreational outlet for both soldiers and prisoners.

By the late nineteenth century, professional baseball was a big business and, as today, the players were popular advertising symbols. Images of baseball players, such as figure 10.19, were often used to attract customers to different kinds of shops. This determined-looking batter, made by prolific New York City carver Samuel Robb, was a cigar-store figure that stood outside the shop during the day and was rolled back in at night.

Another trade sign, a man on a bicycle (fig. 10.20), advertised what was probably the biggest sporting craze of the late nineteenth and early twentieth centuries. Velocipedes, wheel-footed bipeds, or high-wheeled bicycles, as shown here, and, finally, "safety" models with pneumatic tires and wheels of equal size were all extremely popular. They provided Americans with fresh air, exercise, transportation, and just plain fun, and brought about a number of social and fashion changes. Courting couples found bicycles, especially those built for two, a convenient means of ensuring togetherness, and the necessity of pedaling—and finding costumes that made this possible—showed the Victorian world that ladies did, indeed, have legs. This

trade sign, made in 1895, was crafted by wheelwright and carver Amidée T. Thibault, who used it to identify his "Bicycle, Livery and Carriage Shop and Paint Shop" in St. Albans, Vermont.

While bicycling was a rather late entrant in the American sporting scene, bare-knuckle fighting, the sport recorded in the painting *Bare Knuckles* by George A. Hayes (fig. 10.18), was popular from colonial days on. By the first half of the nineteenth century, these brutal fights were no-holds-barred events that included ear- and nose-biting, and often left a participant without an eye or otherwise maimed. By the time Hayes painted this picture, after midcentury, such bouts were illegal but obviously still well attended. Besides the activity in the ring, the artist has also included the no-less-important event that occurs among the spectators, and is still an integral part of many sports today: betting money.

By the latter part of the nineteenth century, photographers as well as painters had discovered the aesthetic and compositional appeal of sports and play. *Climbing over the Fence* (fig. 10.22) is one of a series of photographs taken by Leonard Dakin on August 14, 1888. Two years earlier, Dakin had become interested in photographing people in action and began experimenting by taking pictures of beginners' tennis games. By the time *Climbing over the Fence* was taken, Dakin had become adept at posing his subjects, including, in this case, his brother and aunt, to record activity realistically while presenting an artistically pleasing picture.

10.17 *Pennsylvania Boxers*, c. 1880.
Artist unknown.
Painted wood and metal whirligig,
dimensions unknown.
Present location unknown

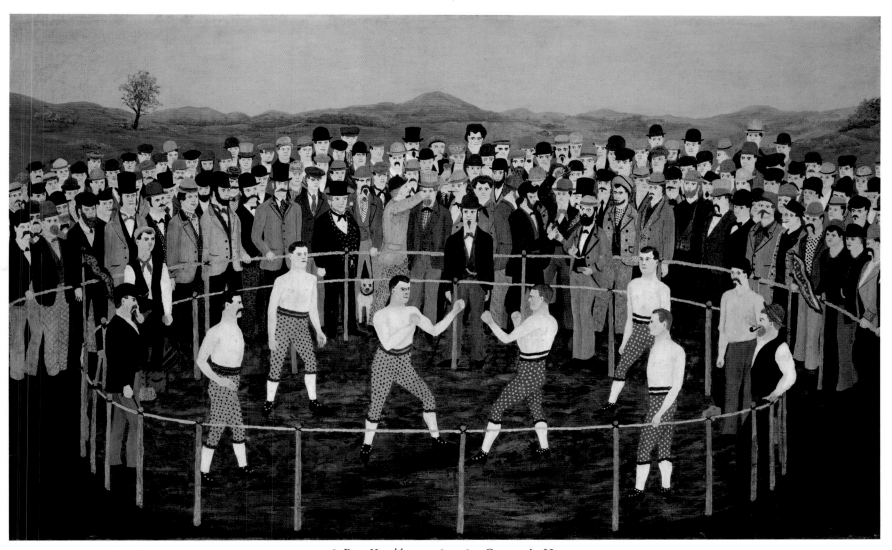

10.18 *Bare Knuckles*, c. 1870–85. George A. Hayes.
Oil on cardboard, 11⅞ × 19⅛ inches.
National Gallery of Art, Washington, D.C.
Gift of Edgar William and Bernice Chrysler Garbisch

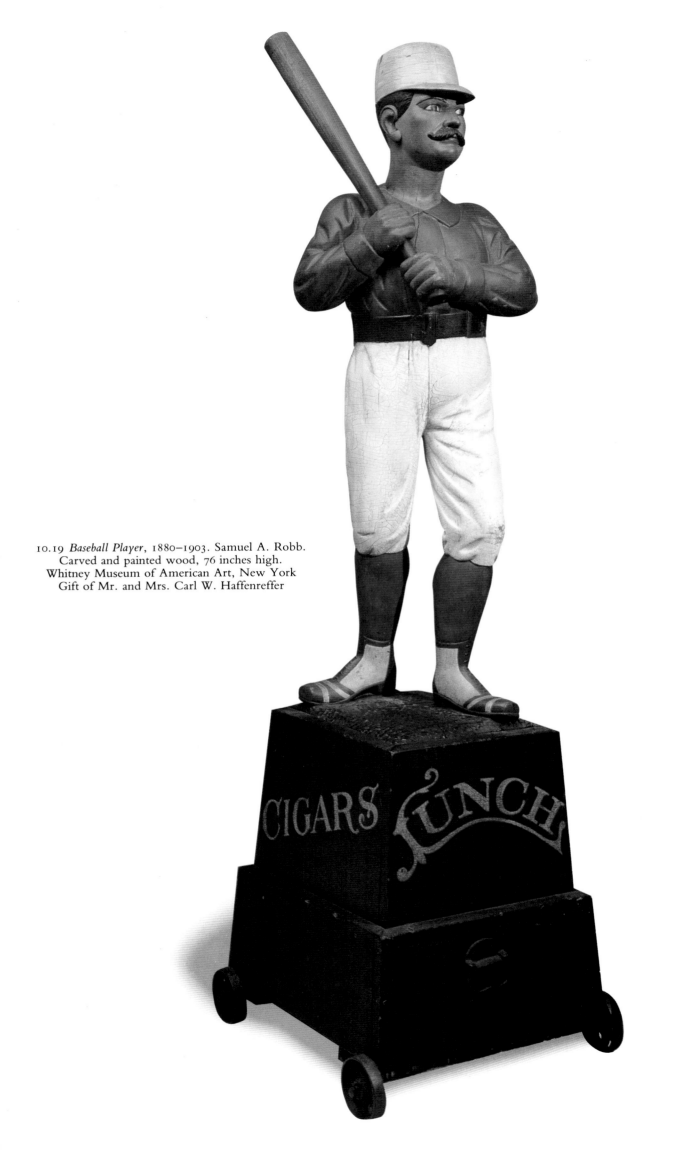

10.19 *Baseball Player*, 1880–1903. Samuel A. Robb.
Carved and painted wood, 76 inches high.
Whitney Museum of American Art, New York
Gift of Mr. and Mrs. Carl W. Haffenreffer

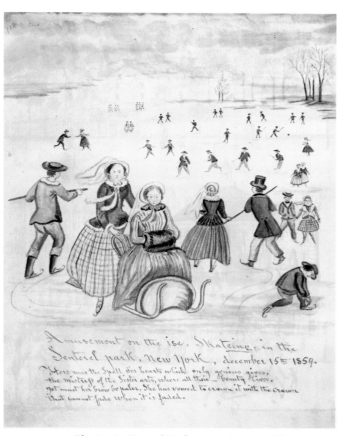

10.20 Bicycle trade sign, 1895. Amideé T. Thibault.
Wood, Columbia bicycle, 84 inches high.
Museum of American Folk Art, New York
Gift of David L. Davies

10.21 *Skating in Central Park*, 1859. Lewis Miller.
Watercolor and ink on paper, 9⁷⁄₁₆ × 7⁷⁄₁₆ inches.
Historical Society of York County, York, Pennsylvania

10.22 *Climbing over the Fence*, 1888. Leonard Dakin.
Photographic print, 3 × 5 inches.
New York State Historical Association, Cooperstown

JUST AS THE nineteenth century saw more leisure time available for games, entertainments, and sports, so, too, was there more time for and more interest in the celebration of events of personal, religious, and national significance.

On a personal level, the celebration of wedding anniversaries became more important. The tenth, or tin, anniversary in particular became, at midcentury, an occasion for a lavish party, with the guests bringing gifts made of tin, such as those shown in figure 10.24. These were frequently meant to be humorous, and often poked fun at the personal characteristics or habits of the celebrating pair. Oversized everyday objects made of tin, like the apron included here, were common gifts; the tin hairpiece is less ordinary! A lively poem written by Mary O. Glazier in honor of Mr. and Mrs. Burdett Loomis, who celebrated their tenth anniversary in 1869, describes their party and the gifts the guests brought them. The following excerpt from the long poem—preserved in a copy by the Loomis descendants—written to the cadence of "'Twas the Night before Christmas," conveys much of the fun and good humor that the buying and giving of these gifts involved.

Not so very long ago, "once upon a time,"
A little back in the past, in the year fifty-nine,
In the month of February and the second day,
Did two young people, in the usual way
Vow each to the other to true be forever,
'Til life should end and that the tie sever.

And now, as the year sixty-nine has come round,
Ten years having flown since they two were bound:
They thought to celebrate this anniversary day,
And have a wedding of <u>tin</u>, which is now quite the
way.
And so they sent to their friends one and all,
Who gladly answered to the hospitable call;
And in large numbers from far and near came
To STONY BROOK farm, not unknown to fame;
Bringing gifts of <u>tin</u> both common and rare,
A motely collection you could but declare—
Vases, baskets, and canes, not a few,
And crumb trays and brushes all nice and new;
And in a box a nice tin fan,
And lanterns a plenty, and a large bread pan.
Then boxes for cake and others for bread,
And a set of curls for Mrs. L——'s head.
And then for the host some fashionable ties,
And a pair of specs to aid feeble eyes—
Boots, shoes, bonnets and hats,
Some pretty things, as wire table mats;

An apron of <u>tin</u> to keep her dress clean,
With pockets and bib as cute as ere seen.

Two examples of Pennsylvania German folk art were also intended as celebratory gifts. Early in the nineteenth century Elizabeth Fedderly received a painting (fig. 10.30) as a New Year's Day present. The fraktur-style piece may depict Mrs. Fedderly herself with her family; it is not known, however, whether the scene represented

is a New Year's celebration or an event of some significance in the life of the recipient.

Redware pie plates such as figure 10.29 were often commissioned as gifts among the Pennsylvania Germans. The sgraffito decoration on this late-eighteenth-century plate, which includes a scene of couples dancing, is an ancient technique in which a liquid clay slip of one color is superimposed on a barely wet clay body of another color; the design is produced by scratching through the slip. Pennsylvania pottery with sgraffito decoration characteristically employs a cream-colored slip that reveals the native red clay when incised with a sharp tool. As seen here, such plates often combine an inscription with the design, and frequently, as here, the words are somewhat naughty.

Among the Native American population, celebrations were frequently part of the religious system. Thus, the scenes of Indian dances included here (figs. 10.25–10.28) do not represent merely social events, but meaningful religious or commemorative observances. Fortunately, these works were appreciated by early anthropologists; many of them, therefore, have been preserved. That they were valued by the Native Americans themselves, as well as by historians, is evidenced by the experience of anthropologist Helen Blish. Studying the Plains Indians in the

10.23 *Portrait of Wilhelm Witz and His Pet Dogs,*
c. 1810. Jacob Maentel.
Watercolor and ink on paper, 11½ × 7½ inches.
Terra Museum of American Art, Chicago,
Daniel J. Terra Collection

late 1920s for the Carnegie Institute of Washington, she reported on a ledger filled with more than four hundred remarkable watercolor drawings by an Oglala Sioux Indian, Amos Bad Heart Buffalo (1869–1913), and arranged to have it photographed before it was buried with his sister Dolly Pretty Cloud. One of the drawings (fig. 10.28) depicts a ceremonial dance, during which warriors "charge" the kettle in which a prairie dog is being cooked, after which pieces of the meat are served to distinguished guests. Amos's father and uncle were famed warriors, and from them he learned of the exploits and ceremonies that his skill later celebrated.

A description of another Native American painting, *Shawnee Indians Having Cornbread Dance* by Earnest Spybuck (fig. 10.25), as published by Lee A. Callander and Ruth Slivka, makes clear the religious connotations of this event. According to these students of Shawnee life:

The Bread Dance is a celebration of the Shawnee's ability to obtain food from the natural environment and of their relationship with the deities. In Spybuck's time it featured two events—a three-day hunt by men, and the preparation of food, especially corn bread, by women. Two days of festivities followed the hunt and included dancing and feasting. A prayer was always offered in thanks for the success of past crops and hunts and to seek a blessing in all future endeavors of the Shawnee people.

Here the men, their faces striped with the distinctive black paint of Bread Dance hunters, have returned from the hunt and dance to the traditional songs. The musicians, called singers, play a drum where they sit to the west of the dance ground. In the foreground a committee of women claims the game from the hunt which traditionally consisted of deer, turkey, and squirrel.

Earnest Spybuck's work is clearly different from the other Native American paintings in this book. Compared to such highly stylized works as *Shootingway Dancers in Mountain Way* (fig. 10.27) and *An Indian Horse Dance* (fig. 10.26), for example, *Shawnee Indians Having Cornbread Dance* is a realistic rendering. Spybuck was a Shawnee who lived and worked in Oklahoma at the turn of this century. According to Callander and Slivka, three catalysts shaped the way—unique for his culture—that Spybuck chose and portrayed his subjects: his natural talent, the availability of manufactured paints and paper, and the patronage of anthropologist M. R. Harrington, who collected Spybuck's paintings for the Museum of the American Indian in New York. Spybuck told Harrington that he learned to draw by tracing a stick over the ground and that "Mother Earth started me drawing." When he met Harrington, the artist's preferred subjects were cowboys, cattle, and range scenes, but the anthropologist persuaded him to paint the kind of picture included here, scenes of ceremonies, celebrations, and other aspects of Shawnee life as he had known them.

Just as Spybuck recorded aspects of Shawnee life, so Lewis Miller documented life in York, Pennsylvania. As discussed earlier, Miller's sketches often dealt with the intimate details of his and his neighbors' lives, such as attending church and school or eating sweet potatoes at a local hotel. But Miller also included events of national importance in his chronicles, and one of the most significant of these was the abolition of slavery. "The Negro's slavery is abolished, and the colored population set free, all over the Union," reads the inscription on his drawing (fig. 10.31) depicting the "Picnic Parti" held by the blacks to celebrate the great event.

The annual celebration of our country's independence on the Fourth of July was, then as now, a nationwide event. In the past, when the memories of the battles of the Revolution were still fresh, the celebrations had a more patriotic flavor, although some of the traditions we follow today have long histories. A broadside announcing the Fourth of July festivities for Douglass, Kansas, in 1871, published by Joanna Stratton, shows how little some things have changed:

A great 4th of July at Douglass, 1871, everybody is invited to come and bring filled baskets and buckets. There will be a prominent speaker present, who will tell of the big future in store for southern Kansas. Grand fire works at night! Eighteen dollars worth of sky rockets and other brilliant blazes will illuminate the night! There will also be a bunch of Osage Indians and cowboys to help make the program interesting. After the fire works there will be a big platform dance, with music by the Hatfield Brothers.

Picnics are as much a Fourth of July tradition in America as fireworks. In the middle of the nineteenth century, Susan Merrett recorded the annual event held by the town of Weymouth Landing, Massachusetts (fig. 10.1). This picture bears close scrutiny, for it is actually a collage: the tiny figures are cutouts that have been painted separately and then pasted onto a watercolor landscape. Making this picture was certainly a time-consuming task for the talented folk artist, who is known only for this work, a highly unusual one for the very large number of the figures.

Events are a bit more raucous at the small-town July Fourth picnic shown on an early-twentieth-century hooked rug (fig. 10.33) than at the sedate affair at Weymouth Landing, and we hardly need the artist's caption to assure us that "all had a good time." So vivid are the scenes on this rug—children setting off firecrackers, chasing dogs, riding bicycles—that one can almost hear the shouting. At the center of it all is the main event of the day, the cakes and other goodies that all have gathered to eat.

The same unidentified artist brought her sense of humor and her understanding of what these holiday celebrations mean to children in another rug that commemorates Christmas (fig. 10.34). It was not until the second half of the nine-

10.24 Lady's riding hat, 1850–80. Artist unknown.
Tin, 8 inches wide.
Collection of Mr. and Mrs. James Douglass Clokey III

Apron, 1880–1900. Artist unknown.
Tin, fabric, 33 inches wide.
Museum of American Folk Art, New York
Promised gift of Martin and Enid Packard

Hairpiece, c. 1867. Artist unknown.
Tin, 9½ inches high.
Ontario County Historical Society, Canandaigua, New York

teenth century that Christmas was as widely celebrated in this country as it is today. In Colonial New England, Christmas was not kept by the Puritans, who believed that the spirit of Christmas had been defiled by gaming and reveling in the streets. The kind of revelry observed by Ruth Henshaw Bascom in Virginia in 1801 would have appalled our Puritan forefathers in more ways than one:

(1801, December) 24 Thursday. . . . We made apple pies for Christmas & other nicknacks – have 1⁄6 per dozen for apples; 1⁄6 per pound butter; 2⁄3 for eggs. . . . guns fired incessantly from 4 oClock P.M. 'till midnight, to usher in Christmas. . . . the novel celebration of Christmas by Virginia's black slaves. . . . (1801, December) 25 Friday. . . . The

streets all day mostly filled with negroes (drest in their best, playing dancing, shaking hands etc (some crying shoe black shoe black while brushing boots). This and the five following days being the negro's holiday, during which time their time is their own and on the first day of January is a kind of market day for slavery on which they are hired & let, bought & sold like the herds in the stalls. . . .

For these slaves, for people on the frontier, and for most Americans, Christmas came to mean a happy respite from the hard work of everyday life. Celebrations, so few and far between for most, provided incentives to continue toiling in the fields, factories, and homes, and brought special enjoyment to the lives of people who had truly earned it.

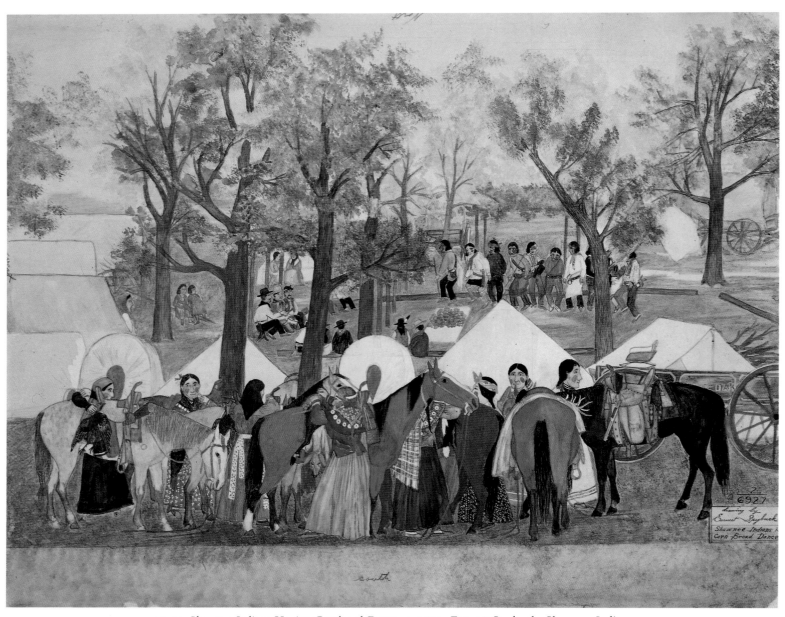

10.25 *Shawnee Indians Having Cornbread Dance*, c. 1910. Earnest Spybuck, Shawnee Indian.
Watercolor on paper, 19⅞ × 24⅞ inches.
Museum of the American Indian, Heye Foundation, New York

10.26 *An Indian Horse Dance*, c. 1900. Kills Two, Sioux Indian.
Watercolor and ink on paper, 16 × 12 inches.
Present location unknown

10.27 *Shootingway Dancers in Mountain Way*, 1905–12. Big Lefthanded, Navajo Indian.
Tempera on mummy cloth, 12½ × 15½ inches.
Museum of Northern Arizona, Flagstaff
Katherine Harvey Collection

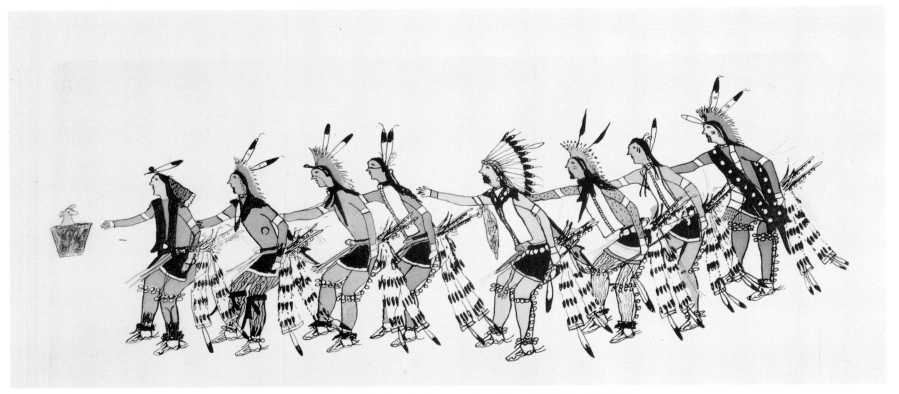

10.28 *Grass Dance: Charging the Dog*, c. 1890. Amos Bad Heart Buffalo.
Watercolor and ink on paper, 7½ × 12 inches.
Destroyed

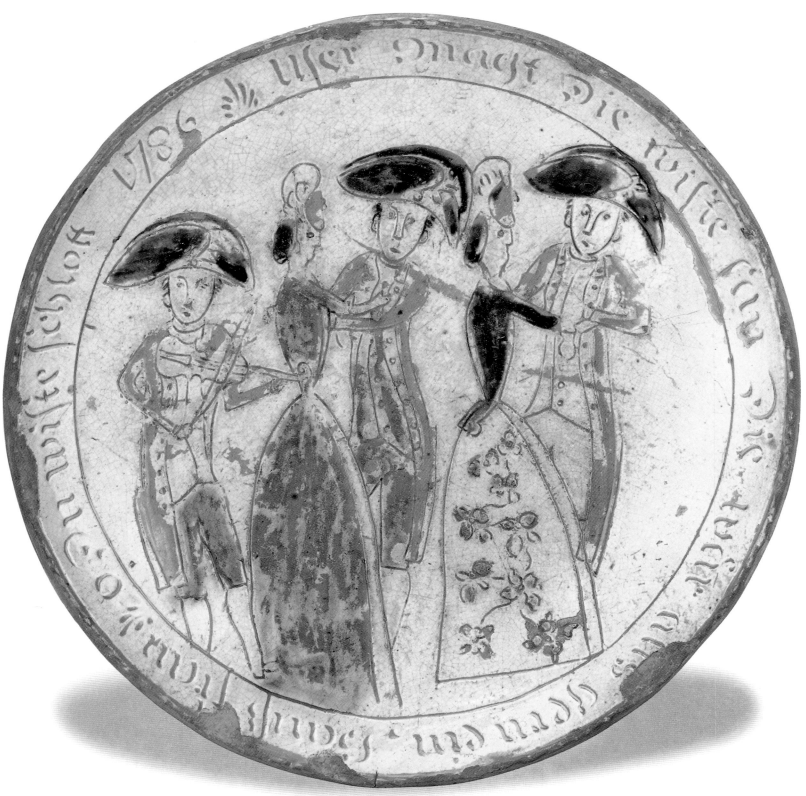

10.29 Redware plate, 1786. Attributed to Johannes Neis.
Pottery, lead glaze with sgraffito decoration, 11¾ inches diameter.
Philadelphia Museum of Art, Philadelphia
Gift of John T. Morris

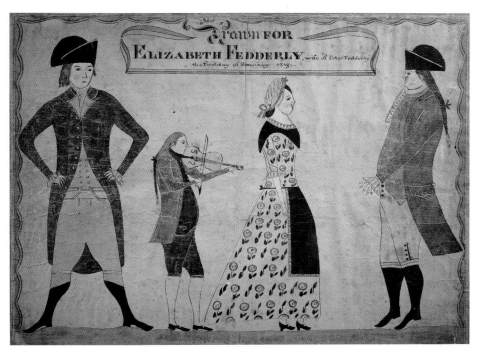

10.30 *For Elizabeth Fedderly*, 1818. Artist unknown.
Watercolor and ink on paper, 14½ × 18½ inches.
Private Collection

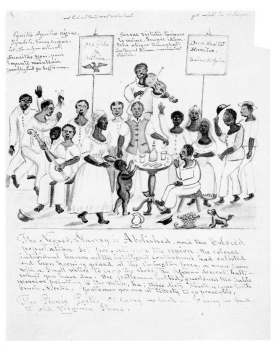

10.31 *Slavery Abolished*, c. 1865. Lewis Miller.
Watercolor and ink on paper, 9½ × 7¼ inches.
The Historical Society of York County, York, Pennsylvania

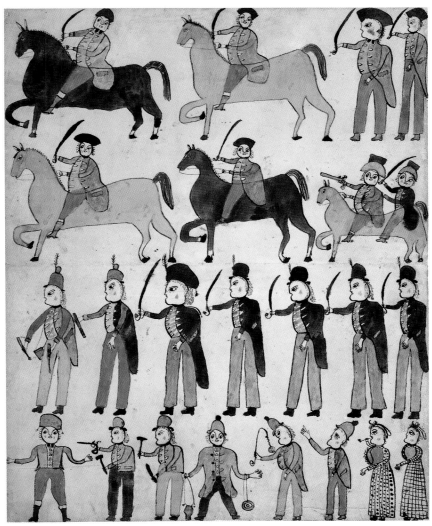

10.32 *Victory Parade*, c. 1790–1800. Artist unknown.
Watercolor and ink on paper, 15¾ × 12¹¹/₁₆ inches.
National Gallery of Art, Washington, D.C.
Gift of Edgar William and Bernice Chrysler Garbisch

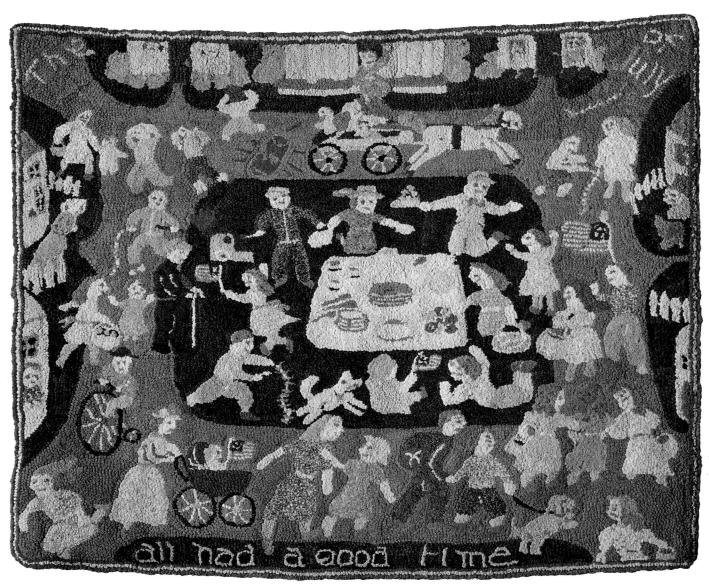

10.33 *All Had a Good Time*, c. 1910. Artist unknown.
Wool on burlap hooked rug, 37½ × 45½ inches.
Shelburne Museum, Shelburne, Vermont

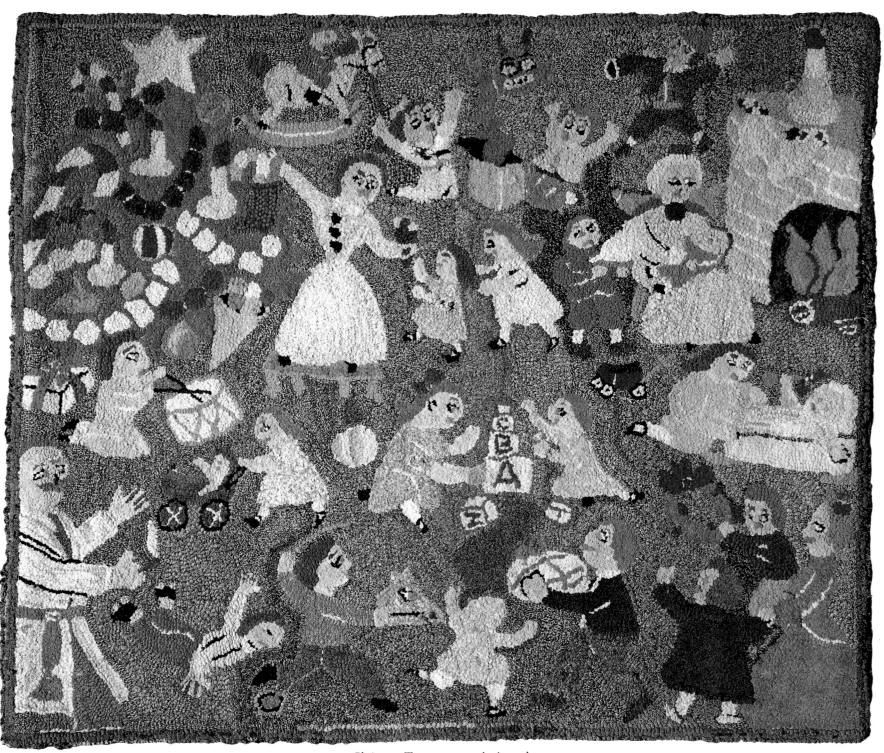

10.34 *Christmas Tree*, c. 1910. Artist unknown.
Wool on burlap hooked rug, 37 × 42 inches.
Shelburne Museum, Shelburne, Vermont

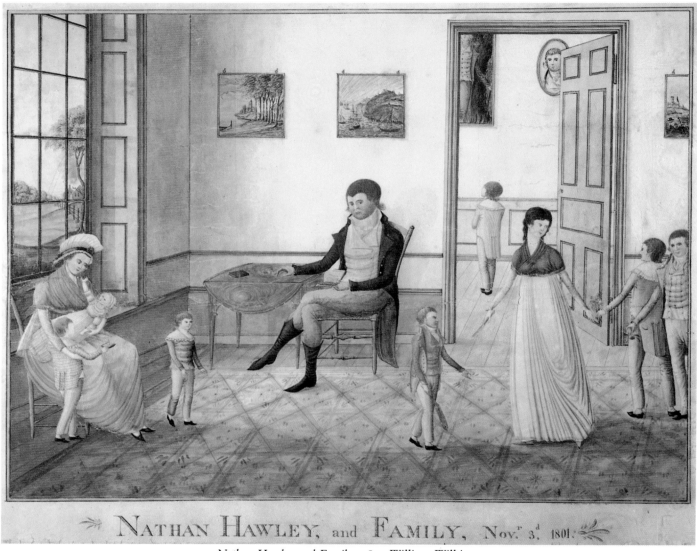

Nathan Hawley and Family, 1801. William Wilkie.
Watercolor and ink on paper, 15¾ × 20 inches.
Albany Institute of History and Art, Albany, New York

Afterword: Rediscovering American Folk Art—
Yesterday, Today, and Tomorrow

IN THE YEARS following World War I, American collectors and artists began actively to seek new information about the artistic past of their own country; a number of artists both collected folk art and adopted some aspects of the styles of the folk painters of the eighteenth and nineteenth centuries in their own works. There was a new awareness of folk art, and during the 1920s and 1930s several major collections were started.

The most notable of these, assembled by Abby Aldrich Rockefeller, is now at the Abby Aldrich Rockefeller Folk Art Center in Williamsburg, Virginia. Henry Ford became enthusiastic about folk art, and his monumental holdings are preserved at the Greenfield Village and Henry Ford Museum in Dearborn, Michigan. Electra Havemeyer Webb's collection became the Shelburne Museum at Shelburne, Vermont, and the collections of the brothers Albert B. and J. Cheney Wells are now in Old Sturbridge Village at Sturbridge, Massachusetts. Howard and Jean Lipman's first collection of paintings and sculpture is the core of the collection formed by the New York State Historical Association at Cooperstown, New York, and many of the masterpieces from their second collection are to be found at the Museum of American Folk Art in New York City.

Many other collectors have placed their folk treasures in various museums. Titus C. Geesey formed an unequaled assemblage of Pennsylvania German fraktur, paintings, sculpture, pottery, textiles, and furniture, now in the Philadelphia Museum. The Museum of Fine Arts, Boston, was the recipient of the folk paintings from the remarkable M. and M. Karolik collection. The best of the great collection of paintings assembled by Edgar William and Bernice Chrysler Garbisch has been given to a number of museums.

Another pattern of collecting was developed by Nina Fletcher and Bertram K. Little, who spearheaded an effort to preserve important old houses, and to furnish them with pieces that were appropriate to the time and location of the architecture. Most of their folk art is destined for the Society for the Preservation of New England Antiquities, which will place the collection in historically appropriate architectural settings.

Through the years, numerous museum exhibitions brought an ever-widening circle of devotees to the folk-art field. Art historian and museum director Holger Cahill organized *American Primitives* (1930–31) at the Newark Museum in New Jersey. Cahill again captured the imagination of the art world when he assembled *American Folk Art, The Art of the Common Man in America, 1750–1900* for presentation at the Museum of Modern Art in New York in 1932. With these early exhibitions American folk art was brought to the attention of art historians, art critics, and a public which continues to increase in size every year.

Cahill viewed folk painting, sculpture, textiles, and ceramics as "the unconventional side of American art." Perhaps it was too early for him to realize fully that in both quantity and quality, folk art had been, in fact, the mainstream of American artistic expression.

Although catalogues accompanied several of the important early exhibitions, much of the major scholarship in the field has reached the public through books. Jean Lipman, Clara Endicott Sears, Carl W. Drepperd, Nina Fletcher Little, Mary Black, and Alice Winchester, to name a few, have recorded the major contributions to American art history made by the folk artists.

Many of the earliest writers appear to have been uncertain about what kinds of objects should be classified as valid expressions of the folk artist. Since then, there has been a search for a definition wide enough to encompass the rich variety of pieces, ranging from unique family portraits to ornamental chalkware produced in large numbers through the use of molds, and for criteria against which to evaluate such works as cigar-store Indians, carousel horses, and circus-wagon decorations, which were generally made in woodcarving shops where several craftsmen sometimes collaborated on a single piece. But no definition of folk art—with its centuries of production and varied content, media, and styles—can summarize the whole subject; Cahill's six-word comment remains the most acceptable start.

In recent years two exhibitions have exerted a profound influence on folk-art scholarship: *The Flowering of American Folk Art (1776–1876)*, curated by Jean Lipman and Alice Winchester in 1974 for the Whitney Museum of American Art in New York, and *American Folk Painters of Three Centuries*, curated by Jean Lipman and Tom Armstrong, shown at the Whitney in 1980, greatly accelerated the interest in folk art.

The Museum of American Folk Art, founded in 1961, has also contributed substantially. More than 120 original exhibitions have been mounted in New York. This fledgling institution publishes the only major magazine in the field, *The Clarion*, which reports the activities of the museum and the results of new and important scholarship on a regular basis. It also includes information about exhibitions and related events across the country.

Of special importance is the new Folk Art Studies Program created by the museum for New York University. Students now enjoy a unique opportunity to earn masters' degrees and doctorates in the department of American Folk Art Studies; in addition, the Folk Art Institute, a division of the Museum of American Folk Art, offers a certificate program.

And, inevitably, as research in the field increases, changes in perception result. The early collectors of the 1950s, such as Colonel Edgar William and Bernice Chrysler Garbisch, felt strongly that the naïve paintings they had gathered should not be called folk art. They seldom lent to a museum where their pictures would be labeled in such a "denigrating" way.

Many collectors of the traditional folk arts have steadfastly refused to acknowledge naïve twentieth-century painting and sculpture and have confined their interest to pieces from the late eighteenth and nineteenth centuries. In *Young America*, Jean Lipman, the museum staff, and I have extended the time frame to include objects up to World War I, for we felt strongly that with that great international conflict America ceased to be a self-contained social and cultural entity, and that the isolation that fed the best creative impulses in the folk artist was over. In other words, America came of age, became literally worldly, was no longer a young nation of innocents. Though many were still self-taught, artists had learned to utilize the sophisticated achievements of the Industrial Revolution, and the less complex products of the folk artists began noticeably to decline.

But the folk artist and folk art did not disappear, as many maintain. There is, after all, a large number of artists today who are self-taught and who are unfamiliar with the "high art" of the past and of our own times. Values have changed but not everything is different. The craft tradition survives today. There are carvers and quilt makers who still use their hands to fashion pieces that are functional and at the same time beautiful.

I believe it is impossible to deny the artistic merit of some of the works of artists such as the northerner Anna Mary Robertson Moses, better known as "Grandma" Moses, and Mattie Lou O'Kelley, the recorder of the rural South. At their best these artists have captured the fast-disappearing country landscape and celebrated its greatness in their folk genre pictures. As chronicles of the period in which they lived their paintings are little different from Olof Krans's action-filled scenes of the nineteenth-century rural community at Bishop Hill, Illinois.

There is indeed a still valid nonacademic tradition in twentieth-century art. It is an art of rich imagery, most often fed by religious conviction and by enthusiasm for the American experience. It celebrates the many opportunities afforded the unschooled artist. To be sure, Young America, as presented in this book and the coordinated exhibition, is gone. The age of innocence has passed and with its passing our life-styles have changed. This is one of the major reasons we celebrate with such feeling our folk heritage from the remarkably rich period between the American Revolution and World War I.

ROBERT BISHOP

ADAMS, E. BRYDING. "The Fraktur Artist Henry Young." *Der Reggeboge (The Rainbow), Quarterly of the Pennsylvania German Society*, vol. 11, no. 3–4 (Fall 1977).

ALEXANDER, HARTLEY BURR. *Sioux Indian Painting, Part II, The Art of Amos Bad Heart Buffalo*. Nice, France: C. Szwedzicki, 1938.

American Folk Art: Expressions of a New Spirit (exhibition catalogue). New York: Museum of American Folk Art, 1983.

AMES, KENNETH L. *Beyond Necessity: Art in the Folk Tradition*. Winterthur, Del.: The Henry Francis DuPont Winterthur Museum, 1977.

ANDREWS, EDWARD DEMING. *The People Called Shaker: A Search for the Perfect Society*, 1953. Reprint. New York: Dover Publications, 1963.

ARMSTRONG, THOMAS N. III. *Pennsylvania Almshouse Painters* (exhibition brochure). Williamsburg, Va.: Colonial Williamsburg, 1968.

BANK, MIRRA. *Anonymous Was a Woman*. New York: St. Martin's Press, 1979.

BASCOM, RUTH HENSHAW. "Journal of Ruth Henshaw Bascom." Manuscript at the American Antiquarian Society, Worcester, Mass.

BISHOP, ROBERT. *American Folk Sculpture*. New York: E. P. Dutton, 1974.

_____. *Folk Painters of America*. New York: E. P. Dutton, 1979.

BISHOP, ROBERT, AND COBLENTZ, PATRICIA. *American Decorative Arts*. New York: Harry N. Abrams, 1982.

_____. *A Gallery of American Weathervanes and Whirligigs*. New York: E. P. Dutton, 1981.

BISHOP, ROBERT; WEISSMAN, JUDITH REITER; MCMANUS, MICHAEL; AND NEIMAN, HENRY. *Folk Art: Paintings, Sculpture, and Country Objects*. New York: Alfred A. Knopf, 1983.

BLACK, MARY. *Erastus Salisbury Field: 1805–1900* (exhibition catalogue). Springfield, Mass: Museum of Fine Arts, 1984.

_____. "A Folk Art Whodunit." *Art in America*, vol. 53, no. 3 (June 1965), pp. 96–105. [Jacob Maentel]

BLACK, MARY, AND LIPMAN, JEAN. *American Folk Painting*. New York: Clarkson N. Potter, 1966.

BLISH, HELEN H. *A Pictographic History of the Oglala Sioux*. Lincoln, Nebr.: University of Nebraska Press, 1967. [Drawings by Amos Bad Heart Bull (Buffalo)]

BOLTON, ETHEL STANWOOD, AND COE, EVA JOHNSTON. *American Samplers*, 1921. Reprint. New York: Dover Publications, 1973.

BOYD, E. *Popular Arts of Spanish New Mexico*. Santa Fe: Museum of New Mexico Press, 1974.

BRANT, SANDRA, AND CULLMAN, ELISSA. *Small Folk: A Celebration of Childhood in America*. New York: E. P. Dutton in Association with the Museum of American Folk Art, 1980.

CAHILL, HOLGER. *American Folk Art: The Art of the Common Man in America, 1750–1900* (exhibition catalogue). New York: Museum of Modern Art, 1932.

[CAHILL, HOLGER.] *American Primitives* (exhibition catalogue). Newark, N.J.: Newark Museum, 1930.

CALLANDER, LEE A., AND SLIVKA, RUTH. *Shawnee Home Life: The Paintings of Earnest Spybuck*. New York: Museum of the American Indian, 1984.

CARMER, CARL. "A Panorama of Mormon Life." *Art in America*, vol. 58, no. 3 (May–June 1970), pp. 52–65.

CARROLL, KAREN COBB. *Windows to the Past: Primitive Watercolors from Guilford County, North Carolina, in the 1820s* (exhibition catalogue). Greensboro, N.C.: Greensboro Historical Museum, 1983. [The Guilford Limner]

CATLIN, GEORGE. *Letters and Notes on the Manners, Customs, and Conditions of the North American Indians*. London, 1844. Reprint. Introduction by Marjorie Halpin. New York: Dover Publications, 1973.

CHRISTENSEN, ERWIN O. *Early American Wood Carving*. Cleveland and New York: The World Publishing Co., 1952.

_____. *The Index of American Design*. Introduction by Holger Cahill. New York: Macmillan, 1950.

CLARK, ISAAC. "Letter to his Daughter, 11th September, 1806. Brewster." In the exhibition, *Evidence of Accomplishment: Schoolgirl Art in New England*. Old Sturbridge Village, Sturbridge, Mass., Summer 1977.

DAINGERFIELD, ELIZABETH. "Patch Quilts and Philosophy." *The Craftsman*, vol. 14, 1908.

DAVIDSON, MARSHALL B. *Life in America*. 2 vols. Boston: Houghton Mifflin Co. in Association with the Metropolitan Museum of Art, 1951.

DEPAUW, LINDA GRANT, AND HUNT, CONOVER. *"Remember the Ladies": Women in America 1750 to 1815* (exhibition catalogue). New York: Viking Press in Association with The Pilgrim Society, 1976.

DEWHURST, C. KURT; MACDOWELL, BETTY; AND MACDOWELL, MARSHA. *Artists in Aprons: Folk Art by American Women*. New York: E. P. Dutton in Association with the Museum of American Folk Art, 1979.

_____. *Religious Folk Art in America: Reflections of Faith*. New York: E. P. Dutton in Association with the Museum of American Folk Art, 1983.

EARNEST, ADELE. *The Art of the Decoy: American Bird Carvings*. Exton, Pa.: Schiffer Publishing, 1982.

EBERT, JOHN, AND EBERT, KATHERINE. *American Folk Painters*. New York: Charles Scribner's Sons, 1975.

EMERY, SARAH ANNA. *Reminiscences of a Nonagenarian*. Newburyport, Mass.: William H. Huse, 1879.

ERICSON, JACK T., ed. *Folk Art in America, Painting and Sculpture*. New York: Mayflower Books, 1979.

EWERS, JOHN C.; GALLAGHER, MARSHA V.; HUNT, DAVID C.; AND PORTER, JOSEPH C. *Views of a Vanishing Frontier* (exhibition catalogue). Omaha, Neb.: Center for Western Studies/Joslyn Art Museum; distributed by University of Nebraska Press, 1984.

FALES, DEAN A., AND BISHOP, ROBERT. *American Painted Furniture 1660–1880*. New York: E. P. Dutton, 1972.

FLAYDERMAN, E. NORMAN. *Scrimshaw and Scrimshanders/Whales and Whalemen*. New Milford, Conn.: N. Flayderman and Co., 1972.

FLEXNER, JAMES THOMAS. "Monochromatic Drawing: A Forgotten Branch of American Art." *The American Magazine of Art* (The American Federation of Arts, Washington), vol. 38, no. 2 (February 1945), pp. 62–65.

"A Folk Copyist." *Antiques*, vol. 124, no. 1 (July 1983), p. 117. [MaryAn Smith]

FRANCIS, RELL G. *The Utah Photographs of George Edward Anderson*. Fort Worth, Texas: University of Nebraska Press for the Amon Carter Museum of Western Art, 1979.

FRIED, FREDERICK. *Artists in Wood*. New York: Clarkson N. Potter, 1970.

_____. *A Pictorial History of the Carousel*. New York: A. S. Barnes and Co., 1964.

GARBISCH, EDGAR WILLIAM; GARBISCH, BERNICE CHRYSLER; ET AL. "American Primitive Painting, Collection of Edgar William and Bernice Chrysler Garbisch." *Art in America*, vol 42, no. 2 (May 1954), special issue.

GARVAN, BEATRICE B., AND HUMMEL, CHARLES F. *The Pennsylvania Germans: A Celebration of Their Arts 1683–1850* (exhibition catalogue). Philadelphia: Philadelphia Museum of Art, 1982.

HALL, ELIZA CALVERT. *Aunt Jane of Kentucky*. Boston: Little, Brown & Co., 1908.

HESLIP, COLLEEN, AND KELLOGG, HELEN. "The Beardsley Limner Identified as Sarah Perkins." *Antiques*, vol. 126, no. 3 (September 1984), pp. 547–565.

HOLDRIDGE, BARBARA, AND HOLDRIDGE, LAWRENCE B. *Ammi Phillips: Portrait Painter 1788–1865*. Introduction by Mary Black. New York: Clarkson N. Potter for the Museum of American Folk Art, 1969.

HUFF, RICHARD L. "Paul Seifert: A Wisconsin Pioneer Artist." *Wisconsin Tales and Trails*, vol. 8, no. 4 (Winter 1967), pp. 16–19.

ICKIS, MARGUERITE. *The Standard Book of Quiltmaking and Collecting*. New York: Dover Publications, 1960.

JANIS, SIDNEY. *They Taught Themselves. American Primitive Painters of the 20th Century*. New York: Dial, 1942.

JENSEN, OLIVER; KERR, JOAN PATTERSON; AND BELSKY, MURRAY. *American Album*. New York: American Heritage/Ballantine Books, 1968.

JENSEN, RICHARD L., AND OMAN, RICHARD G. *C. C. A. Christensen, 1831–1912: Mormon Immigrant Artist* (exhibition catalogue). Salt Lake City, Utah: The Church of Jesus Christ of Latter-day Saints, 1984.

"The Journal of James Guild, Peddler, Tinker, Schoolmaster, Portrait Painter, from 1818 to 1824." *Proceedings of the Vermont Historical Society*, New Series, vol. v, no. 3 (Montpelier, Vermont, 1937), pp. 249–314.

[KAROLIK]. *M. and M. Karolik Collection of American Paintings. 1815 to 1865*. Essay by John I. H. Baur. Cambridge, Mass.: Harvard University Press for the Museum of Fine Arts, Boston, 1949.

_____. *M. & M. Karolik Collection of American Water Colors & Drawings 1800–1875* (exhibition catalogue). 2 vols. Boston: Museum of Fine Arts, 1962.

KATZENBERG, DENA S. *Baltimore Album Quilts* (exhibition catalogue). Baltimore: The Baltimore Museum of Art, 1980.

KAUFFMAN, HENRY. *Pennsylvania Dutch American Folk Art*. 1946. Rev. ed. New York: Dover Publications, 1964.

KLEEBLATT, NORMAN L., AND WERTKIN, GERARD C. *The Jewish Heritage in American Folk Art*. New York: Universe Books, 1984.

KOPP, JOEL, AND KOPP, KATE. *American Hooked and Sewn Rugs, Folk Art Underfoot*. New York: E. P. Dutton, 1975.

KRUEGER, GLEE F. *A Gallery of American Samplers: The Theodore H. Kapnek Collection*. New York: E. P. Dutton in Association with the Museum of American Folk Art, 1978.

LICHTEN, FRANCES. *Folk Art of Rural Pennsylvania*. New York: Charles Scribner's Sons, 1946.

LIPMAN, JEAN. *American Folk Art in Wood, Metal and Stone*, 1948. Reprint. New York: Dover Publications, 1972.

_____. *American Primitive Painting*, 1942. Reprint. New York: Dover Publications, 1969.

_____. *Rediscovery: Jurgan Frederick Huge*. New York: Archives of American Art, Smithsonian Institution, 1973.

_____. *Rufus Porter Rediscovered*. New York: Clarkson N. Potter, 1968.

LIPMAN, JEAN, AND ARMSTRONG, TOM, eds. *American Folk Painters of Three Centuries*. New York: Hudson Hills Press in Association with the Whitney Museum of American Art, 1980.

LIPMAN, JEAN, AND FRANC, HELEN M. *Bright Stars: American Painting and Sculpture since 1776*. New York: E. P. Dutton, 1976.

LIPMAN, JEAN, WITH MEULENDYKE, EVE. *American Folk Decoration*, 1951. Reprint. New York: Dover Publications, 1972.

LIPMAN, JEAN, AND NELSON, CYRIL I. *The Indian Calendar 1983*. New York: E. P. Dutton in Association with the Whitney Museum of American Art, 1982.

LIPMAN, JEAN, AND WINCHESTER, ALICE. *The Flowering of American Folk Art (1776–1876)*. New York: The Viking Press, 1974.

LIPMAN, JEAN, AND WINCHESTER, ALICE, eds. *Primitive Painters in America. 1750–1950*, 1950. Reprint. Freeport, N. Y.: Books for Libraries Press, 1971.

LITTLE, NINA FLETCHER. "The Conversation Piece in American Folk Art." *Antiques*, vol. 94, no. 5 (November 1968), pp. 744–49.

_____. *Country Art in New England, 1790–1840*, 1960. Rev. ed. Sturbridge, Mass.: Old Sturbridge Village, 1965.

_____. *Country Arts in Early American Homes*. New York: E. P. Dutton, 1975.

_____. *Floor Coverings in New England before 1850*. Sturbridge, Mass.: Old Sturbridge Village, 1967.

_____. "John Brewster, Jr., 1766–1854." *Connecticut Historical Society Bulletin*, vol. 25, no. 4 (October 1960).

_____. *Land and Seascape as Observed by the Folk Artist* (exhibition catalogue). Williamsburg, Va.: Colonial Williamsburg, 1969.

_____. *Little by Little: Six Decades of Collecting American Decorative Arts*. New York: E. P. Dutton, 1984.

_____. *Paintings by New England Provincial Artists 1775–1800* (exhibition catalogue). Boston: Museum of Fine Arts, 1976.

LOGAN, RAYFORD W., AND WINSTON, MICHAEL R., eds. *Dictionary of American Negro Biography*. New York: W. W. Norton & Co., 1982.

LUCHETTI, CATHY, AND OLWELL, CAROL. *Women of the West*. St. George, Utah: Antelope Island Press, 1982.

LUDWIG, ALLAN I. *Graven Images: New England Stonecarving and Its Symbols, 1650–1815*. Middletown, Conn.: Wesleyan University Press, 1966.

MATHER, ELEANORE PRICE (text); MILLER, DOROTHY CANNING, AND MATHER, ELEANORE PRICE (catalogue). *Edward Hicks: His Peaceable Kingdom and Other Paintings*. Newark, Del.: The American Art Journal; University of Delaware Press Books, 1983.

McCOY, RONALD. "Circles of Power." *Plateau*, vol. 55, no. 4 (1984). [Indian Dance Shields]

MILLS, PAUL CHADBOURNE. "The Buffalo Hunter and Other Related Versions of the Subject in Nineteenth Century American Art and Literature." *Archivero I* (1973), pp. 131–72.

NYLANDER, JANE C. "Some Print Sources of New England Schoolgirl Art." *Antiques*, vol. 110, no. 2 (August 1976), pp. 292–312.

ORLOFSKY, PATSY, AND ORLOFSKY, MYRON. *Quilts in America*. New York: McGraw-Hill Book Co., 1974.

PEARSON, ELMER R.; NEAL, JULIA; AND WHITEHILL, WALTER MUIR. *The Shaker Image*. Boston: New York Graphic Society in Collaboration with Shaker Community Inc., Hancock, Mass., 1974.

PETERSON, KAREN DANIELS. *Plains Indian Art from Fort Marion*. Norman, Okla.: University of Oklahoma Press, 1971.

PHELPS, MRS. ALMIRA HART LINCOLN. *The Fireside Friend or Female Student; Being Advice to Young Ladies on the Important Subject of Education*. Boston: Marsh, Capen, Lyon, and Webb, 1840.

PIKE, MARTHA V., AND ARMSTRONG, JANICE GRAY, eds. *A Time to Mourn: Expressions of Grief in Nineteenth Century America*. Stony Brook, N.Y.: The Museums at Stony Brook, 1980.

PINCKNEY, PAULINE A. *American Figureheads and Their Carvers*. New York: W. W. Norton & Co., 1940.

"Recent Acquisition: An American Miniature Panorama." *The Bulletin of the St. Louis Art Museum*, vol. XIII, no. 6 (November 1977).

Remarks on Children's Play. New York, 1811.

RING, BETTY. *Let Virtue Be a Guide to Thee: Needlework in the Education of Rhode Island Women, 1730–1830*. Providence, R.I.: The Rhode Island Historical Association, 1983.

_____. "Memorial Embroideries by American Schoolgirls." *Antiques*, vol. 100, no. 4 (October 1971), pp. 570–75.

RUBIN, CYNTHIA ELYCE, ed. *Southern Folk Art*. Birmingham, Ala.: Oxmoor House, 1985.

RUMFORD, BEATRIX T., ed. *American Folk Portraits: Paintings and Drawings from the Abby Aldrich Rockefeller Folk Art Center*. Boston: New York Graphic Society in Association with the Colonial Williamsburg Foundation, 1981.

SAFFORD, CARLETON L., AND BISHOP, ROBERT. *America's Quilts and Coverlets*. New York: E. P. Dutton, 1972.

SAVAGE, GAIL; SAVAGE, NORBERT H.; AND SPARKS, ESTHER. *Three New England Watercolor Painters* (exhibition catalogue: J. Evans, Joseph H. Davis, J. A. Davis). Chicago: Art Institute, 1974.

SCHLOSS, CHRISTINE SKEELES. *The Beardsley Limner and Some Contemporaries* (exhibition catalogue). Williamsburg, Va.: Colonial Williamsburg, 1972.

SCHORSCH, ANITA. *Mourning Becomes America: Mourning Art in the New Nation* (exhibition catalogue). Clinton, N.J.: Main Street Press, 1976.

SHELLEY, DONALD A. *The Fraktur-Writings or Illuminated Manuscripts of the Pennsylvania Germans*. Allentown, Pa.: Pennsylvania German Folklore Society, 1961.

_____. *Lewis Miller, Sketches and Chronicles: The Reflections of a Nineteenth Century Pennsylvania German Folk Artist*. York, Pa.: The Historical Society of York County, 1966.

SMITH, OLIVE COLE. *The Old Traveling Bag*. Privately printed, 1934. [Deborah Goldsmith]

SVININ, PAUL PETROVICH. *The Observations of a Russian in America: A Glance at the Liberal Arts in the United States*, n.d.

STEINFELDT, CECILIA. *Texas Folk Art: One Hundred Fifty Years of the Southwestern Tradition*. Austin, Texas: San Antonio Museum Association, 1981.

STRATTON, JOANNA L. *Pioneer Women: Voices from the Kansas Prairies*. New York: Simon & Schuster, 1981.

SWAN, SUSAN BURROWS. *Plain & Fancy: American Women and Their Needlework, 1700–1850*. New York: Holt, Rinehart, and Winston, 1977.

TAFT, PAULINE DAKIN. *The Happy Valley*. Syracuse, N.Y.: Syracuse University Press, 1965. [Photographs by Leonard Dakin]

TOMLINSON, JULIETTE, ed. *The Paintings and Journal of Joseph Whiting Stock*. Middletown, Conn.: Wesleyan University Press, 1976.

TRACHTENBERG, ALAN. *The Incorporation of America: Culture and Society in the Gilded Age*. New York: Hill and Wang, 1982.

WANSEY, HENRY. *The Journal of an Excursion to the United States of North America in the Summer of 1794*. 1796. Reprint. New York and London: 1969.

WARREN, WILLIAM L. "Richard Brunton— Itinerant Craftsman." *Art in America*, vol. 39, no. 2 (April 1951), pp. 81–94.

WILLARD, CHARLOTTE. "Panoramas, the First Movies." *Art in America,* vol. 47, no. 4 (Winter 1959), pp. 64–69.

WINCHESTER, ALICE. *Versatile Yankee: The Art of Jonathan Fisher*. Princeton, N.J.: Pyne Press, 1973.

WROTH, WILLIAM. *Christian Images in Hispanic New Mexico*. Colorado Springs, Col.: The Museum, 1982.

Youthful Amusements. Philadelphia, 1810.

Page numbers in *italics* refer to illustrations